D0522126

BAND OF BROTHERS

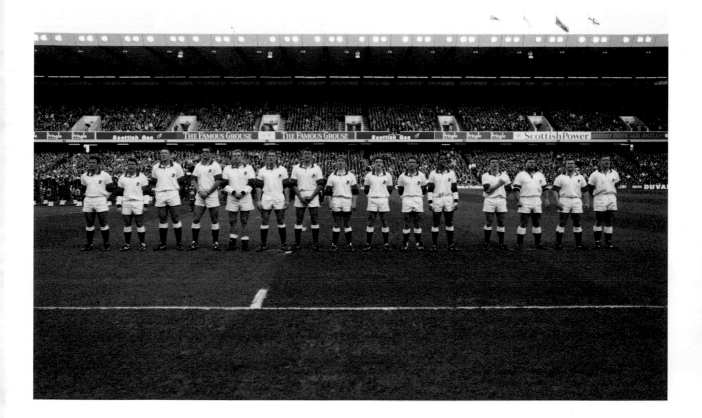

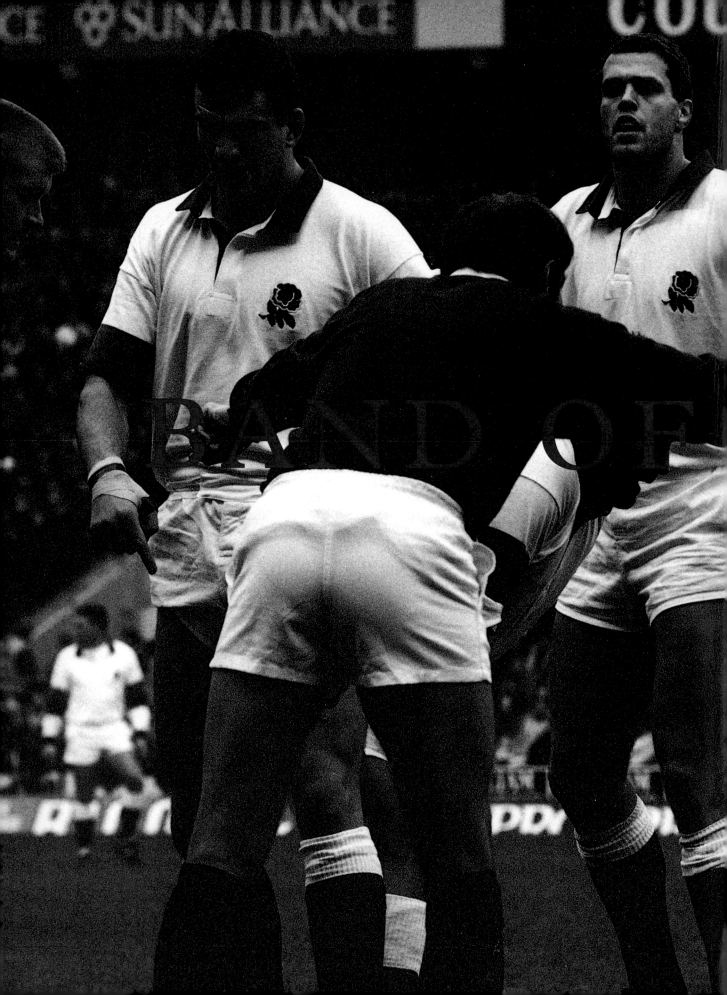

BROTHERS

A Celebration of the England Rugby Union Squad

Written by Frank Keating with the England Players
Photographs by Jon Nicholson

MICHAEL JOSEPH
LONDON

MICHAEL JOSEPH LTD

Published by the Penguin Group
27 Wrights Lane, London W8 5TZ
Viking Penguin Inc., 375 Hudson Street, New York, New York 10014, USA
Penguin Books Australia Ltd, Ringwood, Victoria, Australia
Penguin Books Canada Ltd, 10 Alcorn Avenue, Toronto, Ontario, Canada M4V 3B2
Penguin Books (NZ) Ltd, 182–190 Wairau Road, Auckland 10, New Zealand

Penguin Books Ltd, Registered Offices: Harmondsworth, Middlesex, England

First published 1996
10 9 8 7 6 5 4 3 2 1

Copyright © The Rugby Football Union 1996
Copyright © photographs Jon Nicholson 1996

All rights reserved.
Without limiting the rights under copyright
reserved above, no part of this publication may be
reproduced, stored in or introduced into a retrieval system,
or transmitted, in any form or by any means (electronic, mechanical,
photocopying, recording or otherwise) without the prior written permission
of both the copyright owner and the above publisher of this book

Typeset in 11/15 pt Monotype Plantin
Designed in QuarkXpress on an Apple Macintosh
Printed and Bound in Great Britain by Butler & Tanner Ltd. Frome, Somerset

A CIP catalogue record for this book is available from the British Library

ISBN 0 7181 4173 3
The moral right of the author has been asserted

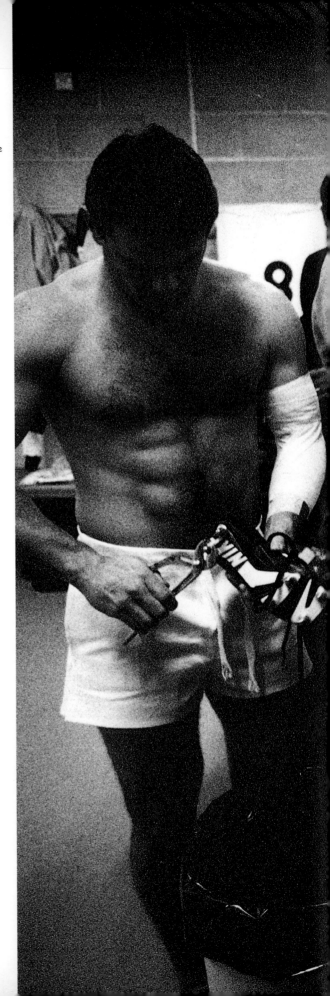

(*page 1*) England's anthem in
Scotland: 'It was pure,
unadulterated aggression from
the crowd. I felt like I was an
extra in *Braveheart*,'said the
new cap Garath Archer (*third
from left*). (*From left to right*):
Carling, Underwood, Archer,
Johnson, Richards, Dallaglio,
Clarke, Dawson, Grayson, Catt,
Guscott, Sleightholme,
Leonard, Regan, Rowntree

Contents

Preface

Reader, it may surprise you to know that some serious international rugby football was actually played during 1995–96, a rugby season of political upheaval and tumult in which a good game totally reinvented itself in just a handful of months after a century of cosy complacency and self-centred calm. But fear not, you found this book on the sporting shelves because sport and sportsmanship, not politics and envy, is the subject matter of all that follows here. For good measure, I reckon as well that it is allowable to claim this as a unique sports book. Well, has any other cadre of international team players in any of the world's leading team games ever before given to a writer and photographer unlimited access into every nook and cranny of its collective psyche? Not to my knowledge. Since modern sport began, the team locker-room has been a secret conclave sacred only to the members of its fraternity. Not any more, and Will Carling and his merrie Englanders – the whole squad and an enlightened management – must be thanked not only for their trust but for their daring in the first place. If nothing else, the end product surely shows that sport does not so much build character as reveal it. After different turmoils in the World Cup, England found themselves a brand new team – wide-eyed rookies joining celebrated old hands – but, as will be revealed, it at once identified that typically English characteristic for which (for once) there are no precise English words, namely *esprit de corps*. And then they went out and, against all forecasts, won the damn thing – if only to illustrate to themselves that, against the odds, as Emerson put it, of all men the Englishman stands firmest in his shoes.

Frank Keating
August 1996

Foreword by Rory Underwood

This book is, mercifully and happily, a purely sporting chronicle of one group's endeavour, expectation, and ultimate success – but what makes it unique is that its action all takes place in a season in which there was one absolute certainty, namely that rugby union will never be the same again. The change to full professionalism hit northern hemisphere rugby following the World Cup in South Africa at such an indecent pace that the resultant indecision, procrastination and jealous rivalry left the game in a condition from which it could take many years to recover. The haste to change engendered a morass of confusion and ineptitude in the unseemly dash for cash – a dash that the International Board could have so easily avoided had they not sat on their hands for so long. It speaks volumes for the tenacity and forbearance of some of the new breed of club chief executives and some of the mandarins at Twickenham that, following such a shambolic re-birth, a workable framework appears to have been arrived at which can carry the game into the next millennium.

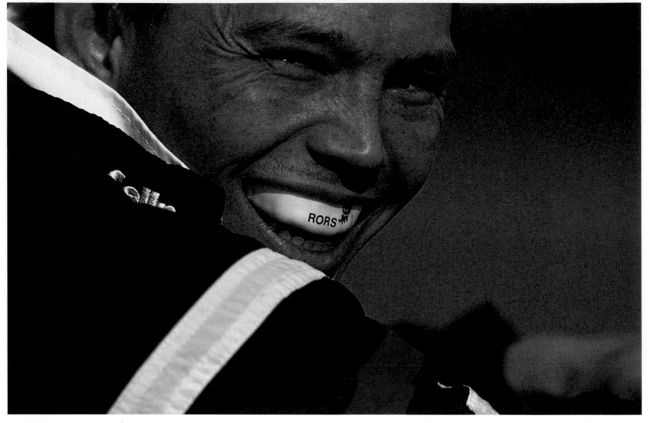

With the professional game comes professional pressure – and the England squad certainly experienced its fair share of that. Even before the first cheque had arrived through the letterbox, that delightful deference afforded the Corinthian amateur had vanished through the cat-flap and England, more so than any of the home nations, became fair game for a hostile press, and the England style of play was being held responsible for everything from water shortage in Yorkshire to the lack of 'feelgood factor' in the nation. Calls went out for the heads of the 'old guard' (including yours truly), and a new-look England squad with many young players had to show great character against a tirade of journalistic criticism. Against this background of literary hostility it had been decided by the England squad that Frank Keating of the *Guardian* and his colleague and photographer, Jon Nicholson, would be shadowing the squad through the whole season to compile this review. So who do you feel most sorry for? The squad, or Frank and Jon? Perhaps Jack Rowell, the man charged with masterminding the great metamorphosis with the added burden of a press monkey on his back? Credit where it is due, Frank got on with his job as a true professional and, despite his ever-presence, he blended well into the background – while Nicholson became so much one of the boys he and his camera damn nearly got selected!

Gummy grin: Rory Underwood in a break from training before the Ireland Match.

The Five Nations began with Parc des Princes and Thomas Castaignede. So that is how Australia felt in the World Cup! This ageing ticker will not stand too many more last-minute dropped-goals. So we were again written off in the media. But little did they know, for, thanks to Wales (a phrase not often heard in English circles) beating France and our own victories over Wales, Scotland and finally Ireland, we were champions again.

Lasting memories of 1995/96? A Championship win with all those young players coming in to the team to such effect, and the retirements of my old friends, Rob Andrew and, as captain, Will Carling. Fading memories? That hostile press, Castaignede's dropped-goal (strange how the mind blots out trauma) and penalty tries against Leicester in Pilkington Cup Finals (trauma again).

So all in all, a pomegranate of a season for England – nice and sweet, but oh those pips! Now read all about it, and enjoy . . .

The forwards demonstrate
their special fraternity in a hud-
dle next to the scrummaging
machine.

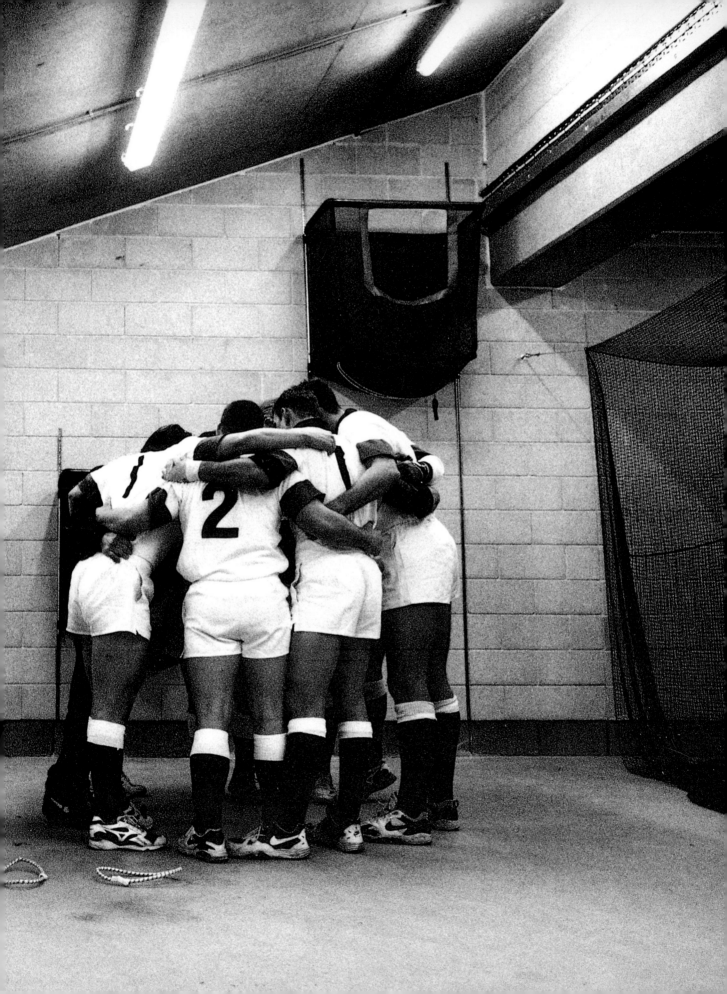

'One for All . . .'

It is ten minutes to three on a ber Saturday in west London.

The face of the referee, Mr Fleming from Scotland, is tautly pallid with trepidation, as are those of fifteen young men imprisoned in this dungeon. Fleming half opens the door, twists his head inside and, with a nervous but schoolmasterly severity, says, 'Captain, please.' To the young men robed in white, those terse words palpably and inescapably clang the imminence of destiny with the same dread of prizefighting's foredoom 'Second's Out!'

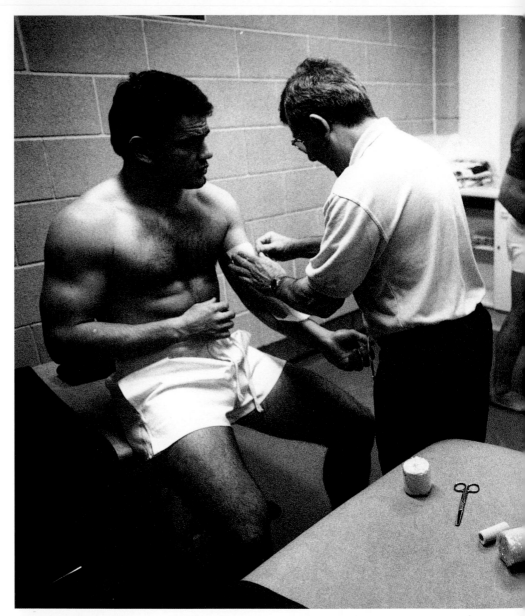

'*Now we are getting there, pre-match strapping. This is where the tension starts to mount – the reality of eighty minutes of hard activity.*' – Jon Nicholson (JN)

'*As we got closer to kick-off, the mood became heavier and heavier. Silence, the odd comment from Will, "Photo in ten minutes!" Kyran was well away.*' – JN

Will Carling, dark eyes narrowed under beetle brows, answers the summons and in the corridor outside the room shakes a cursory hand of greeting with the referee and then with his rival captain, an equally square-jawed blond man – and just as familiar-faced – dressed in the myrtle-green of the new world champions. The referee fussily displays to each man that his coin is not a two-headed one, then spins it, for choice of ends or kick-off. England will kick off. The handshakes are repeated, accompanied by muttered grunts of (presumably) 'good luck'. But neither man's gaze is met by the other.

The captain returns to the long, low, silent cellar. It smells not of liniment, as you might expect, or even of the perspiration of athletes or of private parts. The prevailing whiff, and a strong one, is of a blacking factory, of boot polish. For an hour now, most every man of the twenty-odd have, turn and turnabout, devoted much time to polishing their football boots. As he returned, the captain had glanced meaningfully at the clock, then announced with a firm simplicity, 'Eight minutes to anthems, boys.'

The doctor and physios have finished their final ministrations, and are changed into uniformly bulbous winter tracksuits, ready and waiting and unobtrusive in the corner next to their bags of clobber. From the opposite corner, nearer the door, the England manager stands to his full lock-forward's height; he is not, on match-day, your literal 'tracksuit' manager; Jack Rowell wears a smart blue raincoat over his blazer; he puts on his favourite blue American baseball cap and adopts that familiar wide, gummy grin to soothe courage and good fortune, as his gaze through his large glinting 'nil-nil' spectacles pans round each of his fifteen fond hopes and hopefuls; it is too late to do any more encouraging or, certainly, technical mother-henning; they must fly on their own now – he knows it and so do they. Rowell's lieutenants – the coach, Cusworth; the selector, Slemen; and England's 'director of rugby', Rutherford – had each sweated in these palpitating final apprehensions countless times in their years as international players; now as they flick imaginary fluff from their blazer lapels and straighten their ties, they seem as nervous for their

young charges as they could ever have been for themselves. The four of them leave the room without a word. Those remaining did not remotely notice their departure.

The two half-backs – scrum-half and fly- – have long stopped their whispered 'line-learning' last counsel. The two towering beanpoles, the lineout jumpers who 'lock' the scrum, have uttered no word throughout

'*Well I remember this from school, seeing oranges on a plate. It's all part of the show.*' – JN

(Top right) '*David Pears and Mark Regan. Poor David's only showing, he went on to suffer an injury and was not seen again.*' – JN

(Bottom right) '*As players began to sink into their own mental and physical preparation, I noticed that Jerry Guscott's body wouldn't stay still. He would venture to all areas of the changing room, humming a tune, a quick one-liner to one of the other players (which always went unnoticed) but still totally focused while warming up.*' – JN

the last hour; they have warmed up and greased up, and now stand at their places, shoulder to shoulder, ready to go. Alongside them, it goes without saying, the front-row union (all six ears crowned with elastic bandages) is holding a final, intense and silently embracing chapel-meeting, with 'adrenaline' at the top of the agenda. Likewise, the back-row confraternity, another trio, has now stood as the one single entity, which, for the purpose on hand, it is. These are taller and leaner than the three of the front line, and their look is more of the intense hunters than the defiant hunted.

The captain says, softly, 'Right, boys, ready?' But only the fifteen chosen celebrants can stay. Only fifteen. So the first procession, a glumly and frankly unnoticed one, is led by the six understudies, who have, till now, been part of all the preparation, yet crucially (and cruelly) are now banished from this final pontifical communion. The replacements file out in their winter-warm tracksuits and down the tunnel and up to their 'bench', that lonely lower-grandstand seat of rejection and (yes, each one will admit) of hope that one or two of them might 'get on'. Like the TV advertisement campaign for the new National Lottery, international rugby

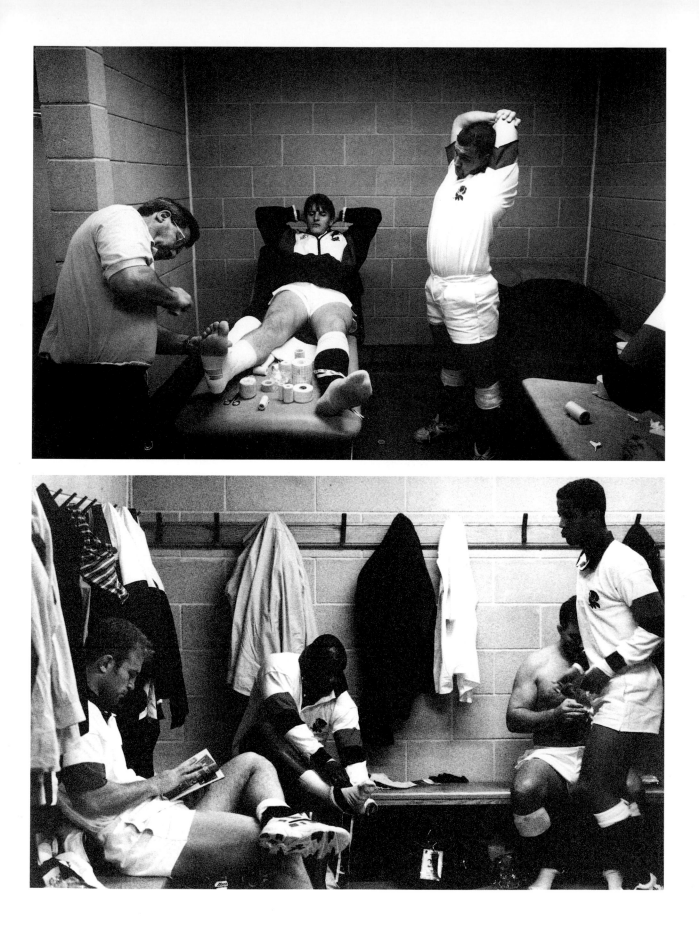

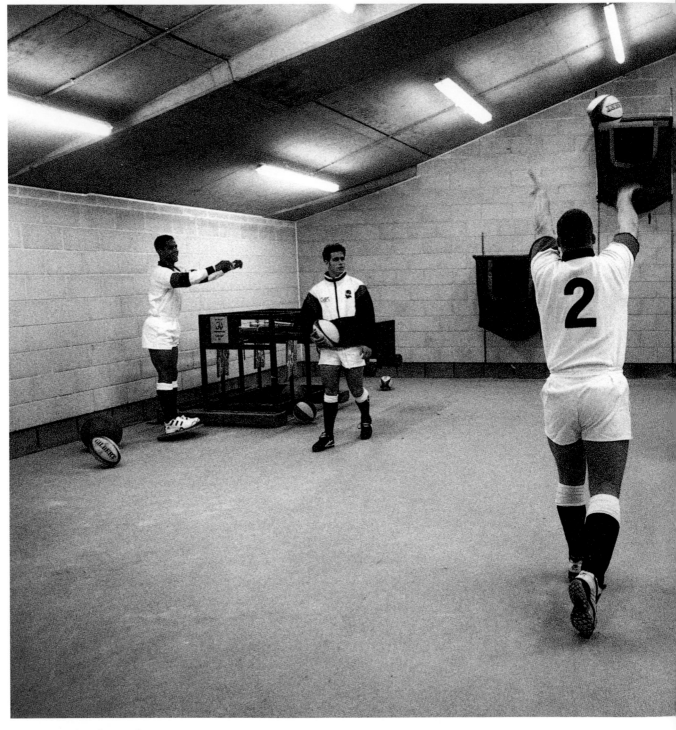

'*Last-minute throwing practice
for Mark Regan. And, guess
what, there's Jerry.*' – JN

replacements dream through days and nights of the podgy golden index swirling from the heavens gloriously to finger them and give them their chance – this Saturday 'It Could Be You!'

The relentless second-hand on the new white-plastic Woolworth's clock above the door has almost finished its last circling vigil towards destiny, and England's animate big Ben now moves briefly centre-stage for hushed, staccato muttered reminders. Clarke is the new pack leader, and, as he speaks, the lieutenants at his flanks, numbers 6 and 7, move closer to him as if to emphasise the importance of this trio's crucial allegiance to themselves and to the rest of them. The very fulcrum of rugby union tactics and strategy in recent times has shifted to the back-row three. They are as the bridge to the full-rigged man-o'-war at battle stations. The back-row control the rhythms and intensities of every engagement. No matter that the fly-half might strut around in gold-braid shouting out numbers. No matter that the captain is the one they all look up to. The back-row control the tiller, the brake, and the accelerator; and they man the very heart of the defences.

One for all, and all for one. Like the front-row steady-as-she-goes stalwarts, so the back-row musketeers come in triplicate, even adjectivally. Strength, bravery, bottle. Rodber, Clarke, Robinson. Speed, defiance, disruption. Robinson, Clarke, Rodber. Tenacity, cunning, imagination. Athos, Porthos, Aramis. One for all, and all for one.

The three back-row capstans having begun it, the other dozen have at once joined them in the middle of the room, and each is now twined close together as one in a full company's huddled, all-embracing final hug, out of which various whispered unintelligible deep-throated private imprecations to valour and resolve are answered with great grunted collective peals which assert the surety of bonded brotherhood. A sort of raucous ultimate of the freemasons' handshake. As they enacted these last

rites one felt half-scared, half-sheepish to be exclusive witness; it was both heroic and moving while it was also, somehow, school-playground juvenile; looking back, such highly charged collective intimacy and bawling ejaculation was embarrassing for this one detached and uniquely privileged observer. Which is as it should be, for a team is a team; no outsiders; and certainly in this context, no prisoners.

The mutual pledge was sealed with a deep, erupting howl from all fifteen throats. Then a split second of silence. A man's gotta do . . . 'We all know what to do . . .' said the captain as he broke away from the tight embrace, picked up a ball from a net of them near the door, and they filed out after him, cold eyes unblinking, each focus concentrated and concentrating. No turning back.

They were beginning something new in more ways than one. This was the start for their sport of a new century; to be sure, of a brand new history. The file broke into a trot. When it burst from the below-stairs gloom and into the sunlight, the collective din which acclaimed them was awesome . . .

Omens everywhere, as well as expectations: fresh paint for a fresh season, and fresh faces for this renewed young team in white which now was challenging the freshest of the world champions in their ancestral livery of myrtle. As well as, dammit and glory be, a fresh stadium, mountainous and four-square to the skies and newly grown like a towering basilica which had this day completely replaced an old game's fondly loved and venerable parish church which for fifteen years less than a century had represented the very core and soul and spirit (aye, and the faults and the 'farts') of worldwide rugby union football, one of the most popular and enjoyed and celebrated global pastimes known to man.

Yet on this day in late autumn of 1995, the most rejoicing hoorays for some – if not, agreed, for others – were to give thanks for the staging of the very first rugby union international match free from the taint and self-reproaching blemish brought on by decades of devious amateurism at this highest level. The grassroots, the rank and file of the game's vast heartland would, of course, continue happily to nurture rugby as it ever has, but here at the leading edge, the shining point of the pyramid was at last and suddenly free from corrosive hypocrisy. It was only a month since the game had officially and universally pronounced itself open, fresh and free, and even England's winter had refused to close in till this day had passed.

It was 18 November, but it could have been April and optimistic springtime, so sharply did the eager sunshine illuminate the gleaming colours of these four sheer cliff-faces of grandeur which enclose the brand-new amphitheatre of Twickenham. And while some romantics allowably sighed

that their evocative, cabbagy-green and splintery old shrine had been replaced (though never forgotten), it goes without saying that the inner sanctum's rectangle of grass down there was as richly emerald-lush as it ever so famously was throughout Twickenham's previous eighty-five-year history, since its first match in January 1910 when the Emperor-King had opened the 'revolutionary and breathtaking' new ground and watched as Wales were beaten.

Now, at the end of 1995, England were challenging the undisputed global champions, for only five months before the Springboks of South Africa had won to exultant acclaim (for a host of reasons, most not simply sporting) rugby's third World Cup at the end of an epic competition on their own diverse home paddocks high on the veld or down on the rim of two southern oceans. England travelled to South Africa warmed and positive with a third-in-five-seasons Five-Nations Grand Slam in their kitbag, and, after a steady enough, if solemn, qualification in the group matches, they won at the last gasp in Cape Town a luminously memorable quarter-final against the Cup holders, Australia, which pinned back the ears of the whole nation in front of their television sets a thousand miles north in the olde worlde and set all England on a roar. A week later, in the semi-final against New Zealand, the viewing figures were the highest ever recorded by Independent Television on a Sunday, but along with the England XV and its noisy band of supporters who had travelled to the brand-new democracy, the result was a fretful disappointment following a dramatic ambush by the All Blacks and their coruscating man-child and phenomenon Jonah Lomu. Not really surprisingly for those who understand how sport can cruelly take the wind from any full spinnaker's sails, England's anti-climax ended without even a medal – beaten to the bronze by France in the third-place play-off a few days later. (The baffled comedown also affected New Zealand, who lost the final to the doughtily inspired South Africans.)

So in November's sunshine, with a handful of the team's older warriors having sheathed their swords (or been carried out on their shields), a significantly different blend of young Englishmen was embarking now against the World Champions on a fresh adventure as they began a new four-year's expedition to the next World Cup. It would be a long and venturesome undertaking, at the same time either perilous or joyfully rewarding; luck and fortune, and the throw of the dice with injury, would play the biggest game; some of them would survive the trek, perhaps most of them gathered here at Twickenham in November; perhaps, again, not very many of them at all. We were about to see what colourful battle-standards they each and collectively put down as markers these next few months. We would see what we would see.

And it would be played out against rugby union's tumultuous new era of honest professionalism. Only a matter of weeks before, with a revolutionary boldness in Paris at the end of August, the game's world governing body, the International Rugby Board, had cataclysmically repealed its hitherto officially sacrosanct amateur regulations. Rugby had agreed at that stroke of a fountain pen in Paris not only to VROOM into nought-to-95 overdrive in terms of 'pay for play', but also to bury the hatchet with its century-old relatives of professional rugby league. So friends will be friends again, after an exact 100 years' war. Why, even at this new beginning at Twickenham in November, there were whispers that the grandest of rugby league clubs, Wigan, would be asked to send a team to play at this very place at rugby union's convivial end-of-term fiesta in May, the Middlesex Sevens. What a bright and historic flare of reconciliation that would prove.

Such reflective serendipity mattered not a fig to young Mark Regan as he prepared for his first international match. He sat in the wide and handsome new Twickenham dressing-room deep under the Royal Box, and at his pre-ordained, pre-destined place below the coatpeg bearing a red-and-blue-sashed but predominantly white shirt with a red rose emblazoned at its breast and, in black, the figure 2 on its back. The young man is engrossed in reading his letters, love letters if you like – 'Dear Mark, On this very special day for you, just to say . . .' – and they remind him of all the work he's put in, all his sweat in the lonely gym, all the hours in the filthy weather of winter, just to be sitting on this narrow slatted bench in English rugby's holy of holies. Did he recall now that faraway and distant boyhood ambition, which some friends and family and clubmates encouraged and others just smiled at indulgently and teased. Well, it had gloriously come to pass this very day – 'good luck and look after yourself, m'boy', wrote his clubmates from Bristol.

Nor does it, to Regan, remotely matter in this almost religious passage of trepidation and reverie before he puts on his armour that the rebarbatively bullet-headed young west countryman is suddenly a PROFESSIONAL international player. Only those last two words count to him. He has joined the elite, a rare freemasonry to which very few are elected. Wherever he plays around the globe from now on, the match programme will print an asterix before the name M. P. Regan, and the fancy will read the key at the bottom of the page, '* denotes international'. The twenty-three-year-old might be winning his seventh national jersey of white – having played for England teams at sixteen and eighteen school-age group levels, England Students, under-twenty-one, the Emerging Players' XV, and England A – but forever he was aiming towards this awesome afternoon which, when

he's played this one game and whatever happens in it, will ensure he is pointed out in the street till the day he dies.

Angle-quirky pressmen this day have also made headlines of Regan as the first-capped 'professional', but he is by no means a 'full-time professional rugby player'. His greatest fan, his dad, sees to that – Mark works daily as a 'contracts co-ordinator' for his father's busy Avon Crane and Commercial Repairs company in their old western city.

At this historic point in a worldwide sport's revolution which, let's be frank, makes a whole new ballgame of its future, nevertheless look around this collection of young athletes in their secluded sacristy under the new stadium, and realise that, like Regan, they have all become 'professional sportsmen' with an overnight suddenness, but by weekday they are still working men and in two mornings' time they will be clocking in like everyone else in the crowd (which, with a faint and eerily detached buzz, you can just hear now as it begins to gather in the seats above them), as businessmen, bank managers, military officers, policemen, schoolteachers, students, farmers, restaurateurs or trainee solicitors. This England XV are still holding down jobs and are in thrall to their bosses and mortgages and hire-purchase agreements. To be sure, the revolution has been so sudden that even their contracts to be professional sportsmen have not yet been drawn up.

Phil de Glanville: 'Most of this squad desperately – and thankfully – rely on their employers' goodwill and benevolence for their rugby. It is also embarrassing to me how companies like mine are so generous.

I am a marketing executive for the management company Druid. Full-time professional rugby must take into account those of us who want to work for a career outside rugby. The game must draw up lines so we all know where we stand in this rugby "revolution".'

Alongside, tight against Mark, and fingering his stubbled chin, or occasionally tweaking his calves and oak-tree thighs, sits the English scrum's intrepid argonaut Jason Leonard. He is reading the programme (you are at once able to tell who has won caps into double figures: to a man, they read the programme with cover-to-cover abstraction; the callow caps read letters from their girls and parents). Leonard scratches his private parts and, even, yawns. No possible way is he BLASÉ about today against South Africa, of course – less than an hour to go. But with forty-four Tests behind him – far more than any other forward in this team – Jason is fulfilling his first sacred duty of the day, which is to display to Regan with an

'Here a moment of thought: Mark, realising a dream to play for England, reads a personal letter, while Jason ponders over the finer points of the match programme.' – JN

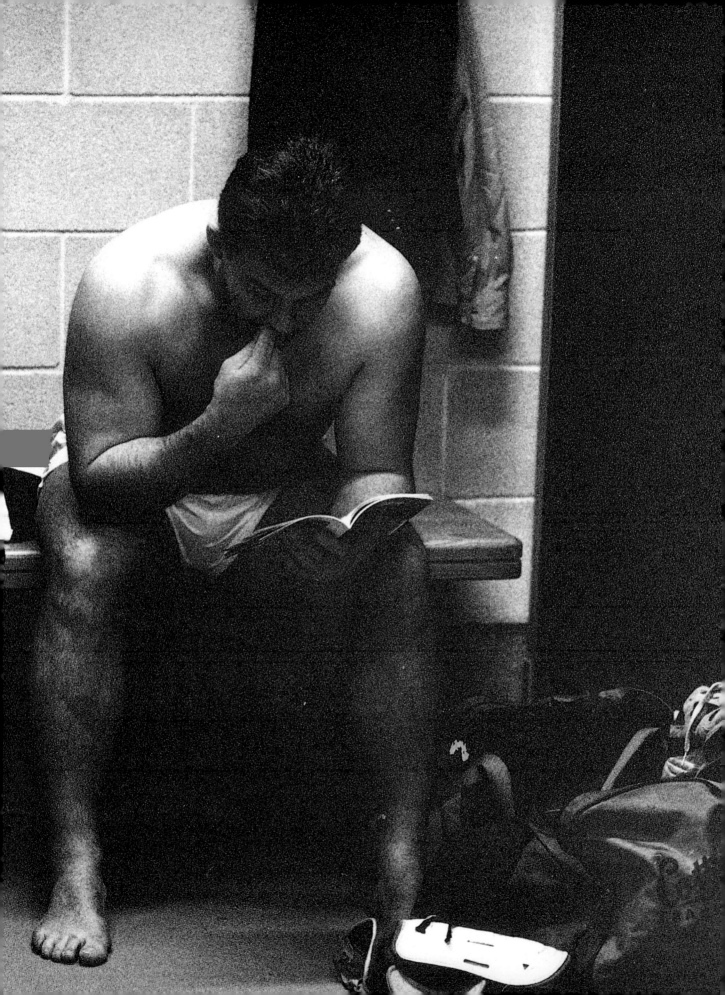

unspoken last word in fraternal comradeship that he, the prop of ages, is beside him to nurse his new rookie hooker into battle. One for all and all for one: nowhere is it more evident than with the front-row musketeers.

'I am very, very nervous,' admits Regan; 'well, who wouldn't be, playing his first match against the world champions? Jason has been a real calming help. He's a fine man, our cornerstone. He's seen it all, done it all. He just says to me, "You've been selected, so it means you're the best in the country, so just go out and do the business, right?" I've just gone across and asked Will if I can follow him when we run out – first the captain, then me. "Sure, Ronnie, not a problem", he said. So I will, that'll help me settle. It shows the captain's character, doesn't it; fifty caps or one cap he treats everyone just the same.'

Any rugby team is the sum of several parts: scrummage, half-backs, centres, wingers, back-row . . . None of these parts is more utterly devoted to each other than that of the front-row trio. The three from the deep and dark recesses are blood-brother Siamese triplets almost, spiritually bonded and socially glued. On the field, they perform, literally, shoulder to shoulder, arms in an embracing hug.

Off it, they still seem inseparable; they share rooms, natter softly together, eat together. If you want to find the hooker, ask if anyone's seen a prop. And vice versa.

The National Anthem can never have been bellowed by a throng of (in this new cathedral) 75,000 with any more of a deafening devotion of din and descant in a homage of expectation for their team of Englishmen. The hymn spiritually envelops the fifteen young men as they stand to attention on the touchline in front of the Royal Box. Some of them, as if too distracted by their imminent destiny, silently mouth the words; others belt out the triumphalism full-throatedly.

It goes without saying that, even as they stand in line at the anthem, those who are to play together, stick together. In his back-row platoon, Clarke's frame loomed over the chunky Robinson. Clarke had a very different job to the one Leonard had with his rookie hooker Regan. At twenty-seven, Clarke was nine years younger than his veteran confrère at Bath, Andy Robinson, who was so filled with joy at adding another to the seven caps he had already won for England, the last all of six years eight months ago – when Clarke was still as gawky a Bishop's Stortford colt as some on his father's stud farm, and with only an amiable ambition about playing fun-rugby for the Saracens, let alone for Bath or England.

Robinson had played a stupendous Five-Nations, Lions-capped season in 1988–89, and then had fallen foul of the modern wisdom that flankers need more lineout length and bulk and brawn than a burrower's jackrabbit

speed and nous. He presumed his type was up as well as his time – till two Wednesdays before when Mrs Robinson had, with a skip in her step, wheeled the pram and the kids from home to the gym at Bristol's Colston's School, where Robinson was teaching his class of ten-year-olds, and said, 'Darling, I've just seen the Ceefax and you're back'. He says they were both tearful with delight. You believed him when you saw the fervour with which he sang his anthem at Twickenham.

Four square for the cause – Rodber and Ubogu, toe to toe, await the next of the champions' charges.

Alongside, Tim Rodber stood ramrod to attention and gave voice with the intensity of commitment you would expect from one of Her Majesty's serving officers. Rodber had walked through the daunting gates of the military college at Sandhurst almost four years before with a smile on his face – that morning he had been selected for England for the first time. He played an utterly blazing match against South Africa in Pretoria in 1994, but by that and his own exceptional standard he had seemed less than at full steam in the World Cup. This would be an important season for him. As they do with the engaging Clarke (like the legend tells they did of the young cricketer Michael Atherton when he left Cambridge University), the sooth-saying knowalls are putting after Rodber's name the initials FEC – Future England Captain.

Till protocol ordered them to desist, for smartness' sake, the other inseparable trio would have had arms entwined still in brotherhood even as they stood for the anthem. As the first set scrummage collides, the front-row will have to withstand and then hold rock-firm against 1,600 kilos of impact. As Regan and the indomitable Leonard, the East End master-carpenter from Barking, belt out the anthem, it is a surprise to see Leonard's fellow prop with his fist at his breast and not at his ear with his mobile telephone; Victor Ubogu, you fancy, was the clinching reason the team's senior sponsor, Cellnet, decided to do the deal; the company must have known they would recoup any outlay from Victor's calls on his mobile alone. Ubogu's low-slung bullocking charges from the front can be awesome on the rugby field all right, but to see the director of the family security firm Cobrawatch vroom out of Twickenham and up to his Chelsea niterie, Shoeless Joe's, in his mustard-yellow Lotus with the melon grin on full beam and the Cellnet at full rabbit is something to behold. This was Ubogu's twenty-first cap. He was thirty-one this autumn, by no means too mature for a front-row, load-bearing titan. Props and hookers traditionally age to superior quality and *appellation*, like a great vintage.

Down each recent decade, England have produced a lineout pairing which will trip off tongues of historians through the next century, just as, say, cricket's opening batsmen or bowlers (Hobbs & Sutcliffe, Hutton & Washbrook, Trueman & Statham, Laker & Lock). In the mid-1990s, it surely looked certain that the pair of lanks from middle-England, Bayfield & Johnson, would make an established and long-lasting place for themselves in the second-row pantheon alongside such as Marques & Currie, Beaumont & Colcough, Ackford & Dooley. Off the pitch, both the Martins, Bayfield and Johnson, are, as the boxing phrase has it, 'gentle giants'; yet the two of them are very different in that serenity. Johnson who, at twenty-five and 6ft 7ins, is younger by three years and shorter by more than three inches, has a steely edge about his play sharpened by a learning-curve which took in a season playing for King Country in New Zealand, a province nurtured and cajoled by the most uncompromising hardnut of the All Black lineout legend, the onliest, 'Pinetree', Colin Meads.

Johnson, from Market Harborough, is a marketing manager with the Midland Bank, content so far to marry his now professional sport with his equally burgeoning career in finance, whereas PC546 Bayfield of the Bedfordshire Constabulary only the week before the South Africans had come to Twickenham abandoned his beat and his truncheon for a sabbatical from the force to concentrate on full-time rugby.

Yapping at the heels of this barndoor eight will be the scrum-half, Kyran Bracken, whose unforced athletic style and self-effacing toothy handsomeness under the thick busby of hair, has gossip-column photographers matching him as a spot-on double for the vogueish film actor Hugh Grant. Bracken had a difficult World Cup, an ankle injury allowing Dewi Morris to resume at scrum-half, a chance Morris took with a series of sleeves-up, socks-down combative performances that had him come home as England's noblest player and put himself into honourable retirement. Bracken is a trainee solicitor in Bristol.

Damian Hopley is definitely not tapping his feet at this timeless Victorian anthem. The witty Wasp is a talented taproom pianist, rhythm and blues. A centre three-quarter by nature, Hopley is on the wing for his second England cap, because of his boisterous tackling and general nous. Hopley left St Andrews with an MA in Theology, then read for a BA in Education at Cambridge, and is now a repro broker in the City on the verge of taking a sabbatical 'for full-time rugby'. Hopley began his scholarly marathon at Ealing Abbey, run by the same Benedictine order of monks as Downside, the public school in Somerset, where the full-back Jon Callard taught until this autumn term when he took a part-time job in 'haulage logistics' with the local Western Freights company. But his club confrère at Bath, Mike Catt, has gone whole hog and as soon as the International Rugby Board made its revolutionary announcement about open and fully professional rugby at its historic meeting in Paris in August, Catt announced himself as England's first ever official 'full-time seven-days-a-week rugby union player'. As his highly strung, thoroughbred all-round game suggests, Catt dives in where others tiptoe, and doubtless to zap his own razor-edge psyche for this South African match he allowed himself to be quoted as saying that his generally revered predecessor at fly-half, Andrew, kicked the ball too much, never fed England's running strengths, and that he (Catt) was going to put that to rights at the first time of asking, don't you worry. More contentiously, he said South Africa's rugby icon, captain and blood brother to President Mandela, François Pienaar, was only 'an average player'. In purely critical terms of all-time-great rugby players he may well have been right, but since playing out of his skin and then lifting the Cup (and all that entailed for matters far more important than sport), Pienaar had been canonised in the mythology. Nor was it quite the wisest of dismissive announcements by Catt when a) the said and saintly Pienaar was in the back-row, which would be marking Catt with a vengeance in his first game as England fly-half and 'playmaker', and b) when you are, to all intents, still a South African yourself and only came to England for a holiday and happened to ask Bath for a game less

than three seasons ago . . . and, well, it is not in the nature of insular white South Africans to take too kindly to one of their own who has defected, waving a flag of convenience just because his mother happened to be born in the English Home Counties.

Pienaar's crusade for Mandela and the new democracy, and the fulminating play of Jonah Lomu, sealed and ensured like never before an indelible place for rugby in the sporting history books. Yet before their arrival it would not have been too fanciful to reckon that hitherto only three faces from the world of rugby would have been instantly recognisable to the immensely wider world of non-rugby. Some might substitute, say, a Gavin Hastings, a Phillippe Sella, perhaps Chester Williams or Nick Farr-Jones, but I daresay most would nominate the trio as the enduringly voluptuous Australian winger streaked with Latin flamboyance, David Campese, and the two Englishmen, numbers 12 and 13, giving voice to their anthem at Twickenham, Jeremy Guscott and Will Carling.

That Guscott's beguilingly handsome face apparently gets the male-modelling ad-world photographers in a tizz is nothing to the buzz of pleasure every rugby devotee has taken from his play since he burst upon an international field all of half a dozen years ago and ran in an unprecedented hat-trick of tries as a debutant's curtsey. Guscott was a self-confessed tearaway at school, worked on building-sites and on the buses before his near-genius at rugby was nourished at his home-from-home, Bath RFC, to such a warmly embracing extent that, when that first call for his precocious talents came from England, Jeremy was quoted as dubious about the honour, because 'wasn't the England squad a bunch of Oxbridge tossers?'. He is now a business development officer for British Gas, but has remained his own man, a one-off and free-spirit – and for all the artist in him, Guscott will readily dirty his hands and knees. Like all genuine-article centres down the century, Guscott is as 'attacking' a tackler as his captain alongside him. That's saying something, for Carling's cutting-edge defence has been unflinchingly bold.

Of late, England's captain has needed a defiant defence in more places than a rugby field. While he will play on every pitch with a chivalry which will never not honour the foe, every tackle that is put in against him will be cheered to the relishing echo by the opposition's crowds, for on any foreign paddock he is the despised demon king whose seeming swank and swagger as chairman and chief executive of W. Carling plc must be tumblingly brought down a peg. Carling riles Celtic and colonial crowds to distraction. He will be thirty this December, a birthday which would signal the end of six months which had dramatically topsy-turvied his life as his name was dragged by a lascivious British press from the back-pages to

the front and have his short marriage laid bare between the broadcast of an unguarded throwaway line in which he referred to the RFU committee as 'a bunch of old farts' and the moment the separated Princess of Wales did, or did not, walk into his life, or rather his health club. You fancied that at last, alongside his troops in front of the new Twickenham's first great congregation and surveyed only by the sporting press, today was a mighty relief for England's rugby standard-bearer and captain.

If sporting fame could only be totted up in record books, then the thirty-two-year-old giving voice beside his captain is the one guaranteed all-time hall-of-famer standing on this green grass. Carling was winning his 61st cap (an unprecedented fifty-four as captain), but Rory Underwood his 80th, by far a record for a British Isles player (already a dozen more than the previous record holder, the resplendent all-rounder Mike Gibson). The RAF pilot-officer, needs to score only three more tries for an unprecedented British half-century. When he does dap down his 50th, Rory will display no more histrionic an expression than he did when he scored his first – a memorably sparkling sprint from broken play, far back in the springtime in Paris in 1984. Since when, each succeeding one has been greeted by the scorer with no more than a darting split-second smile of satisfaction, with not a sliver of swank to ruffle his inscrutability, his self-contained calm. See if I'm not right. You never know, Underwood might even post the half-century during these next eighty minutes . . .

For now has come that momentary evanescence of sound that any sports lover knows – that transitory silence of pent-up anticipation, no sooner come than gone, when a vast throng communally bates one breath for the kick-off . . . and then, tumult. The season had begun.

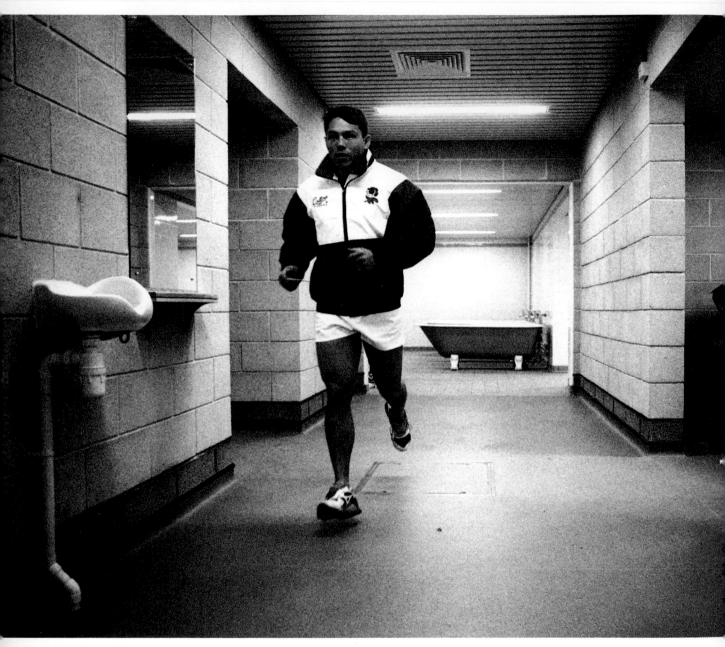

Behind the Scenes ...
'Here three players prepare
for the forthcoming match
in their different ways:
(Above) the outstanding
changing-room area at
Twickenham enables
players to really move
around. Rory goes for a
run, up and down, up and
down.

(Facing page, top) When
I started this project I
thought Tim [Rodber] was a
bit off with me. At a team
lunch after training one day,
he did not look or smile at
me once. I discovered that
he is totally 100 per cent
committed on and off the
pitch. He thinks about how
to win continuously. Here

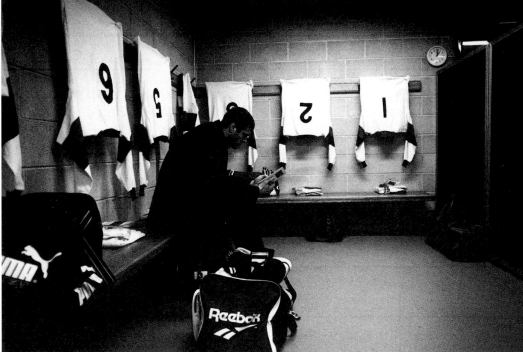

he is doing his own preparation – to be well turned out for the occasion.

(Right) *It's one o'clock; the team have just arrived. Will asks those who want to inspect the pitch to follow. They all leave, apart from Bayfield – who just sits there reading the programme.'* – JN

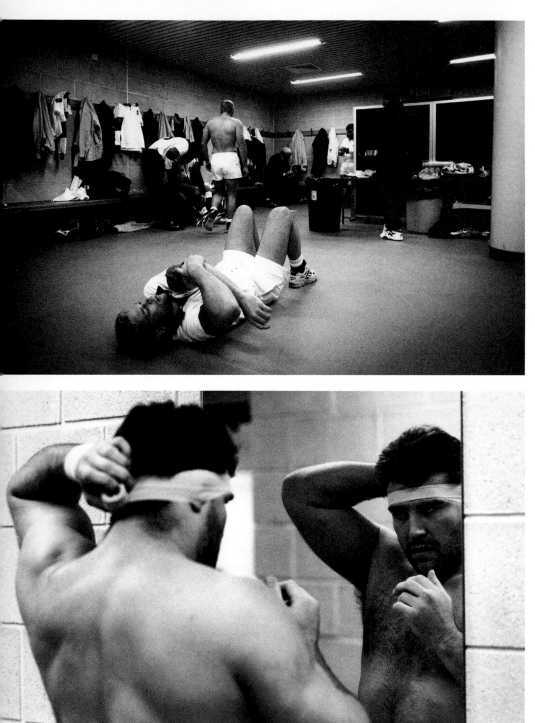

(Left, top) '*Tim Rodber goes through a stretching routine, while others do their own thing.*

 (Left) *Is this man up for it? Jason Leonard assessing what's to be done, face to face.*

 (Above) *This moment completely blew me away. This is the final moment*

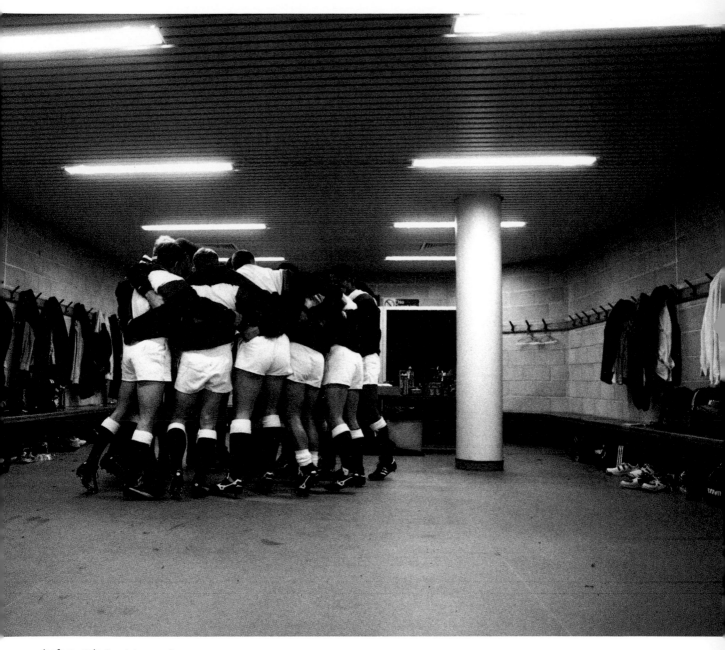

before going out to meet the opposition. Will, in the centre, getting the aggression out of the players. I was almost in tears here, to see all the preparation of the individuals come together as one united body of immense energy and force.' – JN

The Rub of the Green

A new stadium and a new season had, with its old familiar spine extracted, to all intents a new England team to grace the occasion. With the winger Ian Hunter and flanker Steve Ojomoh injured, more than a third of this XV was changed from that which played France only four months previously in Pretoria for the World Cup bronze medal. Four stalwarts from that ultimately disappointing African expedition were gone – a dynamic quartet in their highly different ways which had been fundamental to England's unprecedented European successes during the previous half a dozen winters when they had won three board-sweeping Grand Slams. Rob Andrew and Brian Moore and, more often than not, Dean Richards and Dewi Morris had been towering talismen of those triumphs.

After raggedly dim performances in the first World Cup, staged in Australasia in 1987, England came home to be dramatically knocked into an organised shape by a determined new manager, Geoff Cooke, and two successive coaching lieutenants, Roger Uttley and Dick Best. Notably, Cooke got a grip on England's hitherto haphazard system of selection – one poor match and a player was readily ditched, so even when taking a penalty kick or running in an unopposed try a player in white was metaphorically looking over his shoulder, and no international player took the field expecting a crash-tackle as much as he did a stab in the back from a blazer. No one knew this better than Les Cusworth, now one of England's coaches. His international career as an impish playmaker fly-half spanned a full decade from 1979 to 1989, but he had only twelve caps to show for it, being yo-yoed around on selectors' whims, and was only that morning in the breakfast room at the Petersham relaxing England's new incumbent in the crucial No.10 jersey, Mike Catt, by relating his own first cap, against the All Blacks in 1979 at Twickenham. 'Just before kick-off, big Fran Cotton comes up to me and says to make sure I keep kicking for touch. So I did. We lost 9–10. At the end, the captain, Bill Beaumont, comes up, puts an arm round my shoulder and says, "Well done, son, first cap of many."' But he was out, and it was another three seasons till he was given another (brief) run in the team.

Such wanton disregard for both personal feelings and team strategy could not happen now, so Catt was left content only in his concentration on his afternoon job in hand.

It was a stern enough challenge as it was to fill the boots of Andrew. As the team's pivot at fly-half down the years, Andrew had heard his critics all right, but time and again he had seen them off. He was a kicking fly-half who nursed his pack and played the percentages, a nerveless strategist in the mayhem and a fearless tackler in the cannon's mouth. When England needed a kicker of goals to better balance the side, he did not just shrug and say 'OK, I'll give it a go', he diligently put in hour upon hour of practice each week and made himself the best there was, on an all-time level with Naas Botha and Grant Fox.

Andrew's right boot was responsible for probably the most thrillingly eruptive and communal moment in the history of the game in England when a vast television audience, the majority unaware of rugby's finer points, were held in thrall on the Sunday afternoon of 11 June as live satellite pictures were beamed from Cape Town and England's quarter-final against the holders, Australia. The scores were level 22–22, two minutes and thirty-six seconds had been played in the time added on for injuries. From fully forty metres out, Andrew kept his head down, swung his

boot . . . and as it bisected the faraway H the ball was still rising. Australia were done for and the usually imperturbable Andrew turned, hollering, to punch the air in triumph, just as they were doing in thirteen million sitting-rooms back home. 'The real joy and utter excitement as it flew onwards and over could not be contained,' said Rob, 'and for that split-second I totally forgot where I was.' Same for the thirteen million.

Less than three months later, back at home in London, the television evening news announced that the Geordie industrialist Sir John Hall, who had been responsible for the dramatic phoenix of Newcastle United soccer team, had bought the nearby Gosforth rugby club. Hearing the news, Mrs Sara Andrew shouted from the kitchen, 'I bet he'll want you to be the next Kevin Keegan and be the manager.'

'I doubt it', laughed Rob. But two days later he was having dinner with Sir John and, hey presto, he was – and when his club, Wasps, resented his player 'poaching' and dropped him, he simply retired from international rugby on the spot. So forward stepped Mike Catt.

Andrew's half-back partner, Dewi Morris, had made a less convoluted and altogether cleaner break with England, announcing even before the World Cup that the tournament would mark the end of his international career. The son of a Welsh borders' farmer, Morris had been easily England's most consistently compelling operator through the South African trek, but now was happy to put himself out to grass, helping with some coaching at his first junior club, Winnington Park, which he had joined a dozen years before when he had first come to Cheshire as a student. There he could concentrate fully on his burgeoning job as a brewery executive, specialising particularly on exporting Death Watch vodka to Russia. 'At thirty-one, my other career finally had to come first. I knew I couldn't live and breathe top rugby any more,' said Morris.

Having announced, like Morris, his rugby retirement by the end of the World Cup, another veteran, Brian Moore, the enduring and combative icon of a hooker the nation knew fondly as 'Pit Bull', had second thoughts and allowed himself to be talked out of it by England's management – but which had now preferred Bristol's craneman, Mark Regan, in the position. This understandably irked both the fairness and logic in the mind and pride of solicitor Moore, so to relieve the pain of watching his side, for whom he had won a hooker's record sixty-three caps, he had taken himself off for this weekend to Dublin's comforting bars and a seat in the stand as Ireland played Fiji.

Perhaps, at almost thirty-four, Moore's yeoman service was at its natural end. As a full partner, his job in commercial litigation with Edward Lewis & Co was more demanding than ever, and possibly his utter commitment

to training was fraying. In his ten years in top-class rugby, he took only two holidays, a factor which contributed to the break-up of his marriage – but this autumn the opera buff found himself happy enough to skip a sacrosanct Thursday training night with his club Harlequins, because he had managed to get a ticket to hear *The Pearl Fishers* at the ENO.

To lose one of England's valiants of the pack was one thing, simultaneously to lose another, Dean Richards, made daunting this new task for the eightsome reelers. If Moore was the front-up-in your-face defiant leader of the pack – 'Give 'em fuck all!' he was heard to holler above the din of the crowd as France gathered to pounce for a final assault on victory in Paris two years earlier – Richards was the quiet, four-square heart-of-Englander, ox-strong in the back-row, who could read the pulse of any game and play it like a beacon as it crashed and eddied around him. For match after match, this motorway-control police officer in the Midlands would slow down, then direct the traffic, and clean up any nasty mess on the way.

Younger men were queuing up to attempt to fit into the boots of the half-backs Andrew and Morris, but which of these forwards lining up against the world champions could at once replace (in their different but, in the context of a rugby pack's bonded cohesion, complimentary ways) the standard-bearers' courage, shrewdly unerring sense of game plan on the hoof, and stomach for the fray of the squashed-nose extrovert grandee Moore and the shy and truly gallant Richards?

Alas, we were not to learn it in this match. After a passionate singing by the team of their two anthems (Mandela's haunting new one *Nkosi sikelel' iAfrika* and the defiant old Voertrekker's *Die Stem*), the stoked-up South Africans leaped from the traps. England were rocked back at once.

The pattern was grimly established, and would continue. Each distinct pocket of the South African XV was as tough as they were fast, as collectively well drilled as they were occasionally and individually sparkling. They pressured and manoeuvred the home side into all the places and contexts they did not wish to be. The great captain Pienaar had said in the week that, as the credo was that nothing was more important than the next game, this team would be more sharply focused than they had been before the World Cup final. The point was being rudely illustrated to the England team in this first ever professional international at Twickenham, and although the South African players were on £130,000 a year and England, for the season on a basic £24,000 plus £2,000 per match, the difference in the sides was not as wide as that ratio by any means. The crowd was fast getting the message about the game's new professional age.

Mike Catt: 'When a South African rugby player sees an opportunity in a match, he invariably cashes in. The English hang back too ten-

tatively. South Africa is far more positively competitive right from junior school – the whole ethic is to compete ruthlessly with your best friends, to be top of the class, to be best in the swimming-pool and on the sportsfield. South African teams are 100 per cent full of players mentally tuned in to nothing but success. Only Britain's players from Bath come anywhere near that philosophy. I know, I've seen both sides. Mind you, I may have been born in Port Elizabeth, but nothing stops me playing 110 per cent for England now. It's like I might be an executive for Dunlop, but if I was offered a job by Pirelli, it doesn't mean I'd be working any less for them, does it?'

England had not played since the World Cup and had hoped to be rested and fresh against a South Africa tired and drained after taking their trophy on a prolonged lap-of-honour to all points. The champions had spent a long year on the road in which they had posted, incredibly, fourteen successive victories. This was their last match before a deserved break at home till the New Year. Might England catch them not only jaded, but also too relaxed and demob-happy?

No such luck. It was England who looked ring-rusty, lacking in match hardness. They strove manfully all right, and had their moments, but more and more often there were defensive moments decorated by Callard's catch-up penalty kicking. England's scrummage fought the staunch fight well enough, but the luminaries of the back-row and midfield were mostly forced to operate on the back foot, whereas South Africa's shining trio of the all-time hall-of-fame, the full-back André Joubert, the winger Chester

Tim Rodber held: 'South Africa's is a daunting pressured defence,' he says; 'they just work to force the few chances they invariably take.'

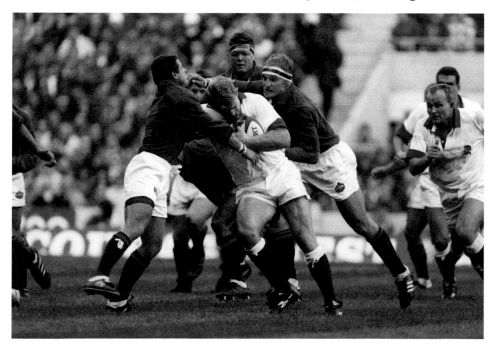

Williams, and the scrum-half Joost van der Westhuizen were too readily on the front, and to such an extent that the unbiased, at least, in Twickenham's mountainous stands were truly enchanted.

Not that England had spared serious homework on this trio in their concentrated team meetings at the Petersham. In the weeks before, they had even called in a number of English rugby men lately living in South Africa and apparently wise to the ways and foibles, strengths and even weaknesses of these three players of grandeur. For instance, how Joubert was an out-and-out left footer, and though he can thread a needle with it, force him to use his right foot and he becomes an ordinary mortal; how Chester Williams was only dangerous if given room at very close quarters to the try-line, and once nailed he stays nailed; and how van der Westhuizen never ever breaks blindside. All that sort of thing.

However, come the match, Williams, on the left wing, scored two compelling tries and should have had a third when he hared in from thirty metres for a score 'given' by the south-east cornerflag touch-judge but unaccountably refused by the over-preening Scots referee, Jim Fleming, who ruled he had not 'grounded' the ball properly. But Williams only any good at close-quarters, eh? Of his two tries that Fleming could find no

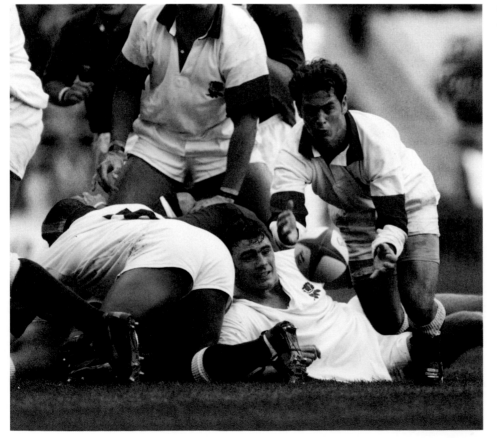

Catt's eye-view of Bracken's quicksilver pass to his fly-half.

fault with, Williams's first was another longish dash, and the other, in the second half, was an absolute peach – this time to the north-west corner and another ground-consuming buffalo charge after André Joubert had deliciously and delicately slippered through from midfield an inch-perfect grubber with his (you've guessed it) right foot. Williams collected the ball at his ankles, half-fell when half-sandbagged by Callard, but recovered his stride exultantly and careered on over the line. No, once nailed he didn't stay nailed. The devoted England supporters from South Africa were well briefed and well-meaning. But at the peaks of sport no one can forecast which way a true great will jump.

Although on the back foot, England's traditional grit under pressure had sustained them, on principle, as it were, through the first half. They knew they'd had the rub of the green with Williams's disallowed score but, at only 11–6 down, they were still just one converted try away from the lead. Although puffing, England reckoned they were still in the hunt. Especially as South Africa, after such a marathon of matches through 1996, would surely tire first.

With tactics more seriously advanced and intensely applied these days, the coach is allowed on the pitch at half-time but, in Rowell's philosophy, England's coach is more often than not maturely content enough to stand tall and silent on the rim craning over the close conflab just to check the captain is tweaking the right buttons or readjusting the correct reins.

Sucking Lucozade from the sponsor's tubes, or seeming oblivious to the ministrations of the medics, Kevin, Terry and Richard, the tense warriors huddled round their captain. Having been so often in strategic conclave, Carling's shorthand suffices here, 'Key areas must tighten up' ... 'Aggressive defence' ... 'Their mistakes ... be on them in a flash' ... 'We must start moving the game around, not let them', and so on. The captain glanced across behind the goalposts to confirm the scoreboard's none-too-pessimistic 11–6, a figure which sponsored the same insistent thought that every English supporter was voicing in the grandstands and at home in front of the television, that, with just one score in it, the team which exploded from both barrels with the more venomously well-aimed intent would catch the other cold and score the try to settle the match.

But now Joost van der Westhuizen was to show why rugby's wise-birds as well as men of commerce considered South Africa's scrum-half – even less than five months since the All Black golden eagle had landed – was now just as hot a property as Jonah Lomu in world sport. Van der Westhuizen still announces himself as 'a humble student boy'. Immediately after the World Cup final he coolly turned down a $500,000 signing-on fee from the Australian rugby league club, Sydney Bulldogs. 'There's

more to life than money', he said, 'like playing for the Springboks.' He could well be the best scrum-half the world has ever seen. Rugby's chronicle down its century and more has been, to say the least, patchy until recent years.

Before the log began to be writ indelibly, were all scrum-halves – till, say, Haydn Tanner – little Indiarubber Jeepsian mudlarks-with-a-divepass, like 'Kay' Kershaw and Danie Craven? In modern times, the most celebrated of all for purity of pass remains the Australian Ken Catchpole. I well remember hearing the collective gasp the moment Twickenham first saw – or, rather, did not – the blurring speed of Catchpole's hands as he whipped the ball to his fly that wintery afternoon full thirty years ago.

Since when, who sits at the very topmost plinth in the scrum-halves' hall of fame? Jointly, Gareth Edwards and Nick Farr-Jones, I suppose, and deservedly so. That is, till Joost van der Westhuizen came along. His power and strength are two things, his flowing, whipcord-wristed pass another. He has the up-yours combativeness of the world's best flanker; the speed and acceleration, and blink for a gap, of the finest centre; the put-it-about oomph and the stomach for the battle of any ace No.8. He has amazingly fierce and piercing eyes and you do not take liberties. Was there just one (literal) blind-spot to his game – for had not one of these spies from South Africa told the England team that van der Westhuizen never made solo breaks down the blindside when he was close to the touchline? So that's all right, then.

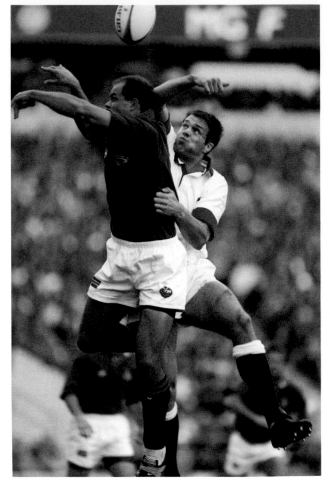

At the peaks of sport no one can forecast which way a true great will jump.

When the referee blew for the second half, England, although creaking, were very much still in it. One quick score and they would be ahead. South Africa kicked off, going north-east. England fumbled in the colliding mêlée, and a lineout was called. South Africa's ball – a ruck and they heel it. Van der Westhuizen was half a metre from touch and was already going some once he had wheeled away and arrogantly brushed through an astonished Bracken. Rory Underwood stood in his path, coiled four-square to take him, as England's defences piled back and across. The South African brazenly chipped through Underwood's fingers, and so accurately that an inch lower it would have given a centre-parting to the

winger's close-cropped hair. The scrum-half swept on, the body tilted now to gather his chip after one bounce as Ubogu rallyingly closed in from behind. Van der Westhuizen skipped his winged heels away from that grunting and despairing dive, and while still only a boot's-length from the touchline, his body upright now, he high-stepped for the cornerflag before slapping himself and the ball down even as a still-astonished Callard flopped onto him.

Rory Underwood: 'He's a superb player. My hands went up like a goalkeeper as he shaped to kick – but it's a fractional split-second instinct because if your hands go up too early he'll just keep the ball and waltz past you. It just brushed my hand because my immediate thought was I'd parried the ball into touch. He's strong and quick, and a close-to-the-ground running style makes him very hard to tackle. In Pretoria last year, Tim, Dewi, and the back-row trussed him up, but he certainly proved himself to us today.'

The match had been settled in that blink. England were now ten points adrift, and floundering from that try of tries. In crowded defensive territory it was the most daringly perilous of blindside breaks – the one single killing arrow not supposedly in van der Westhuizen's quiver. As well as the England XV, the thing had stunned the England seventy thousand. You could count five seconds, slowly, before the multitude generously gathered voice, and then stood to acclaim. Some things in partisan sport, as they have since Tuscan times, transcend even the most blinkered bias. This was one of them. A try of shining solo grandeur for Twickenham.

Van der Westhuizen had put his side almost out of sight, and then, twenty-five minutes later, Williams's third try, following Joubert's pokerwork chip, extended the distance. Immediately after the latter, Tim Rodber went off in pain, his trodden-on, badly bruised arm hanging limply by his side: 'In hindsight I should have come off earlier. When you get a so-so injury your first reaction is to guts it out. I'll probably get slated for staying on.' A dozen minutes later, almost at the end of the eighty, the stadium was hushed when Carling was felled. He stayed down, a leg twitching. He lay awkwardly, his body jacknifed on the grass, worried players from each side looking over him, seeming to fear the worst. Terry Crystal and the paramedic back-up pored concernedly over the captain. Carefully, they applied a neck-brace, and gently strapped him to the scoop-stretcher and then carried him across a now sombre green field. The congregation was now not just quiet but ominously so. Carling, covered in blankets, his face in repose, was carried down the tunnel, out of sight, and into the new medical-room, built 'for all eventualities'. They were extremely worried eyes, those millions of pairs which were focused now on Twickenham.

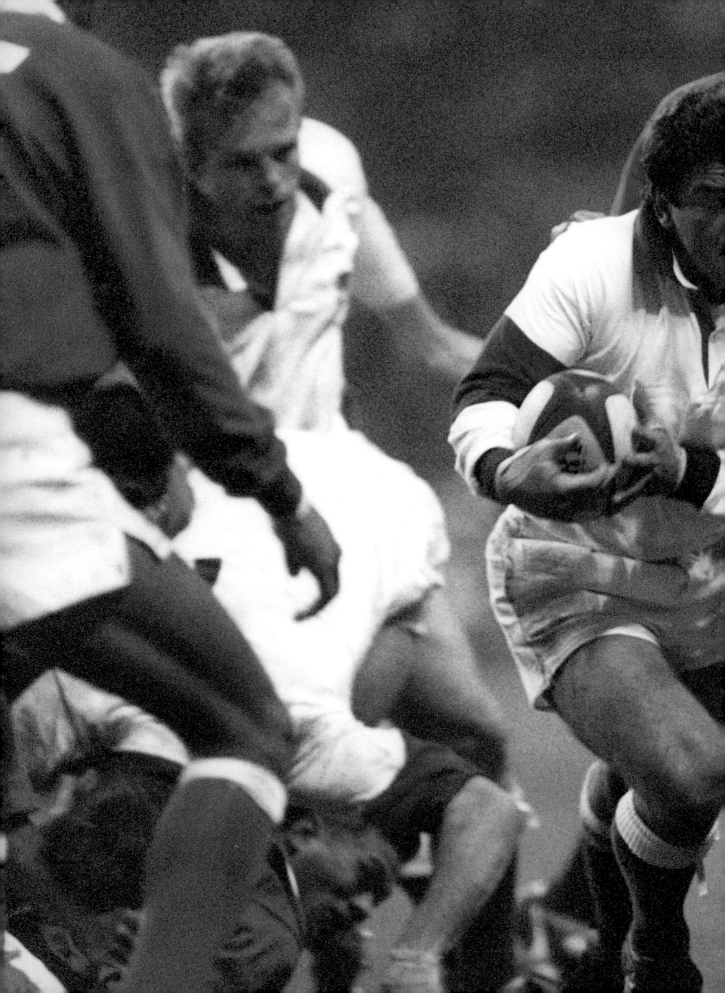

Fresh Legs

It seemed an irrelevance that the game had just those five or six minutes to run – literal 'injury time' – in which Carling had been prostrate on the turf. It was time enough, however, for the two English replacements, Phil de Glanville and uncapped Lawrence Dallaglio, to stretch fresh legs and readjust the scoreboard's ratio – for the two Bath men who had taken most of the first half to settle into the maelstrom, veteran Andy Robinson and young Mike Catt, to finish at least having played a part in England's only try. Dallaglio made meaty inroads, Robinson burrowed and gave at speed to Catt, who served up a perfect pass for his full-pelt Bath captain de Glanville to cross in the south-west corner.

Phil de Glanville: 'Will's down and the Doc and Kevin Smurph are calling for a stretcher and there's still no time for your heart to miss a beat, and you're charging on. Then there's the long hiatus as they get Will off. Everyone's very worried. Finally, first set-piece and I realised I've not even grabbed the ball for one touch of it. Jerry calls the move – "Going right, a miss-move to de Glanville, who beats three men and scores under the posts." He's just joking, trying to settle me down. So set-piece breaks down, we take a tap-penalty – great quick hands by Robbo, to Lawrence, to Catty, who went half-through as I came outside him; so he dummies to give himself an extra stride as I get back in position, and take his pass at fair speed ten metres from the line. I just get there. Best warm-up routine I've ever done!'

No sooner said than done, the no-side whistle blew and then, after handshakes all round and to the stadium's relieved and then most rafter-rattling acclaim of the day, the public-address announced, 'You will be pleased to learn that the England captain Will Carling, who was concussed on the field of play, is now standing and making a complete recovery.'

As soon as the captain had been felled, the tubby physio, Kevin Murphy, had hurtled across with his cure-all bag, his spinnaker-billowing tracksuit making him look like Michelin-Man playing Rory. But you knew it was not a time for flippant similes when he was followed at once by the beanpole former Harrogate RFC No. 8, Terry Crystal, the team doctor. 'It had looked bad,' said Crystal, half an hour later in the medical centre which adjoins the dressing-room. 'It happened at the far side from our bench, but it was obviously a hell of a knockout bang Will had taken, and the main worry was how awkwardly he had fallen. That's a danger sign. When I arrived, he wasn't unconscious, but he was very, very dazed so couldn't identify to us any exact point of pain; his fist was still curled up on the turf like a baby's, unmoved since he had fallen. So we decided to treat it, just in case, as a neck injury and to attach the neck-brace as a precaution. It must have looked upsettingly significant to the crowd. But once in the medical

centre, Will had fully come round and begun to move more freely and he told me the pain was more particularly in his shoulder than his neck. He'll have bad bruising and a headache tomorrow. I know the neck-brace, the stretcher, the blankets, the furrowed frowns and all, presaged awful gloom to spectators and players – but better to be safe than sorry.'

All part of the day's work to the sports-loving Yorkie Doc who loves his England rugby only marginally more than his county's cricket and his Leeds United soccer. He treats the onliest Will Carling in front of seventy-five thousand and TV millions at Twickenham on Saturday, drives home on Sunday, and first in the queue at his large GP's practice on Monday morning will probably be a limping Joe Soap who the day before had been kicked on the shin at pre-pub football in Pudsey. Crystal also runs a specialised sports-injury clinic at Leeds' BUPA hospital. He says you get a sixth-sense if it is a bad injury the moment a player goes down. 'Top-level soccer, much as I enjoy that game, is strewn with histrionic "Hollywoods" as players go down writhing, only to be on their feet getting on with the game thirty seconds later. Rugby doesn't have that sort of philosophy. Also, in rugby, you get to know your players – for instance, when Deano (Dean Richards) was in the team, he would just imperturbably get up and get on with it; but if Deano went down and stayed down, from the touch-line, you would know at once it was something serious.'

The score was 24–14. As well as Williams's disallowed try, the South African kicker, Joel Stransky, was skew-whiff with at least four kickable goals which he would have made any other day in his carpet-slippers. So England knew there were no excuses. Not that they would have had breath to voice them for a long passage of time. 'Simply knackered', said the silence. Sitting on the floor at 'front-row corner', Jason Leonard swigged a can of beer, finally doffing it to and holding the gaze of Mark Regan alongside, saying softly, 'Ace stuff, m'boy.' To be sure, Regan's had been a stout show against the champions' pack.

'Only when the back-row came off was it particularly difficult to hold them,' said Regan. 'Jason looked after me all through, he was tremendous.' More quietude all round. Someone muttered how the try – THE try – immediately after half-time had buggered the works, been a killer blow. 'It shouldn't have been given,' said Regan. 'I had him covered and was moving across to flatten him – but the ruddy ref got in my way and I found myself tackling him instead. The ref said "Sorry, my fault", so I said "What about a scrum back, then?" But by that time the bloke had scored, and that was that.'

Robinson swigged deep and stared at the ceiling, eyes closed. He

looked all in. Well, they all did. Last time Bath's blond and balding ball of fire was sitting in Twickenham's home dressing-room after an international had been six years earlier, and he was on the point of being voted 1989 European Five-Nations Player of the Year. 'I'm still proud of myself,' he said, 'because I hung in there, didn't I? I hung in. I know I was off the pace to begin with. I kept hitting brick walls. I really had my work cut out to get involved, to really contribute something. That Kruger [Ruben, his Springbok opposite number, and five inches taller and two stones heavier] is a heck of a player. He forced their gameplan on us to set the whole tone. But Ben [Clarke] played great, didn't he? It was one hell of a frenzy, but I'm proud I not only hung in when really under the cosh, but then began to show my worth as the game went on. This is the first match I've ever lost at Twickenham, for England or Bath. It's not a good feeling at all – although I wouldn't have missed the return for all the world, it was truly tremendous to be part of unveiling the new stadium, and the whole occasion was electric.'

Robinson's back-row confrères, Clarke and Rodber, were two others painfully baptising Terry Crystal's gleaming new treatment room – Ben with a suspected broken jaw (it was only severely bruised), and Tim's arm hanging limp from the shoulder. The fourth of the back-row trio was at his place along the bench with the replacements and, though very much part of the collective all-in silence, you could tell he was glistening in his reverie at the utter personal satisfaction of it all. And why not? Lawrence Dallaglio had played for only a quarter of an hour, but time enough for his speed and muscularity to put themselves about, as they say, with such positively disciplined and unafraid gusto that Twickenham's more studious aficionados, as they retired for a few for the road in the carparks, were certain they had witnessed the call to the colours of a fellow who might well be carrying the battle-standard into the thick of things for some years to come. '**Personally, I just didn't want it to end. I could go out right now for the full eighty minutes. Mind you, I realise it was my good fortune to come on with fresh legs when the South Africans realised they had just about sewn it up. So I had nothing to lose, except to give it a real go and just show myself I could be reasonably competitive at this level.**' In quarter of an hour at least, Dallaglio had done that, with shining brass knobs on. He was now a player in the big game.

Mike Catt sat there, pondering. His play thrives on confidence. How much of it had been drained? His captain sat supportively alongside. No international rugby captain in history was as experienced as Will Carling. As well as optimistic geeing-up for victory, he knows all about the down-

side of carping post-mortem pessimism and gloom, and he was already well aware that this had been a good match for England's critics in the public prints who have come to expect so much in the seven years of his stewardship. So, in the time-honoured rugby way, as counsel now for the defence, he was getting his retaliation in first. 'It's ludicrous to blame individuals,' said Carling; 'it's a collective responsibility, you cannot lay it only at Mike's door. He was a brand-new fly-half. If a team doesn't perform as it knows it can, then it's everybody's fault. The forwards battled really well, but I'm at fault as much as anyone – no, I'm more to blame than anyone – if the whole unit behind the scrum failed to function.'

Because of his injury, Carling was excused the captain's obligatory press conference. So even as he consoled his younger buddy Catt, manager Rowell was facing some fifty journalists and broadcasters in Twickenham's press-cellar behind the visitors' dressing-room – now allowing themselves to be as demob-happy as their Afrikaaner sing-song was raucous. With his wide defensive grin, Rowell braced himself for some flak. From the first question it was obvious that Catt was on the rebound from suggesting that South Africa's captain and talisman Pienaar was 'only an average player' and that his correspondingly disappointing show would be featuring prominently in next morning's news. International rugby managers these days need to know as much about lineout calls and lines of running as diplomacy. 'Mr Rowell, had Mike Catt's observations last week helped put his game today under too much pressure?'

Big Jack took a bigger breath: 'Indubitably. The last psychological thing he needed to do was to wind up the opposition and make them even doubly determined. The team has pulled his leg unmercifully since his comments were printed, so much so that in the end we couldn't get a squeak out of him when we needed it. Certainly it is a possible reason why Mike was so tentative out there. If so, I sure hope he's learned his lesson the hard way. He made errors and he knows it, but he's a very strong man and, don't forget, he is a very instinctive player who was part of a brand-new half-back pairing up against a formidable defensive opposition.'

Still, the questions were, you might say, catty. Would he keep his place? 'I have no doubt that next time Mike pulls on his England shirt he will have moved on a dimension. Don't forget, it took Rob [Andrew] some time to settle into the position. You've got to have a "head" to be a top Number Ten, it takes time to get one. Sure, we are missing Rob, as well as the only man who could have matched him through his reign throughout, [Stuart, now a journalist] Barnes, who went over to your side of the counter in a cloud of good claret a year ago. No, don't worry too much about Mike Catt, he's strong mentally, and cocksure, but he'll learn from

this, you see – he made some errors, but this is sport, and on another day he might have got away with them.'

Was the chasm between the southern and northern hemispheres now wider than ever after this drubbing? 'You might like to call it a drubbing. We don't. Look, these Springboks have been together for fourteen matches now this year. We've not only changed a third of our team, but they spend more time with their clubs than they do with England. The gulf between club rugby and top internationals is enormous. We showed great commitment today, but at the end of the day we played too loosely. It showed us we cannot afford slack moments in the big league – but "a severe drubbing", nonsense.'

And so on . . . and on . . . Worth briefly re-running a press conference to illustrate the glare and microscope under which modern international rugby has to live. Only twelve years ago, as one of the very first regular managers of the England team, the former dynamic flanker Budge Rogers, instituted two official press conferences, to announce and discuss the selected team and, post-match, to parley over the performance. Remembers Rogers: 'Fleet Street was printing mistakes and things that were untrue – they weren't to know; nobody was informing them. Taking the press into our confidence made for a much better relationship – and now they began to print things that were not necessarily agreeable to read, but at least they were giving an opinion based on the correct facts.' Quite so, years before when I began hanging around that windswept concourse at Headquarters in a grubby mac' and a pencil stub fixed to my ear, you might ask an RFU blazer something to make an innocuous sportspage paragraph, and he'd gimlet you with distaste and say crisply 'Mind your own business'. You had to be there in the first place, because the RFU telephone number was ex-directory.

Once, after an England v. Wales match in the 1960s, I asked the pioneering Welsh coach, Clive Rowlands, his opinion of the game and he glinted and smiled unkindly – and answered with a torrent in the Welsh language. When he was wheeled in for his duty interview, François Pienaar did not try Afrikaans. Nor did Kitch Christie, the Springbok coach. The very 'unaverage' Pienaar chivalrously sidestepped the Catt questions, except to say, 'Catt showed a couple of glimpses of real class, especially when he ran with the ball.' Christie also refused to be embroiled – 'How can any man be expected to move into the Number Ten jersey in a Test match for the first time and it is presumed he'll play like a superstar. England stuck to their guns – but they obviously missed Andrew, one of the great fly-halves of the world, and their two old pit bulls [presumably Moore and Richards].'

Mike Catt, spruce as ever, sat in the team coach on the way back to the Petersham. Typically, the hint of a smile that played on his lips had no despondent edges to it: 'That's life, the press is the press and TV is TV, this sort of story makes them tick. Sure, I might have said things better left unsaid. But when I remarked that Pienaar was "an average player" I meant that in the context of the whole history of Test rugby – e.g. he was an average international player, not an average rugby player . . . And I agree his captaincy is altogether a totally different aspect, he's a truly superb captain, and there's a tremendous aura of leadership about him. Sure, I've taken a hell of a lot of abuse from the England boys, you know "good old Banza speaks his mind", but I can take it, although I've learned some sort of lesson, I guess. Sure, the South African team let me know about it during the match. Oh, worse than just little verbal niggles. They were swearing at me, pointing threateningly, saying "Be careful, boy, you're a marked man, we're targeting you" – just good old banter; it didn't worry me. There might have been once or twice in the past when that sort of thing intimidated me, but not this time, honestly.

'In fact I enjoyed the whole game immensely. I was very positive and personally I thought I did pretty well in the circumstances . . . their tries each came from our mistakes, Williams's did for sure, and while West-huizen's was a truly great effort, our defence gave him a slight helping hand, didn't it? But what a player he is, probably the best ever; you can't coach someone like that, you just send him out and let him go.'

Eighteen days later, the night of 6 December was wet and wintery. But neither the windscreen visibility nor the road surface on two different dual-carriageways to the north-west of London would have been remotely to blame had there been two separate motor accidents involving a handful of young men who were on their way to a routine training night with the England rugby squad at Marlow RFC alongside the River Thames. The police would have put both accidents down to 'excitement'.

Driving one car was Tim Rodber, twenty times flanker for England and a strong and confidently upright man who would have admitted, neverthe-less, that for the first time in yonks he could not dispel the niggling pin-prick of anxiety in his mind, the possibility that, after the match against South Africa when he had carried his trodden-on and painfully bruised forearm through most of the second-half, his place in the first fifteen might be in doubt. He drove on. The sports channel Radio 5 was playing. In the back-seat chuntered his two fledgling Northampton clubmates, best friends and half-backs, Paul Grayson, twenty-four, and Matthew Dawson, just twenty-three. A celebrated club all down the century, Northampton

had been relegated to the Second Division the season before, but had retorted with such zest, sparkle, and sackfuls of points that already, pre-Christmas, no bets were being taken that they would whizz straight up again to the First. Only the murky Saturday before, Tim had captained the two half-backs as the three of them had played a luminously significant part in the Midland XV's glittering try-speckled rout by 40–19 of the touring Western Samoans, due to play England at 'new' Twickenham's official opening in ten days' time.

The car droned on. Radio 5 prattled on. Every half-hour the sporting news comes on, as regularly as night follows day. Suddenly, out of the blue, the voice said, 'Jack Rowell has announced his England team to play Western Samoa ...' and with solemnly undramatic tread began to list it ... 'Catt, moved to full-back, Hopley on the right wing', then continuing with the permanents (Carling, Guscott, Underwood ...) At the naming of the next two, fulminatingly there came to pass in this particular motor-car two eruptive vocal explosions which drowned the surnames because the Christian names were twigged in the instant the radio announced, 'first caps for, at fly-half Paul Grayson and at scrum-half Matthew Dawson.' The shriekingly gleeful din seemed enough to roll-over the speeding motorway vehicle – so could the rasping and practised sar'nt-major's barrack-square command from the officer and gentleman who was driving it. 'SHUT UP' bellowed the British Army's Green Howard as they began to list the selected scrummage. Dead silence; until ... 'flanker at No. 6 Tim Rodber ...'

At which Her Majesty's relieved officer straightened his motor-car, flickered a contented split-second smile to himself and, glancing in his rear-mirror, ordered, 'Bloody well done, you two lads.'

Meanwhile, at precisely the same moment and not all that far away from Rodber's M1, another motor-car, this one heading westwards on the M40 out of central London, was also full of cheery glee at Radio 5's sports news. Jason Leonard was driving to Marlow with two Wasps clubmates – and the announcer told a relieved Damian Hopley he had kept his place on the wing and, to noisy whoops, that twenty-three-year-old university student of estate management Lawrence Dallaglio's impressive quarter of an hour as a replacement against South Africa had won him poor thirty-one-year-old Andy Robinson's so-proud position against the Samoans.

Simultaneously, travelling eastwards from Bath towards the Marlow slip-road of the M4 was Mike Catt. The radio told him he'd been moved from fly-half to full-back and that Kyran Bracken, who would have been telephoned that day by a commiserating Jack Rowell, had been cruelly relegated to the replacements' bench. Said Catt: 'It is a real body blow for

Kyran, and although I'm delighted to still be in the XV, I must admit I'm very disappointed . . . I think we did pretty well, and if there were any worries about us we could have sorted them out before and during the Samoa game. But there you are, that's life, and sure I'm happy and relieved just to be in the side, whatever my position.'

At the end of any sports teams' selection meetings, by definition one man's misery is another's joy. All-change at half-back made the headlines next morning, of course, and only in parenthesis, as it were, was anything made of another important decision announced by Rowell and his coaches – elevating at prop the Leicester loose-head, the intelligent and cheerfully industrious twenty-four-year-old Graham Rowntree, and demoting Victor Ubogu to the replacements' panel, a move which had Jason Leonard moving across to tight-head, the right-hand 'capstan' of the front-row.

Jason Leonard: 'Generally, non-rugby people don't realise that loose-head props and tight-head props are two very different positions. They think you just put your head down and blinking well shove. But the skills and the strength needed are on exact opposite sides of your body. They are different strengths, too. The loose-head has particularly to be strong in the back, the tight-head gets more weight bearing in on him from a horizontal direction. Tight-head has to help make the opposing hooker's life a misery by helping to obscure his view by stopping his loose-head keeping things upright and balanced and steady. For this his right side – arm, trunk and leg – does all the work and bears the load. The loose-head uses his left side to nurse his hooker. So they are diametrically opposed positions because the tight-head is all right side. So practice in both technique and strength is absolutely crucial for the side you want to be – and I mean years of it. I've had to move across before, even for the British Lions, but unquestionably I've done all my best work at loose-head down the years. It's difficult to adjust – but you know me, I'll play wherever England tell me, don't you worry about that. And no question about it – Graham Rowntree has been knocking on the door for ages and fully deserves his chance.'

The *Daily Telegraph* suggested that the popular Victor had been 'living on borrowed time for the better part of the year' and the 'darling of the Chelsea-set had been too regularly out to lunch'. The cheek of it! At full-back, Jon Callard, who had done nothing wrong against the South Africans, would also be joining his Bath colleague, Ubogu, on the bench, to allow Mike Catt to remain in the side.

Just twenty-three, Matthew Dawson had been earmarked as an

international scrum-half for any number of years. He had played mini-rugby on this same Marlow RFC pitch since he was seven. He was educated at the impressive rugby 'academy', the Royal Grammar School at High Wycombe, which has produced a number of international players. Dawson played in all the England age-group teams, even once as a centre for the under-twenty-ones. In 1993, he was obviously first-choice scrum-half on England's A tour of Canada, but in the opening game he badly tore a hamstring muscle – allowing Kyran Bracken to seize his chance – an injury which presaged others and a seeming dip in form. He is an innate ball-player, has kept wicket for Buckinghamshire and played for Chelsea Boys at soccer. But he can never have had such an illuminatingly notice-able game at anything as that the week before for the Midlands against the Samoans in the gloom of Leicester in front of the television cameras and, crucially, Jack Rowell.

Dawson was serving a year as a teacher at Spratton prep-school, seven miles north of Northampton, before finishing his degree at Loughborough University. Although his pupils might address him as 'Sir', the raggedy-haired blond has an engaging boyish presence still; he seems slighter than his 5ft 11ins, perhaps because his jackets hang too floppily big on him; but he is bonily strong, in mind and ambition too. With this selection, the two firm friends Dawson and Grayson – 'The Twins', Carling at once dubbed them – posted England's 50th half-back club pairing in history.

The Lancastrian, Grayson, is an all-rounder, too, having played serious league cricket for his hometown Chorley and, as a soccer-loving teenager having trials for Preston North End and the now defunct Accrington Stanley. He switched to rugby only six years ago, with the junior club Preston Grasshoppers (where the grand England lineout stalwart Wade Dooley remembers the frail lad – 'as a ball-playing kid Paul was a natural'), then at Waterloo, before being recruited by Northampton, where he works as an insurance broker. Rugby's traditional playmaker's and 'artistocratic' position of fly-half appealed hugely from the very first. I noticed the name of Grayson in a short article in an obscure magazine three years ago when the twenty-one-year-old claimed he was building up a video library of history's finest fly-halves, both for his delectation and his own rugby development. About that time was published an historical chronicle *The Great Number Tens*, which rambled at length about the specific position and the lineage, from the James brothers of Swansea back in the mists of the nineteenth century. Grayson's mother bought him the book for Christmas, and before he had grabbed it to devour it at one sitting (he says), Mum had time only to inscribe inside the front cover, 'A very Happy Christmas to the future England Number Ten . . .' He was still playing for little Waterloo.

As a fly-half – upright 'Church' of the legend, not tubby scampering 'Chapel' of the other – Grayson certainly looks the part. He is a pale-faced six-footer, with a patrician's nose and the straight-backed alertness of a sleek thoroughbred. You cannot imagine Grayson playing with his socks rolled down. He has an eerily calm centre, but when he smiles, it's a real smile all right. Like now, just arrived for training having heard the news of a full England cap. He still could not believe it, even as the remainder of the squad, in their ones and twos, moseyed over with genuine and companionable handshakes and congratulations. I may have missed something, but throughout this project I never heard, among the squad itself, any voiced anger or jealousy once a new team was selected, announced, done and dusted.

At once, at practice, the new No.10 had to assume his lynchpin role and stamp his identity on it. Afterwards, he smiled and shook his head, still in wonder: 'Wow! It's all happened so quickly. I only got a full game for the A team last year. But when they made me captain of the midweek A's a couple of times on the tour to Australia it made me feel more responsible and mature, if you like. A sort-of general ambition to move up the representative ladder can be in you, but it can be a pretty airy and vague sort of

Jeremy Guscott throws his weight about in a pre-match training session.

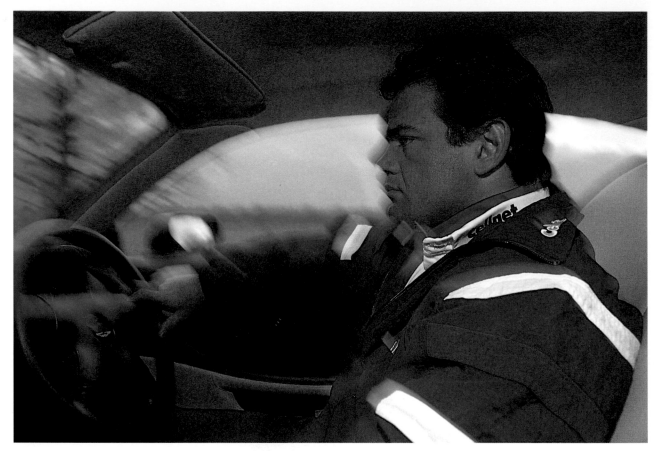

'Will Carling on his way to the first training session since South Africa. He was going through it: media interest in his private life was pretty grim.' – JN

thing if the truth was known. But around the time of the South Africa match last month [which he watched on television], don't ask me why, everything suddenly crystallised, just like a boffin shouting EUREKA! I had a long late-night phone chat with my dad [a solicitor] back home in Chorley and, don't ask me why, but I found myself insisting to him with a definite resolve as well as excitement, "Dad, the penny has finally dropped. I've just got to go for it in a big way, everything's got to be geared towards it. If I don't go for it now with every jot of application and concentration, in ten years' time I'll loathe myself, saying 'you once had a real opportunity to work to pull on that Number Ten jersey for England – and you blew it'." Mind you, telling Dad that, I didn't remotely expect it to happen within a year, let alone this season, let alone a month!'

Whether a young provincial schoolteacher or insurance broker, the late winter of 1995 was undeniably the right time for a rugby player in his early twenties to win the first of what he would hope were many international caps. There were 'proper' legal over-the-counter monies and legitimate group perks to be banked. In this respect, one had to have a pang for the likes of, especially, Brian Moore, who had for so long been perceived as the player working to drag the game's establishment into the modern

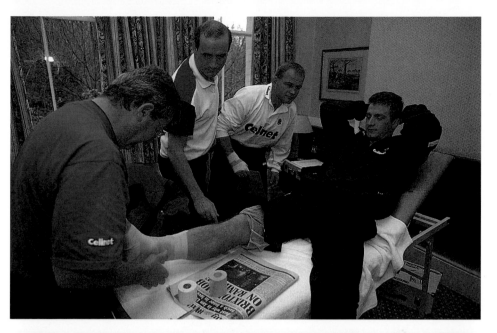

'*Before training at the bank of England, Mike Catt is made secure.*' – JN

'*Victor, trying to keep his cool during some fraught training sessions.*' – JN

The team gets a measure of Twickenham in a training session.

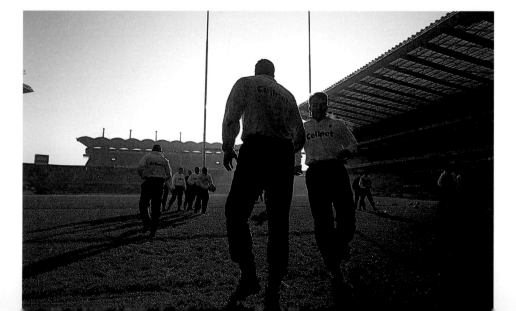

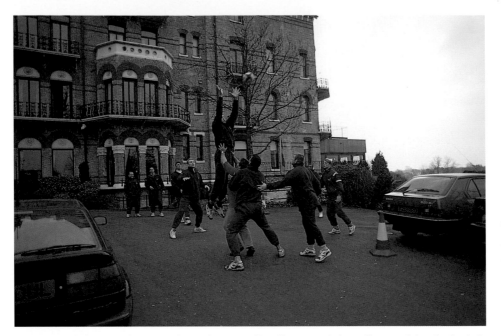

'*Saturday morning, Petersham Hotel. Forwards practise lineout calls* (left). *Some fans/match-goers who are at the hotel for a drink have their first glimpse of what is to come.*' – JN

'*After the Management leaves the room, players gather round and the final brainstorming session takes place* (facing page, top). *Will and other key players do a bit of positive talking. Tim Rodber has not fallen asleep.*' – JN

'*The new boys* (facing page, bottom). *Their friendship is fantastic: being able to talk, help each other through the mounting pressure of their first international.*' – JN

commercial age. It was the players, jiggling and juggling with their job commitments, who were putting the 'bums on the seats' – hundreds of thousands of them wherever they played around the world. Now the game's International Board had unilaterally announced 'open' rugby in August – and, in October, Moore had been unceremoniously kicked off the England team.

Yet even in the week before the Twickenham international against Western Samoa – as rumours continued to circulate that the players were being offered vast sums by a serious commercial 'breakaway world league', funded by Australian TV money – the England team had still not signed their individual twelve-month contracts, promised to be back-dated to 1 September. Till the captain made a stand and took the lead. In no time, his entire squad had followed him to the contract's dotted line.

Two days before the international, Carling pooh-poohed the 'rebel' organisation and told me: 'Personally, I cannot remotely see any rival "breakaway" franchise as a viable option. I am very clear in my mind and have made my views clear. I will be delighted to be signing the RFU contract. It is very fair. I agree, other players might, for various reasons, need a bit longer to consider every ramification. At the end of the day, it's a player's individual business and it's up to him to make his own decisions. I accept that, but I've made up my mind. One or two of the guys have already said to me that they aren't interested in any contract other than the RFU's, because just a glance at this other one on offer, if it's examined carefully, means they own you, lock, stock, and barrel. They can tell you where to play, when to play, the whole lot. That doesn't appeal to me, I

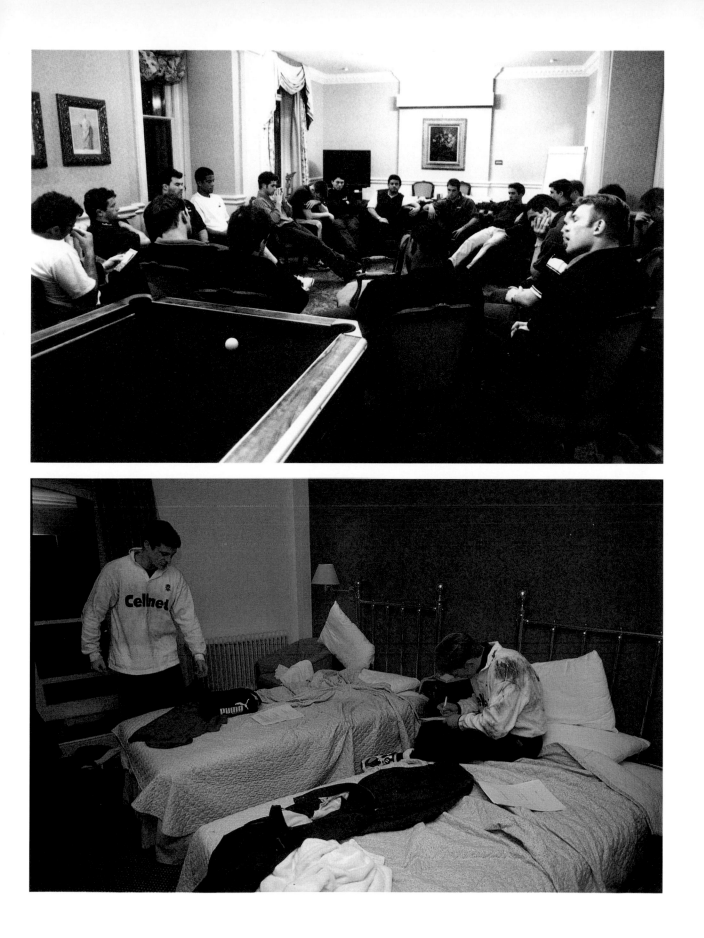

must say. With a RFU contract and their own club contract, I think our top players will be doing very well anyway. They will still have a personal flexibility in their life, as it were, and that to me is far more appealing than selling up everything to go and play precisely where and when they tell you to and where, unless you perform consistently for them on the pitch, nothing else is guaranteed. It is playing matches that matter which is the appeal for me – like this one to a full house against the Western Samoans – and that's the point I am going to be making to the guys, that is, let's get it all sorted out, done and dusted, so we know where we stand, and then concentrate on the match and the rugby.'

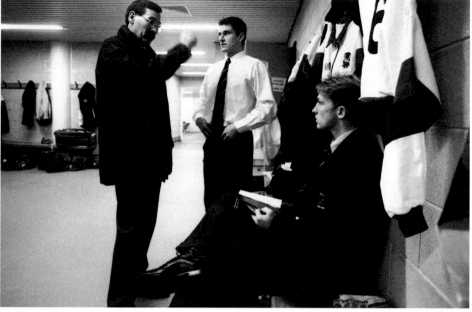

'The coach to Twickenham. Paul Grayson in reflective mood, oblivious to the waving crowds lining the roads. By now I'm as nervous as they are.' – JN

Dawson and Grayson receive final words of advice from Mike Slemen.

Another day on the bench. (*From left to right*) Bracken, Robinson, Callard and de Glanville.

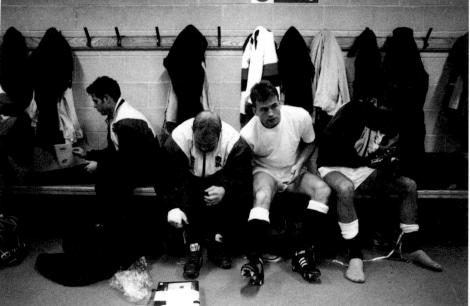

It was a winning advocacy by the captain. By next day, Friday's eve of the match, the entire England squad had signed their contracts before rounding off their practice with a sniff of the flavours at an empty Twickenham.

On match day morning England's debutant Paul Grayson showed me one of the pile of letters of good wishes he had received. It was from the former England stalwart Wade Dooley, superduper star of Preston Grasshoppers when the teenager Grayson had first taken to rugby. It read, 'Tremendous good luck – but beware of low-flying Samoans!' Sure enough, after the Duke of Edinburgh had done the honours and officially opened the ground, the famous Samoan tackles started coming in with a gusto, as did the offside spoilers around the fringes. England were always

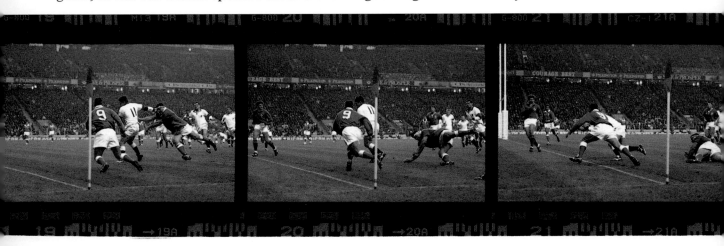

in command, but could not shake themselves into any consistent effervescence. There was a disjointed lack of flow about the whole match and, on the weekend before Christmas, not much festive spirit about the rugby. For the first hour, penalty-kicks were swopped to England's advantage – the penalty-count, including free kicks, ended at 28–8 in England's favour, by which time England led 15–9. Those five England penalties, variously difficult, had been struck with clean and nerveless aplomb by Grayson, but when Carling tossed him the ball and he prepared to take a sixth, the crowd began to whistle and jeer noisily, reckoning England's 'cushion' of points was enough to begin decorating the game with some running rugby and colourful streamers. They could not have known that this sixth penalty Grayson was preparing to take (an easy enough one, just outside the twenty-metre line and halfway out) might be about to level the all-time international debut record by Gavin Hastings of Scotland and the All Black Kieron Crowley. 'I suppose I could understand the crowd's point in a way,' said Grayson afterwards. 'They thought that against Samoa they'd see a feast of tries. But these guys have proved they're no mugs, and 15–9 is not quite the lead you need before throwing it around

A zig, a zag, and Underwood lands his 48th England try. 'Most wingers' tries are undramatic,' he says; 'most are just narrowly squeaking inside corner flags.'

with abandon; you've got to have a base first. As the catcalls increased and I realised that they were aimed at me, yes, I did look down at the red rose on my breast and momentarily think, "whose side are they on anyway?" The fact is that if the captain says "take the kick", you take the kick.'

It almost goes without saying, he missed it.

Giving the bird was nothing personal, of course, but it represented 'new' Twickenham as opposed to 'old' Twickers. The old lot, for eighty-five years, would clap off both teams after the most turgid o–o tussle, well fought. Those that thronged this new colisseum expected, one fancied, after paying a lot of money for tickets, to be entertained by a non-stop string of 'edited highlights' showing spectacular killings by their gladiators

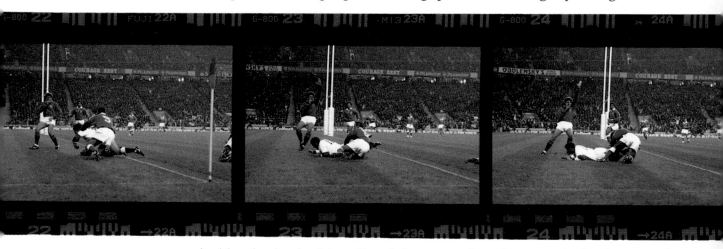

in bloodstained white. Certainly not against the perceived minnows of Western Samoa were the finer points of embattled strategy going to be appreciated – not in the holiday mood a week before Christmas anyway.

Nevertheless, it might - or might not – mean something that within eight minutes of this collective raspberry from the crowd England scored their two tries. First a back-row move of classic simplicity, with Clarke taking a fast channel-one ball, driving to the openside and flipping a one-hander to Dallaglio, who crashed exuberantly over near the posts. A few minutes later, that same now rampant pair of new comrades made driving inroads from a scrum and, when the ball was niftily recycled, Dawson, Grayson, Catt and Carling combined sweet and sure to make a try for Underwood with a final inside pass.

That was the sum of it – 27–9 – and if the mass celebrating back in the carparks into the evening remained silently miffed that the perceived 'little islanders' had not been given the expected 45-point mauling, as the claret and festive fizz went down they began to reflect at least on the day's ringing-in of the new in the shape of the rookies who shone out with promise. In the back-row Dallaglio's lantern jaw was a beacon, his game

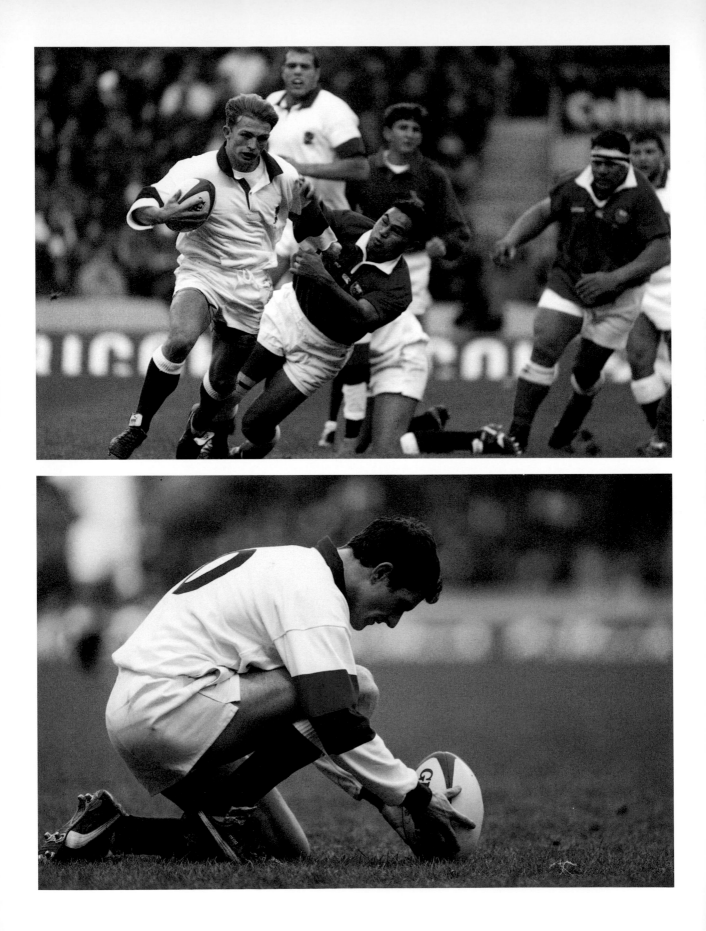

bristling with attack and vigour; in the front line, in physical contrast but not in spirit, Regan's bull-neck defiance again and Rowntree's nous and first-up stomach for the fray, had to be appealing plusses.

Graham Rowntree: 'Simply, thank God for Jason. I wouldn't have made my first start for England if he hadn't moved across. He's already a world legend, played against them all and taken them on. He's the rock of England. He talked to me all through. But to be honest I can't remember a thing. It was all a blur. I just kept telling myself to do the things they had picked me for. How I actually played, the Lord only knows, I don't.'

And while two swallows by no means make a springtime, the half-back duet made its debutants' curtsey with an engaging aplomb. Twickenham's most critical ringsiders would have warmed to Dawson, the terrier scrum-half of tradition, the beaverer and burrower with the lick of 'Just William' hair flapping at his forehead as well as, in contrast to him, his pal and club partner who impressed with his calm detachment and, any top sportsman's vital 'hidden' ingredient, serenity in the cannon's mouth. The whole team already know Grayson simply as 'Grace' – which even the dictionary agrees is spot on: 'elegance, charm, and unrushed fluent movement'.

Casting fresh light on the players and stadium alike, and representing the last stage of the stadium's eight-year redevelopment, were 184 new lights, 92 each on the rim of the grandstand roofs of the East and West stands, each fitting giving off 2,000 watts. Alas for my old and distinctive and splintery cabbagy-green old shrine from boyhood when in particular gloamings of midwinter you could scarcely distinguish one player from another in the last twenty minutes of the match.

In the dressing-room, the players, almost to a man, grabbed a can of beer, fizzed it open and in a whacked, all-in, silence sat sucking down the brew under their coat-hooks and coat-hangers and surrounded by their clobber and the detritus of battle – bloodied, muddied headbands, finger-thongs, bandages and swirls of now filthy surgical tape. Some had been fast out of their shirts, some just their shorts, others their boots. None had yet taken off all three. Some had backs to the wall, with vacant eyes either closed tight or, blankly opened, half focusing on the freshly installed white-lit ceiling; some lay on the floor, feet higher, resting on the benches; others, elbows on knees and chin cupped in hands, stared at the floor in a glaze.

Rowell spoke: 'It's like a morgue in here. Don't forget, a win is a win. But if you are looking like this after a comprehensive win, it means you know that we've still got an awful lot of work to do.' That just about summed it up. But one could detect in the new boys a sense still of wonderment. Their

Debutant Dawson 'only remembered the things that did not go according to plan, rather than the ones that did.'

Preparing for a record-breaking kick as the jeers rain down, Paul Grayson thought 'whose side are they on anyway?'

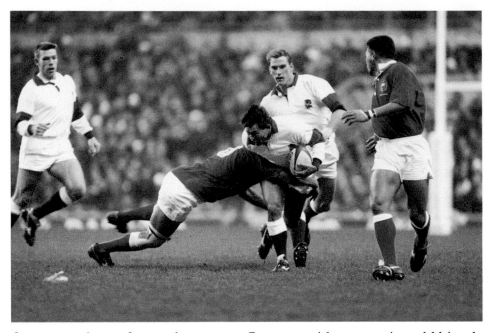

Dallaglio poised for the pass (*left*) before exuberantly flopping over (*right*). 'I knew Mum was up in the West Stand doing her Annie Underwood bit.'

first cap, a victory for good measure. Grayson, with a wry grin, told his tale of being jeered in his first match at Twickenham. 'It was not in the least personal,' I insisted. Dawson said, 'I know we didn't set the Thames on fire, and although we'd been brought in to make things happen you're not exactly going to order guys with sixty or eighty caps how you think they should be playing the game, are you?' (In fact, the official match statistics were to show that, of the two half-backs, Grayson ran the ball three times, kicked five times, and passed eighteen; Dawson ran once, kicked seven times, and passed thirty-five – a huge ratio of passes to kicks and more than an England team had managed in years.)

One along from Dawson, under No.7's peg, sat Dallaglio, head in hands in his reverie. I congratulated him. Softly, 'Was that OK?' He gestures with a nod across the room where Andy Robinson has already begun busying himself with the replacements' chores of packing up the kit and clobber. Dallaglio, remember, has usurped Robinson's place in the XV. 'I've a lot to thank him for; Robbo helped me out with lots of little tips and wrinkles of the position. He didn't have to. It's the measure of the man. Still the best Number Seven in the country, isn't he?' There's two helpings of chivalrous generosity for you.

If the Samoans had tackled hard, this twenty-three-year-old had tackled harder. His body was bruised and wealed. If the Samoans had put themselves about with brio, ball in hand, Dallaglio had done so with knobs on. His first try in his first full international match might have been a routine enough close-quartered dive over the line, but there was nothing run-of-the-mill about it for Lawrence and the Dallaglio family.

Lawrence's very presence in the England team this winter – surprisingly, too, for he had not even made the squad for the World Cup – had helped lift the pall of grief under which the close-knit Anglo-Catholic family had lived since 1989 when, on a dark and benighted River Thames, the evening pleasureboat *Marchioness* had collided and gone down with the appalling loss of fifty-one lives, mostly young partygoers, including his older sister Francesca, a nineteen-year-old ballet student. The tragedy totally blacked out the schoolboy Lawrence's announcement of himself to the sporting world when his Benedictine public school, Ampleforth, uniquely won both the open and festival tournaments at the national schools' sevens. He enrolled at Kingston University and lived on a riverboat on the same Thames in an effort to purge his anguish. His mother, Eileen, led the dignified campaign for an official disaster inquiry for stricken families of the other victims.

Dallaglio's burgeoning rugby career, the family admit, helped cope with their devastation. In 1993, Les Cusworth as coach took Dallaglio with a scratch, callow, and untrained (only three Sunday morning sessions allowed) England team to the World Sevens at Murrayfield and with a Corinthian panache they quite gloriously won the thing. Now in his first

'I never knew they got caps.
Bill Bishop presents the new
boys with their caps. Matt
Dawson looked as if he was
going to collapse . . . Well
done!' – JN

full England appearance, Dallaglio not only had a try with which to decorate it, but also one to celebrate the family's continuing rehabilitation. 'It's just something else to show us there's more sunlight at the end of the tunnel. Francesca's loss will never disappear, but it really means something to be able to dedicate your first try for England to her. She'd have been so proud. As I ran back I tried to recognise Mum and Dad in the new West Stand – I bet Mum was up there on her feet and in tears doing her Mrs Annie [mother of Rory and Tony, caught by the cameras in ecstasy in the grandstand a few years before] Underwood bit, arms in the air and all.'

The raw red weals of combat, and the studmarks, seared his pale body as he stood and then walked naked across to the high pile of fresh royal-blue towels on the way to the baths and the shower-room. The intense green eyes glistened still with the excitement of the afternoon and the pilgrimage it represented. 'More sunlight at the end of the tunnel . . .' In the family home at Hammersmith, he said, his parents had this week put up a cheerful Christmas tree for the first time in the seven Christmases since the *Marchioness* horror had made havoc of their lives. Now there was an England try to go on top of that Christmas tree.

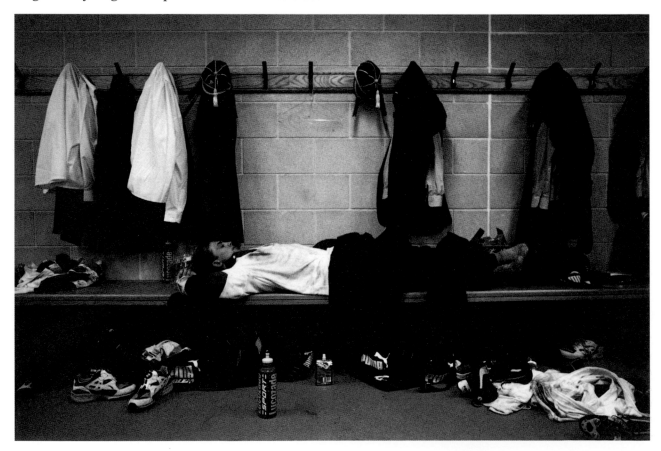

The captain had been first showered and changed. He had already done a couple of 'live' broadcast interviews, on-the-hoof and off-the-cuff as soon as he'd arrived in the tunnel from the field. Now Colin Herridge was corralling Carling to join Rowell for the official media post-mortem in the new press interview-room along the corridor. But first, Carling had a far more sacred duty to witness, the presentation for the two brand-new boys of their Victorian-replica tasselled caps of plum-red velvet with gilt and silver 'piping'. They might win fifty caps, but this was the only real and tangible one. When Carling had first won his, eight years before, Grayson was possibly still dreaming that his England cap would be for soccer. But he looked at it with delight, and kissed it softly. Dawson's childhood fantasies, however, had always sustained and aimed for this rugby moment at his game's holy-of-holies in south-west London. He had this moment in mind even before his eleven-plus. He, too, had played for England's 'first' team in the 1993 Sevens at Murrayfield along with Dallaglio – and also Rodber and Hopley of today's XV. Dawson looked down in awe as he held at last tradition's venerated and sacrosanct titfer – then the bright terrier's eyes just glazed over, and he promptly keeled over in a cold faint. He was out for the count on the floor.

'First Cap' by Matt Dawson: '"Grace, what are you doing today?"

'"Oh, nothing much. I'm playing rugby for England this afternoon though!"

'Pathetic laughter, followed by a wry smile, was all we could muster. All of a sudden the first few notes of the BBC's *Grandstand* intro and Steve Rider greeting the nation from Twickenham. Our ugly mugs followed in a pre-match interview which maybe sent the final signals home that it was to be a special day. A knock at the door and the captain wanders in to ask how his lads are. The answer was self-explanatory as I was already on the toilet and Grace was pacing around waiting impatiently to follow. Nothing to worry about, though, as it is apparently a familiar trait for New Caps.

'The pre-match meeting, the bus journey and the wander on to the pitch are blurry memories as the focus was purely on the kick-off. The last twenty minutes, however, ticked by at a snail's pace as my adrenaline began to increase. Every stretch and every mouthful of Lucozade could not pass the time away quick enough. Eventually the final knock on the door from the referee meant this was it. After one last glance at Paul, and several good-luck messages from the players, we were walking through the tunnel. The roar of the crowd and the rush of the December wind created an outstanding initial

'Over he went. The emotion was too much for Matt Dawson: he went as white as a sheet and hit the deck. Comrades helped him on to the bench and got the Doc.' – JN

impression. I dazed into the huge arena see-
ing thousands of people chanting.

'I remember wanting to stand next to Paul
during the National Anthems and hopefully
catch a glimpse of my family in the West
Stand. When the singing had finished my
thoughts were briefly with Paul Thorburn as
my eyes were starting to well up. I am sure
there is a fine line between being emotional
and patriotic during those few bars! As the
teams chose ends the concentration switch
was flicked ready for the first whistle. I find
the game hard to recollect as everything was
performed at lightning pace, the passing,
kicking, and more importantly the decision-
making had to be accurate. Any mistakes
were punished with either points or territori-
al advantage. I seem to remember the parts
of the game that did not go according to plan
rather than the ones that did. The second
half was hard work as the pace and strength
started to become less and less available. In
fact with ten minutes to go my legs and lungs
were burning due to fatigue, that was until
we secured the victory with Lawrence's and
Rory's tries. All of a sudden I found the
reserve tank.

'As I staggered into the changing-rooms
my thoughts were of whether I had warrant-
ed re-selection. I felt mentally and physically
drained so crashed out on the benches to
recover. My calming few minutes were inter-
rupted by the President of the RFU, Bill
Bishop, presenting Paul and me with our
senior cap and tie. A moving speech I will
never forget!'

'*"Welcome to international rugby!" Tim Rodber said to me, while giving me a pint of gin and tonic. Celebrations went on into the night. De Glanville, Andy Robinson, Terry Crystal (who thinks he's Elvis) sang songs in the bar.*' – JN

Behind the Scenes . . .

(Top left) *'Farmer' John Richardson – responsible for the hallowed green turf of Twickenham.*

(Bottom left) *Carpenter Ron Green. For eleven years he has been Twickenham's Mr Fix-it.*

(Top right) *Tony Hallett, Secretary of the RFU. Following a career in the Royal Navy and having masterminded the redevelopment of Twickenham, he moved into the hot seat immediately after the game went professional in August 1995.*

(Bottom right) *Don Rutherford, Technical Director and ex-England and Lions full-back, standing in the England Rugby Internationals Club. Behind him is the national players' tombstone, where inevitably all England Internationals end up.*

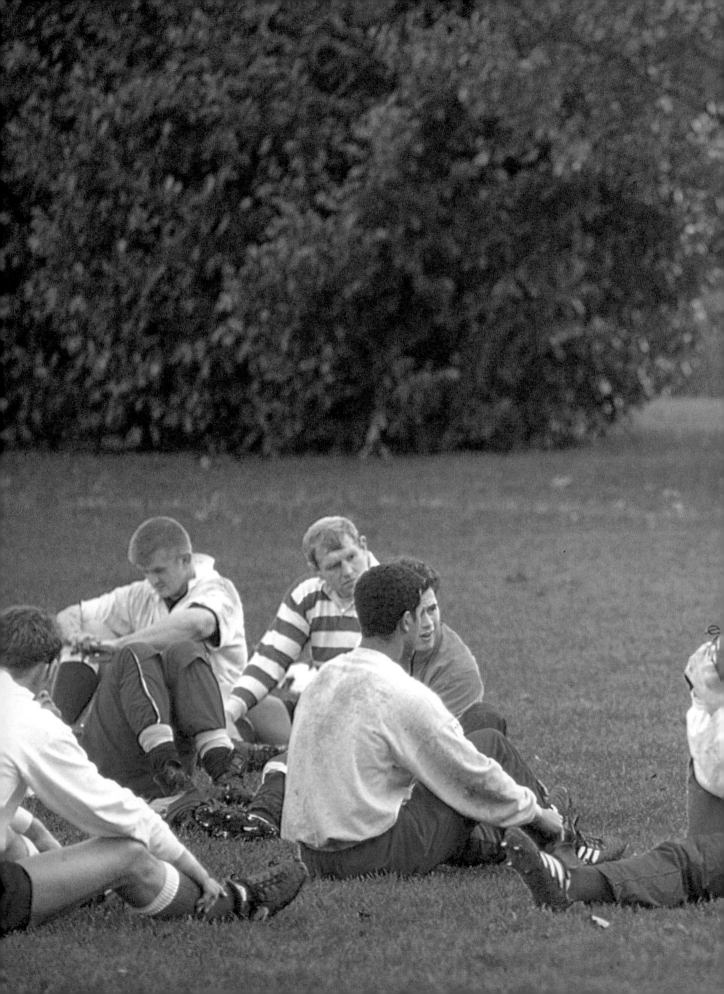

I sat next to Dean Richards on the British Midland afternoon Channel-hopper out of Heathrow to Paris. The quiet, amiable, ursine Deano, icon and talisman of the English national and provincial game, had been called up only the day before to join the replacements when, first, Tim Rodber (who had been relegated to the bench, anyway) cried off altogether with leg injuries and then Ben Clarke had announced worry over a slight abdomen 'pull'.

Martin Bayfield in a change of code.

Only a week before it had been drastically communicated to Richards that, thirty-three this summer, he had little future with the England squad when the powers that be asked for the return of his free training 'rowing machine' and his sponsors' Cellnet mobile telephone. (When I told him that I fancied he'd said they were welcome to them if they could find them, still unopened in their gift wraps, among the clobber in his garden shed, he didn't actually deny it, just smiled his slow smile.) Yet on the field, and in his singular slow-burn effectiveness, the force was still with him, and only two Saturdays before he had played a stupendously typical mud-wrestler's game in Leicester's defiant away victory at Bath. You sensed he had been recalled now as standby to the colours by Rowell almost by public demand.

With the stalwart Richards dramatically restored, even as bench stand-by, some of the headline heat had been deflected from the brand-new and surprising debutant. Jon Sleightholme was the fifth player to be baptised in only the three England XVs that had been selected thus far in the season. He was a stocky, fast, athletic Yorkshireman, born in Malton in 1972, whose electrically charged exploits on the wing for Grimsby, Hull Ionians, Wakefield, and for his county in the championships, had him drawn inevitably to the crack side Bath, in which city he now taught PE and general studies at Culverhay School. An out-and-out touchline trampler, Sleightholme had replaced on the right-wing the wholehearted Damian Hopley, whose natural stomping ground had always been in the midfield at centre. The team was sad to see the mighty popular Hopley out of the squad altogether.

Damian Hopley: 'When he announced the team before the South Africa match, Jack looked at me and just said almost in passing, "Damian, we know you're a natural centre, but have a go on the right-wing and we'll see what you're made of." Typical Jack. "Thanks, Jack," I replied jokingly; "thanks for showing and voicing such utter confidence in my abilities!" Anyway, I thought I did all right against the Springboks and Western Samoa, not great, but OK. Then the squad was due for the first-up Five-Nations against France. It was a Sunday. I went to Mass at Church Street, Kensington, and when I got back the "answerphone" was flashing. I pressed rewind with trepidation. It was Jack's voice: "Sorry, Damian . . ." I was pretty shattered. I suppose I should have said a few more Hail Mary's at Mass! I was out totally, not even in the squad, not even the A squad. The week before the Samoa match, I had given up my City job as a repro broker to try a season of full-time "professionalism". It seemed sense to give it a go. Now I was out on my neck. I kept training, but not being in any squad I began to go totally stir-crazy. Yes, lonely, and really utterly depressed because the whole idea had been seriously to channel my aspirations for England. Doing some writing and journalism took my mind off things, and the promise for April to captain the England "7" in Hong Kong. It was a demoralising period.' (By the summer, Hopley had returned to the City.)

But the tight confraternity of team sports has to live with this regular and cruel pruning of their brotherhood. You are in, or you are out. If you stay in, you shrug and get on with it. Form is by no means the sole criterion or yardstick. They all know that, and that's what makes the possibility of execution the more fearful. Luck and a perceived change of strategy play a large part, as do unexplained hunches allowably played by selectors seeking that collective, mystical, accidental 'gell'.

Before Christmas, Rory Underwood had displayed a strong winger's affinity with the engaging Hopley. Now, noticeably touching, he and Sleightholme had wheeled their baggage together as blood brothers through the airport departure lounge and still they were alongside on this cramped short-flight aircraft. Rory was still in the throes of the *Daily Telegraph* crossword, started after the morning training. For the journey and the calming of his mounting excitement, Sleightholme was carrying one of the newly published top-of-the charts Gulf War memoirs, *Immediate Action* by Andy McNab. He had not begun it yet. In the row behind the wingers, the team's mighty strong and mighty silent 6½-footer, Martin Johnson, was deep and furrow-browed into his tale of derring-do from the same desert conflict, Chris Ryan's *The One That Got Away*.

Always good cheer, good company and manfully confident while never being over-loud, Jason Leonard was still mother-henning Mark Regan, both bursting out of these mean economy-class aircraft seats. Alongside, fellow cauliflower-eared front-liner Graham Rowntree looked, in his studious spectacles as he read the *Evening Standard* feature pages, more the young 'varsity lecturer than the heart-of-the-matter prop forward bound for the eye of the mayhem come Saturday. Or, OK, he looks what he is in his 'other' life, a finance broker. So does the other one to whom 'civvy' spectacles add an academic air, Jon Callard, ever chirpy, much liked JC, the former public schoolmaster. Graham Dawe opened at page one his new paperback, Laurens van der Post's stories of Kalihari's bushmen. Rowntree looked down, flipped back the title page then, spectacles glinting, challenged the Cornish farmer, 'Bet you don't remotely get through half that?' Not affronted in the least, Dawe replied, 'Dead right, don't suppose I will. I never actually finish many books. I just enjoy getting into them, though, seeing what they're about, getting a flavour, that's enough for me; then I'll try another one.'

It was generally accepted, even by Regan himself ('Every match I've played for Bristol against Graham's Bath has been a crucial learning experience for me, he's so tough and hard, and so knowing in the secret "black arts" of hooker') that Dawe was probably still all-England's finest hooker now that Moore had gone. But veteran Graham was born way back in 1959, and Mark in 1972, so he was here for the future and, to be sure, had so far taken his chance with a will in spite of criticism about his sometimes wavering lineout throwing. 'At practice, I try to get him to concentrate on being more accurate with a torpedo-ball like me, but he just doesn't seem to listen,' moans Graham with an avuncular 'Bah! Modern youth!' shake of his head.

Differently, Rowntree's precociously wise and industrious make-it-count performances seem, on merit, to have made for a permanent seat on the bench for Victor Ubogu. But Nigeria would be represented on the field from the start in Paris because Steve Ojomoh, also on merit, had taken Rodber's No.6 shirt in the back-row. Here was a big bounding athlete all right, with a delighted beaming smile to match. With Sleightholme in for his first cap and Ojomoh for his tenth, Bath's contribution of nine men to this squad of twenty-one was champion stuff.

Ubogu was born in Lagos in 1964, Ojomoh in Benin City six years later, an age difference which meant they never played together in school teams at West Buckland school on the plumply rolling glories of Exmoor where both were educated from the age of twelve. In the under-fifteens, remembers Victor, they stuck him on the wing, 'because of the generally

held perception that all black men have to be speedy wingers and nothing else – but one day the regular loose-head prop was injured and because I was the next-biggest guy in the side, they pointed at me and said "You're now a prop"'. Not exactly true if you telephone his old sportsmaster at West Buckland, Laurence Whittal-Williams: 'Well, Victor had never seen a rugby pitch before, so he had to learn the game from somewhere, didn't he? Once he had, he was such a good ballplayer and so marvellously pacy that I'd have made him a modern hooker if I'd props big enough for him. I still think Bath and England should change him to hooker.' So there. Academically, Victor was just as fast, sailing first into Birmingham University's engineering schools and then to Oxford to read PPE.

Steve was less academic, but by far the more natural all-round sportsman – south-west schools champion at discus, long-jump and triple-jump, and all-England schools' decathlon bronze medallist in 1988. Yet his rugby elevation surprised his old schoolmaster. 'Victor had that "ice in the soul" to succeed at the very top but, bless him, I confess I thought Steve for all his natural genius and zest was, well, too nice for the seriously nasty hurly-burly. But it's that part of his temperament that has won him through in fact, and it is marvellous seeing how unfazed he gets when rugby opponents have a go at him, and how anyone who attempts to knock him about soon lays off because Steve just smiles that smile and just gets on with it as if to say, "Hey mate, you've got to try a lot harder than that".' (Whittal-Williams and his wife were usually engaged in school sport at weekends but, when free, still enjoyed watching their two celebrated former pupils whenever they could.)

A general presumption is that 1988, when the two other England players from Nigeria, Andrew Harriman and Chris Oti, were capped, was the first season a black player was chosen for the lilywhites – Jeremy Guscott, whose father was born in Jamaica, first played a year later. In fact, James Peters, born in Salford, the son of a West Indian sailor, was the pioneer, winning ten caps for England as a dashing half-back in the seasons 1906–8. The RFU Centenary History still referred to him as 'Darkie' Peters when it was published in 1970.

Ubogu played for the dark blues in the 1987 University match against Oti's Cambridge. It looked then as if Oti's glorious wing play might continue to set Twickenham on fire for half a dozen years, but wretched knee injuries put paid to that. Posterity, however, will thank (or not) Chris for he is credited by legend as being responsible for 'Swing Low, Sweet Chariot', the negro spiritual, which lilting cadence now carries England to their victories; apparently it was first heard emanating from a cluster of tuneless choristers low near the north-west terrace cornerflag after Oti had spec-

tacularly run in a hat-trick of tries against Ireland in his opening season. There was the waft of beer on the breeze that day as the hymn died (as ever) after the first two lines, so the happy perpetrators probably don't even remember what they started. But now it has become almost an official anthem, as special to England rugby as Scotland's pop-song dirge 'Flower of Scotland' – and more than rugby, on the satellite cricket coverage from South Africa this winter one distinctly heard, bouncing down time and again from space, the English cricketers being encouraged to 'Swing Low . . .' Same at soccer's Euro'96.

Ahead of his charges, seated alone and oblivious to (or weary of) the team's droning chatterboxing, Rowell's long frame and an aeroplane's pinprick reading-light playing on the back of his fluffy, almost snow-white hair, gave him the air – to the fanciful romantic anyway – of being prophet and leader into the promised land. Which, in a way, he was. In fact, Jack the big businessman was reading his glossy big businessman's magazine. He read with a studied and detached businessman's concentration three long businessman's articles. He held the mag in such a way, moving back to my seat immediately behind him, that I could read the headlines and sub-heads. The first was 'MAKING ITS MARKS – although Frankfurt has proved its muscle in Germany's economic strength and balance of power, it still displays some vulnerability'. The second was 'VIEW TO A RENTOKIL – Rentokil's chief executive Clive Thompson has turned the environmental-services group into a leading world performer. It consistently delivers 20 per cent earnings growth each year, and intends to maintain it.' The third was headlined simply 'IN BUSINESS, YOU DON'T GET WHAT YOU DESERVE, YOU GET WHAT YOU NEGOTIATE'.

This big businessman had been a captain of industry through his working life, with rugby football increasingly a devoted hobby. Although he maintained a string of directorships and consultancies, for nearly two years now the England team's balance-sheet had been paramount to him. After a Grand Slam in his first season and (admittedly disappointing, but as much, he says, as he had honestly expected) a semi-final place in the World Cup, Rowell was here embarking on his first Five-Nations Championship with his own England team, not the one so suddenly bequeathed him by his successful predecessor Geoff Cooke, who tossed in his seals of office, out of the blue, in 1994. Rowell was the only realistically possible appointment. He was the most successful club coach European rugby had ever known. Since the Courage Brewery had sponsored a divisional league championship in 1988, Rowell's club Bath with disdainful panache had reeled off five Division One championships. Under Rowell's tutelage, since they had first won it in 1984, Bath joyfully lifted the annual knockout

Pilkington Cup an incredible seven times, never losing a final. Even before then, his coaching first burst into English rugby's consciousness in 1976 and 1977 when his little soccer-encircled north-east rugby club Gosforth (for whom he had played as a towering lock) won the pre-Pilkington John Player Cup. His playing time at Gosforth was a bonus he had not expected. Between West Hartlepool Grammar School and honours at St Edmund Hall, Oxford, he badly wrecked his back playing a Freshers' trial and was warned off any more games for life. He settled at the time for business. From Newcastle's Proctor & Gamble combine, the obvious high-flier was to spread his wings to arrive in the west country as managing director of the Lucas Group and from his boardroom there one day he telephoned the Bath RFU secretary Jack Simpkin to ask if there was anything he could do to help about the place. By the time the hitherto matey but meek Bath sides had begun to roar all over England and monopolise the silverware, Rowell was chief executive of Dalgety plc, the billion-pound food and agricultural multinational. He knew his stuff all right and, by golly, he obviously knew his rugby.

Rowell finished his glossy-magazine considerations of the profiled philosophies of his boardroom peers, and turned with a beam to be quizzed on his own. The Five-Nations Championship started here, I said. 'So let's begin at the beginning. I will be asking the England players in Paris exactly what I have asked at the beginning of a season of every team I have ever been involved with, that is, "What do you want to get out of this season?" And I will expect only one answer to that, "Enjoyment and satisfaction through success." Having heard that, and with players and coaches in complete harmony, we will each of us roll up our sleeves and seek to attain it.'

Leadership in business management and on the sportsfield had similarities, he said. 'The aim is to help make your personnel make THEMSELVES better at what they do. You don't do that by giving orders to jump through hoops. There are only odd and rare times when you have to put your foot down as a coach. To any team member in business or sport my watchword is "self-reliance". And with an international rugby selection of the very best, such as this one, you must never underestimate how very much about rugby these guys actually know. Anybody with decent experience in industry is fully aware that if you select a team to work on a production line, the idea is to train them to manage themselves and, once that is attained, you will see a noticeable gain in productivity. Same with sport – the crucial thing is INTERACTION.

'OK, the manager sets the pattern, for his coaches and his players. Then the pleasure for everyone is to explore every single option and to

'*No disrespect to French fans, Eddie Cripps is in charge of kit, travel etc. (He is also renowned for giving Dean Richards a black eye in training later in the season.) He is not a player.*' – JN

bring each player into the action. I believe in all-court rugby, involving every part of the field and every player, from both props to both wings. I believe our England side can achieve that – if not this year, then next, if not the year after that.

'While rugby is an endlessly fascinating game in its myriad aspects, of course the scoring of tries remains crucial. They are the whole reason, and you cannot expect to win consistently without scoring them consistently. That is what we seek to attain. A coach doesn't play a rugby match. The self-reliance is on the player. An international player is within a team but, equally, he's on his own for eighty minutes and must be wholly self-reliant in that time. A big match, like this one coming up, is an intense occasion and the scrutiny these young men are under, you know, will be intensely overbearing, both for what they do right and what they do wrong. So in the first place you select young men for the athletes and footballers they are, but most especially for their possession of the mental strength to reproduce their skills under pressure.'

Jack's philosophy. The air-hostesses begin to clear the tea-trays. He returned to his magazine. Of his players seated behind him, you could not (alas) expect them publicly to offer anything about their coach, who had in his gift – just like that, with one swipe of a Samurai's razor-sharp sword – their very existence in these fields of fame and their future dreams. They were not going to go public on their coach. Only the Bath and England veteran Graham Dawe, who played under Jack man and boy, offers an insight with his name to it, 'The thing with Jack is, and always has been, is that you never know which way he's going to jump. He always

'*They get their way: French screaming youngsters burst into the dressing room. Who are they after?*' – JN

keeps you guessing. He doesn't make you want to play for *him*, but for his team, OUR team. He was, still is, adored at Bath, although, mind you, one or two couldn't take it. He can lay off you for months, not a word, and then suddenly he lays it on and gives you terrible, awesome stick for a week; or vice versa, know what I mean?' I was getting the picture. FASTEN YOUR SEATBELTS. Rowell's grin gets wider. Paris. The Five-Nations starts here, in the most daunting colisseum of them all. Personally, so far I've found Jack a true-to-the-bone rugby lover and an absolute charmer, but without a clue about what makes him tick, or why the songs sing for him.

The bus edged slowly round the Périferique's rush-hour for a good, stuttering hour. Halfway to the hotel at Versailles, it passed a series of road signs for the Parc des Princes. If they saw them nobody mentioned it. The fact just brought their destiny that much nearer, and the company became even more silent. The physical priorities were: unloading, room allocation, supper and bed. The mental ones were far more complex and full of fret.

The hotel was glorious and deliciously apt for a band of visiting warriors. The team was housed in the swish annexe to the celebrated Trianon Palace Hotel, just across the parkland from the splendours of Versailles

itself. This was the hotel where, in May 1919, Georges Clemençeau and other Allied leaders presented the conditions of the Treaty of Versailles to the beaten German envoys and where, in 1944, the Generals Eisenhower, Patten and Montgomery first met after the Liberation of France. There would be history made from here of a far more trivial sort this Saturday – but history nevertheless.

 In the morning there was a training session in the stately shadow of Versailles. Training sessions take up much of an international player's life. They will not take up too much space in this book. We will take them as read. They are as bogglingly relentless as the *corps de ballet* at their backstage bars, *encores* over and over again, all aimed at the evening performance in full dress and lights. It'll be all right on the night. This is where Les Cusworth and Mike Slemen come into their own, the high priests of the mystique. Jack, most pontifical of all, of course, still looms large all right in his anorak and matelot's cap, but he is not a ranter or shouter out there. 'What goes on at each session varies each time,' he says. 'One may feel, like today, that the guys need a fairly short but stiff session just to remind them of the realities of what they will be facing tomorrow. Another day, later in the season, the Friday session might be very light and will

'Wandering around the hotel in Paris, I noticed a door ajar. I crept in to find Mike Catt asleep. I took a snap, which woke him up. He then started throwing whatever he could at me. I can't think why.' – JN

be no more than brushing up and gently rehearsing what we all know by heart. You can overtrain, you know, and you can under-perspire. It's a delicate balance.'

After jigging about, jogging and generally stretching with general muscle-nursing callisthenics in a group, the forwards might break away and strafe themselves all along the touchline, up and down, this way and that, perfecting their lineout calls, the hookers Regan and Dawe taking it in turns to throw in ball after ball of differing lengths – short ones, long ones, medium ones, sneaky ones, torpedo ones – preceded by in each case, and gauged on, the varying numerical calls the pack leader (in this case good big Ben Clarke) has nominated in tandem with the hookers and either of the scrum-halves, Dawson and Bracken. Up and down the line they went about their variety of dances inspired by such bunches of figures as, say, '4–3–1' or '7–5-4' or '6–2–8' and so on. They have different ones, or sometimes the same, as their separate clubs. Don't they ever get confused? 'Sometimes,' grins the affable Jason, 'but on the whole you just realise what team you're with and what the calls are and you at once click in and

'Les, keeping in touch with his skills.' – JN

are just switched on to auto-pilot so you realise exactly which is which and what they mean.' OK, translate these numerical conundrums? No way. That's the state secret. Nobody's telling. Spies! The back-row moves, 'called' between No.8 and the scrum-half are also utterly crucial ones. If an opposition back-row knew those off pat any team would be in big trouble. Same if your own side weren't word-perfectly versed in them. Especially if you've got an educated smartarse in there somewhere: once the famous Welsh team of the 1970s had a scrum-half call which meant that if he shouted any word plucked out of the air at random, as long as it began with a 'P', then the pack would go right; any word not beginning with 'P' and they'd go left. Of course, the onliest Gareth Edwards suddenly and chucklingly called 'psychology' – and six of the eight went left and the two university-educated forwards went studiously right!

At training, the six substitute replacements are like theatre managers. They are part of it, but not 'of' it, yet they are crucial, hardworking cogs at training. They play as 'opponents' and

'"*Hello there, sweetheart.*" *I think that was Jon Callard's greeting to Ben Clarke as he arrived at the salon. The lady cutting JC's hair was on the verge of calling a doctor. She thought we were all mad . . .*' – JN

'*. . . I think she was right! This man, Jon Sleightholme, was preparing for his first international. Maybe he was being brainwashed . . .*' – JN

markers, or field spare balls, or hold the tackle bags – bulbous six-foot padded plastic 'trunks' which are stood in serried ranks and regularly sandbagged with dervish dives and grunts.

At supper, having been to the daunting field of the morrow to sniff the flavours, every man-jack (coaches and faithful medics, too) were noticeably more uneasy, more slippered, more hushed, more singularly turned into their own souls. You could hear the scrape of fork or spoon on china. There were no wisecracks, no guffaws, no boys-will-be-boys on an outing. These boys had to be men tomorrow. Colin Herridge's bold notice pinned

on the back of the dining-room announced the captain wanted a word immediately after the meal and before bed.

It was almost time. Kick-off on the morrow was ticking inexorably nearer. Expectations were now fevered on both sides of the Channel and Paris was getting raucously noisy as the planes and trains decanted thousands of rugby men from high in the north and deep in the south. Nowhere was the utter tension more unbearable than among the French team, staying 'somewhere near Paris', and here in this small windowless England team room in Versailles. Twenty-one young men were in it, but it was almost excruciatingly pin-drop silent.

After a couple of minutes, this intense seance of quietude and concentration was broken by the captain when Carling, in the front row, said a few words and bent to insert a tape they had already watched in London in the video machine's 'letterbox'. The video ran about five or six minutes and was edited from the England XVs highlights of their last eight winning Five-Nations matches against France, home and away. There was a triumphantly clashing double-ZAP of raucous rock-music each time the screen was superimposed by a 'flown-in' caption giving each succeeding year and the score – 1989, 11–0; 1990, 26–7; 1991, 21–19; 1991, 19–10; 1992, 31–13; 1993, 16–15; 1994, 18–14; 1995, 31–10.

The tape finished with a crescendo showing a try of typically unstoppable and vibrant pace and power by Rory and the sound of Nigel Starmer-Smith's BBC commentary turned to full volume – '... that's magic! And surely this final glorious try has hammered down the nail in yet another French coffin!'

Carling switched off the video, and turned his chair to face his still utterly silent compatriots. They sat on their chairs in a variety of postures – some less sprawling, or more lounging, others as upright as the chair-backs, some leaning forward, arms folded and staring at their shoelaces. We had been in here for over ten minutes now, and still the only two sentences spoken had been by Carling and by the miracle of science, Starmer-Smith.

Carling was safe here, far away and protected not only from those wretched front pages, but also from the back. Now at last, he spoke. If his players had heard it before, they didn't show it as they sat like a tableau of statues, unmoving but tangibly spellbound as their captain addressed them in a tone of impressive, almost whispered, power. This is exactly what Carling said:

'It is important to remember how important it is what we do, how important we are in our scheme of things. It is crucial to realise how

special all this is, how lucky we are, how privileged. I remember going down to Hereford in '91, not long after the Gulf War. There were about eight of us who had gone down to visit the SAS boys, and we were, each one of us, in deep awe of them. Scenes of desert warfare passed through my mind and I remember saying to the soldiers, "God, you went through that! If I'd done that I'd be shitting myself, I'd have been blown out of my mind with fright." They looked at us, "Nonsense, it was just a job, nothing exceptional. But we'll tell you what, if we all had a dearest wish it would be like you lads – to walk out and represent our country at a major sport".'

'So there. That's why you guys here in this little room are very, very special. You've achieved it. You're playing for England, we're playing for England. Only you. Realise it. And our "bench boys", too. I realise it, that's for sure. I won my first cap here in Paris. At the time I thought it would be the only one. It wasn't, but it was so special. This match is special for all of us. We must be proud, proud of ourselves, and fight with pride. The Scots and the Welsh and the Irish do it – certainly the French do. They fight with pride for their country.

'But what about us English? What of us? Decent guys, yes, nice blokes. But why should we be "nice"? Too nice? We are. Our nature is to let people walk all over us. They tell me when I go to Scotland, "Carling, you're truly hated here!" If that's their context, then I hate them back. If they hate me, I hate them. Because I have pride. And I have most pride in what we've done as Englishmen this past five years. We've won three Grand Slams. The Scots haven't. Three. Not even the great Welsh teams of the seventies managed that.

'We've done that and much more, and we must not be shitting ourselves about a few crummy results in the past six months. We've done it – and we're ready to go in the next six months, aren't we? So join me in saying I'm proud as proud can be in playing for my country, and proud and determined with what the challenge offers me.

'Most of all things, I love being part of this squad of ours. I can't express how much it means to me, this challenge we have together. Newspapers say it's an individual thing, rugby. Bollocks! It's not. It's collective. It's a team, a group, it's the pride of brothers. This match we play for each other. That's it. Whatever happens, we are brothers in pride. We each have pride in getting this far together – and I'm proud not so much as to be captain but to be part of this squad of friends. When I come off this pitch in France, it will be you I look straight in the eye. Each one of you. And it will be a look of pride with

which we gaze strongly back at each other, and we'll be hugely proud of what we've achieved.

'But it will have taken a lot of care and awareness and commitment. We must take care of each other. We must not leave people on the ground. Never leave a colleague down. Look after each other, protect each other. It must be severe pressure on them, and disruption, but let us also remember that this thing we are going to do is also for enjoyment and for the fun of stuffing them. That's the great challenge we have – to physically and emotionally stuff the French. That would be enjoyment to the full. But we must get our challenges in, that's all I can say. Except that we are proud men of all rugby history, and this match is a statement about how we feel about each other. We must run on that pitch, look around, and say, "Yes, we are awesome. We have talent. We can play rugby all right. We carry each other, too. We know all about each other, and on this field, in this stadium in Paris, we are making a statement to the world about what we are".'

Carling turned away, dropped his head, and picked his nails in a beetle-brown study of meditation. This time the complete silence lasted easily two more minutes. Then the captain said softly, 'Let's watch the tape one more time.' He rewound it and then pushed 'PLAY'.

The beat was insistent, palpitating . . . Then they all filed out, in ones and twos and threes, still completely silent, like communicants leaving eight o'clock Sunday Mass.

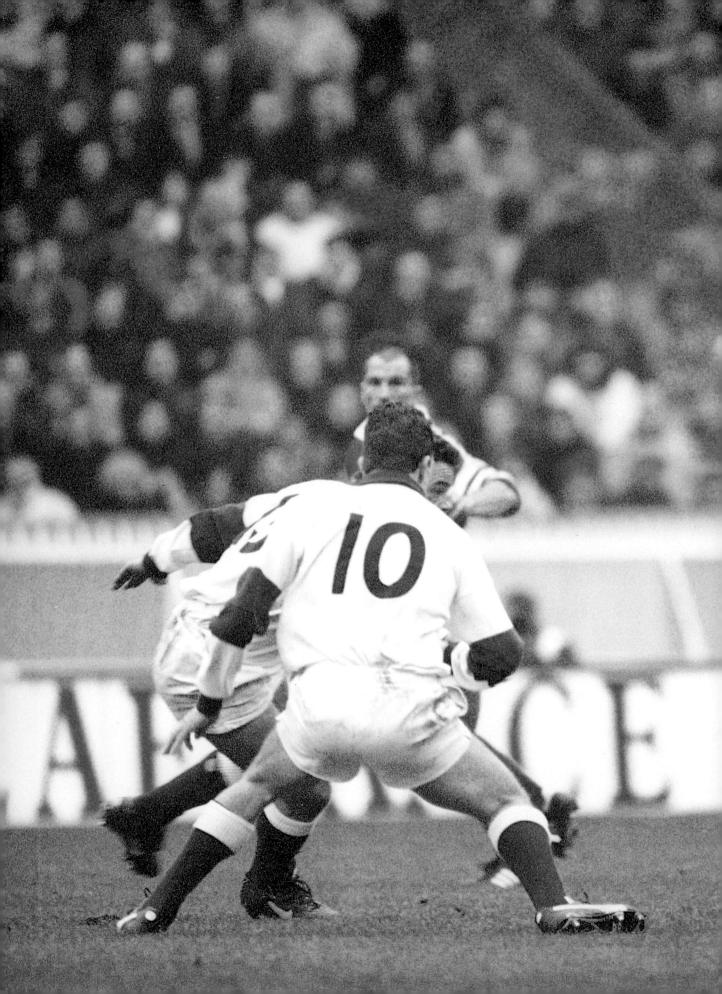

A Wing and a Prayer

The two coaches, Les Cusworth and Mike Slemen, had missed dinner at Versailles and taken a taxi to Paris to watch England's A team match against France A the night before. Les was first down on Saturday morning. He poured a cup of thin French tea and an orange juice from the long breakfast buffet table, and at once went next door to a smaller room, also marked with a stencilled ENGLAND TEAM fixed to the door with sellotape. In front of the twenty-odd upright mock-Louis XIV chairs, and the television, the gnomish little coach set up an easel, not a 'blackboard' so traditional to sports team coaches down the years, but a large bundle of 4ft-square white paper rollover sheets.

The French A squad, of course, were junior blood brothers and part of the general cadre of which the senior XV would play England's finest that afternoon. The philosophies of their strategy would be the same. England could learn something from last night's winning match by their 'Stiffs'.

Rapt in thought, Les took a sip of tea, uncorked his fat black marking-crayon, and began to write at the easel – in bold upper and lower case or full capitals, interspersed with ellipses, arrows, squiggles, and underlinings.

Next door, in their breakfast room, there were the first rumpled and muffled sounds of players tiptoeing nervously into their famous day. Someone had put a pile of London papers on a corner table. The *Sun*, a couple of *Mail*s and doorstop Saturday *Times*es and *Telegraph*s. Ben Clarke was quietly riffling through the heap to extract the sports pages. There was a portrait in *The Times* of Martin Johnson. An earlier bird had already defaced the mouth with a felt-tip pen and writing 'F . . . off, fat lips'. Meanwhile, Steve Ojomoh, having crushed six Weetabix into a large soup plate, was holding a jug bearing the sellotaped label 'Fresh skimmed milk' and attempting to get a waiter to understand that he'd prefer 'Full cream milk'. Alongside him and having shrivelled French bacon and mushrooms on his plate, Graham Dawe stared at the silver tureen in front of him containing a sorry mush of scrambled egg, pulled a face, and said to no one in particular, 'That can't be real scrambled egg; who knows what 'poached eggs' is in French?' He went without eggs.

In less than six hours, these young Englishmen would be 'going over the top' in France. Now they knew it all right.

They were ready. The bus would leave on its date with destiny at one o'clock. A journey into the unknown for more than half of this company, for five of them had not even played a Championship game before, and eight had not played an international at the perilous Parc. By 12.30 they were changed, spruce in their dark blue blazers (a tiny red rose at the breast pocket), grey flannels, polished black shoes. There were French-roll sandwiches on offer in the team dining-room, but not many fully committed takers; a few nibbled; some downed glasses of orange juice, or skimmed milk, or sucked at the ubiquitous Lucozade. A number had second cups of coffee – Don Rutherford said there was strong evidence that coffee an hour or two before a game mobilised fats and so prolonged the muscle glycogen store, which would be advantageous to second-half performance. Some carried their coffees into the next-door team room, and the door was closed on another silence. Now they sat bolt upright.

Rowell stood, faced them, and spoke softly, short sentences with pointedly effective pauses between each, and almost in a whisper: 'A final gathering, fellows, just to collect ourselves. Practice has gone extremely well,

exceptional. The old French RU liaison man says he's been looking after England teams in Paris since 1968, and has never seen sharper, more committed, practice. But so did training look brilliant before Western Samoa. But that's behind us now. Let's take all our good work onto the pitch this time. We can do the basics utterly well, if we do so this afternoon you have got a truly big game inside you. Honestly you have. Take it from me. Backs – don't hang off the ball. Forwards – run, attack the ball, and use it. I fancy the scrummaging-machine makes you feel too comfortable – hit them ten times harder than that this afternoon. Concentrate on what's up French sleeves – like their 8, 9, 15 and 14 trying that blindside move, it's utterly crucial to be aware of their blindside.

Jon Sleightholme, we scoured the country to find a man to play for England on the wing. Just think of all the men we had to choose from, some truly superb wing operators. But we chose you. Only you. Don't forget that today for a second.

I go on and on about it, I know, but in the loose, realignment is absolutely critical – realignment. Just don't give them space, else its their game. Pressure is tackling, tackling is pressure. The great thing is to impose our pressure game; once that's established, they panic and crack. If we aren't in it together, then we're nowhere. Streetwise, be streetwise, be spot on. We've been too fresh in the dressing-room after our last two matches, too fresh – you've got to give it all today, and there's more to give in you, much more to give. Jason Leonard, Bayf, Johnno, Ben Clarke, Rory, Jerry, Will, all you multi-capped – and multi-successfully capped I might add – we need even more of an extra edge, an extra impetus, to your game today. These young men are looking up to you. Where you go today, the younger, less experienced men will follow, you see. Extend yourselves, and take them with you. Right, good luck.'

Rowell sat down. Utter silence for some thirty seconds. Carling leaned forward and slotted in the video compilation of the night before, ending with 1994's victorious side in Paris, greased-up, jaws clenched, taking the field from the start. The beat of the music died. The silence remained deafening. Another minute of monastic contemplation. Then Carling stood and looked across at Sleightholme. 'Slights, I won my first cap in Paris. Have a great one. It's just like any other game. But at the same time it's very, very different. Enjoy it. Never forget, we're each of us right behind you. We're all together in this, right? OK, let's go.'

They filed out, still silent, their new regulation black shoes clinking

across the marble foyer. They crocodiled outside and straight into the bus looking neither to the left nor to the right.

The pronunciation is as 'slight' not 'slate'. Jon Sleightholme is, however, anything but slight. An inch under 6ft, he is a powerful coil-shouldered fourteen-stoner and he looks a runner all right and you could imagine that barndoor upper body lining up for a heat in the Olympic 100 metres. He has an open, candid four-square face which frames a defiant kestrel's beak and bright aware eyes to match. His ready smile and witty chortle are under wraps today. He is on the right-wing for England and this, totally out of the blue, is his first cap; Rory is on the left-wing and it is Underwood's 82nd. Even around the baggage and customs area at Charles de Gaulle airport, Underwood wheeled his trolley touchingly alongside Sleightholme. Now the almost veteran record-breaker motioned his pale younger charge onto the bus and, inside, into a window-seat halfway down the aisle – as four French police outriders on motor-cycles, lights already strobing fiercely and klaxons winding up, revved their machines with increasingly impatient off-spinner's twists of their black-gloved wrists. And then, at a sudden mutual nod of command and a liberating, scrunching, bucking back-wheel 'wheelie' each on the hotel-drive's gravel, they were off – and the bus followed, taking Jon Sleightholme to a different world and, in a way, a new life:

'Rory has been truly brilliant about what's happening and what to expect. It's almost impossible to believe that Rory scored his first try for England here in Paris, a brilliant solo effort from broken play apparently, all of a dozen years ago when I wasn't even twelve and my new school, Whitgift in Grimsby, wasn't even a rugby-playing school. Rory's been drumming into me all week to use the so-called venomous atmosphere of the Parc des Princes to my own advantage. "Drink it all in, revel in it, and let it gee you up," he says. That's what I intend to do.

'My major priority this past ten days has been getting off the ceiling – you know, Cloud Nine and all that – since that lunchtime I came home and my girlfriend, Julie, was jumping up and down shouting how I'd been chosen for England. "Oh, great, brilliant, I'm in the A team," I said. "No", she said, "the First team, you're playing against France in Paris!" I was gobsmacked. That's still less than two weeks ago. I'd even been uncertain of, and in and out of, Bath's first team, what with competition from such superb wingers as Simon [Geoghegan], Adedayo [Adebeyo], and Audley [Lumsden]. But Bath have done wonders for my game and my determination. Although I was still on air when I arrived for training, especially that first day when

all I seemed to do was shake hands with the guys congratulating me for being picked in the first place. But then Will and Jack separately took me aside and settled me down and talked seriously and frankly and at once I realised I had been picked for a special and specific reason, and for a purpose that was personal to my particular game. I know I've got power and pace, and I'm working like mad on my concentration and my power-defence in the tackle and my all-round support work. Brian Ashton [the Bath coach] especially and the props Kevin and John [Yates and Mallett] in the weights-rooms have done wonders for me.

'Will insisted forcefully that I hadn't joined England to make up the numbers and just sort-of to be eased into a first international outing. That's exactly what I needed to hear. He was really strong about telling me I was in because of my pace and because of who I was in the here-and-now. Will said he was expecting me to perform, no two ways about it. That heart-to-heart from him at once determined me trebly and made my sense of belonging in the squad very real and tangible. Being with the Bath guys has also helped enormously, but when Rory took me under his wing and began feeding me information and painting me pictures of what to expect and, particularly, what was expected of me, everything started to get focused and I cannot tell you the hunger I felt, the need to get on with it, and by the time we were on the plane I was overcome with almost a desperation for it all to begin and for the referee to blow the whistle.

'But I admit I woke exceedingly nervous this morning. I suppose I'd slept sort-of OK. I opened my eyes and was suddenly very frightened for myself. It was not a good feeling – very negative. I lay there, and had to work really hard to force some positive images into my mind. It was hard work. I was not pleased with myself. I tried to visualise, to "play", the first few minutes of the match, me getting involved, me being everywhere in the thick of it. I was still very nervous. I did not enjoy breakfast. I pretended to read the papers. How can you take in anything when your mind is either a blank or a swirl of emotions? I knew the most important thing was to keep cool and calm. I knew I had to shut out anything negative.

'Will's speech last night plugged into me. I tried to re-live the emotions I felt. Jack's this morning before we got on the bus as well. It was superb of them to single me out. Mid-morning I went and re-read Les's notes from the A match. Drummed the stuff into my mind. I began feeling much better. I knew, however, that it was crucial for me not to be rehearsing the game in my mind too early. It was right to be

focused, but not to the extent of wasting up mental and physical energy wondering and worrying about the exact scenario. It was a very delicate thing, and now we're on the bus, I think I might have timed it pretty well after all. At least I hope I have. People underestimate this mental approach towards pressure and tension. I am going to work on it with myself much more in the future. Basically, what is going to happen this afternoon is that there are thirty of us, fifteen each side, trained up and honed to be physically equal, man for man and marker for marker. But it is in the mind, the mentality, the psyche, which is going to find out each one of us, test us to the limit, scrutinise us. Physically, I'm feeling tremendous – I must now be ready for the mental test . . .

'This has to be the most special occasion so far in my life. It is so thrilling, and I don't think just for me, the first-timer, but for all of us, the whole team: just look at Rory, and Will across there, they've made lots of trips over here to play, and Les and Slem up front, but they can't help be deeply moved and inspired, surely? If this is it, I want it, I adore it. I'm determined to play a game today which shows how more, much more, I want. I can't have enough. I've got the bug. I want more.'

The bus had now clipped the southern rim of the Bois de Boulogne and, once past the evocative Roland Garros tennis courts of summertime, the traffic became thicker, the white-knuckled journey less of a pelt behind the daredevil outriders on their motor-cycles. They edged us through and

'Arriving at the ground. It was so nice to see some friendly people.' – JN

across the wide six-way intersection which makes up the square in front of the stadium, two of the wide pavements in front of bars now crammed with a jostle of hundreds of what seemed predominantly English supporters, probably no end of them without tickets, who had travelled over in the hope of a cheap last-minute buy from a scalper or, simply, just for the crack and a weekend 'with England' in Paris. The motor-cycle klaxons announced the England bus, and the uplifted greetings and God Speed – plus no end of cheerfully derisive Gallic thumbs-down for good measure – palpably seemed to delight and warm the still-silent band in the bus. Generations of English international rugby players had exactly experienced this journey, prefaced by its solemnly cloistered and quarantined team meeting. But how many 'outsiders'? Why should they have? Perhaps no outsider at all, ever. Till now. Jon Nicholson and I were privileged.

The motor-cyclists took their leave with a wave as they handed us through the police barrier and on round the half-circle of the stadium's empty inner-road. It aimed for a deep narrow tunnel, pulling up with a dramatic whoosh of brakes less than a foot from its too-narrow entrance. The driver shrugged in expansive disgust as only Frenchmen can, stood up, and through each of his side-windows simply removed in one piece the two great Prince Charles-ears wide wing mirrors, brought them back in and slung them on the front seat next to Jack Rowell.

'Ze mirrorz,' he grunted, by way of explanation.

'No worries, you never needed them, you didn't use them once,' said Jack, sotto. They were the only two sentences which had been spoken in the thirty-five minutes since Versailles when Carling had said, 'OK, let's go.'

Given six inches on each side, the bus could now snake down the tunnel into the dark, damp, concrete bowels of the stadium. A practised routine, still in overbearing almost sombre quietude, now took over. The management were first off the bus. Then the medics, Kevin, Terry and Richard, at once efficiently attacked the luggage boot for their great tin boxes of MASH-style field-hospital equipment. Then the six faithful replacements were off, workaday squires to the fifteen knights, to help unload the rest of the clobber. The fifteen carried only their one personal kitbag and they filed off, one by one, and made their way down the corridor into the dressing-room.

It was likely to be the last time the England team changed in this small, cramped, paint-peeling, windowless dungeon. By 1998, France would be playing their rugby at a new all-purpose national stadium being built for the soccer World Cup north of the city. The medics had a tiny annexe room in which to lay out their bits-'n-bobs, alongside the loo with three

stand-up pans and two cubicles. Twenty-one players was a crowd in the 'main' dressing-room. At the far end there was one deep communal bath. Along the way, across the tunnel entrance, the home dressing-room was three times as spacious.

The fresh new white shirts were unpacked and Don Rutherford helped the replacements, Dean Richards and Graham Dawe, to hang them – 1 to 15 – on the hooks above the narrow bench which rimmed the room. Inside the door had been left a pile of programmes and some half-dozen copies of the French sportspaper *L'Equipe*. It's banner headline shrieked '*Huit Ans – Ça Suffit*' (Eight years without a French victory – that's enough). The first thing Martin Bayfield did was to borrow Kevin's scissors and cut off his

'*This is the last view of this stadium (Parc des Princes). But I was amazed at the size of the changing room. Small was not the word. Poor old Will having a massage in the shower.*' – JN

long sleeves at mid-bicep. Less chance for the opposition to grab you at lineout or scrummage. In no time he was stripped and ready for Murphy's soothing massage. Bayfield did not go for the routine pitch-walk with all the others, still in their civvies. Jeremy Guscott changed first into his boots, stamped them on the floor and then against the wall so they were a snug fit, just so, then he, too, took in the flavours of the field. The din was already brewing. By the time they had been back to change and then returned to the pitch, in their ones and twos and threes, for a more seriously strenuous warm-up, the noise too had warmed up distinctly. Matt Dawson ran out with Jon Sleightholme. 'As soon as you are out of the tunnel, you collide with the intensity of the atmosphere. Bang! Just as I was hoping. Jon and I threw a ball about, practised hoisting kicks and him chasing. The boos and catcalls were violent – but equally uplifting. I looked across at Jon. He was smiling, revelling in it. He was going to be OK. "Use it to gee-up ourselves, to inspire us", was the general feeling as we swopped grins.'

Dawson, with one whole Twickenham cap behind him, could afford the confidence of experience. Sleightholme was not too sure about it to begin with: 'The utter confusion, noise, colour, all the possible distractions, hit me slap in the face as soon as I got out. This was going to be very difficult, I thought, not healthy or welcoming at all. The atmosphere was so electrically volatile and palpably anti-English. It was scary.

'Then I remembered Rory – "use it all to your own ends, plug into it and enjoy it." Dawse and I threw up a few balls for me to chase. I was feeling much better. It was all suddenly helping to spur me on. They booed me, but I was finding it not only highly amusing now, but actually inspiring. Rather than having its desired effect of "blanking" me out, putting me on a "downer", this crowd was suddenly switching me on, charging me with a marvellously concentrated "up".

Carling's voice was crisp, in a way even coldly businesslike. 'Three minutes to anthems. Jon, in here, please; we're ready.' Sleightholme prised himself to his feet and clambered from the bath, where he'd gone for a final meditation. 'Right, gather round,' ordered Carling. The replacements had already gone to their grandstand stations. So had the management and coaches, and the medics were on their touchline bench, awaiting the warriors, the gladiators.

Time enough, simply, for the fifteen to gather in one huge embrace, a wigwam of bowed heads, bristled and greased chins; twined arms tentacled around each other to make for one huge animate, concentrated, grunting tent round their captain. Carling said with a soft intensity, growling with defiance. 'We know what to do. We are ready, aren't we? We are going to come back here proud of what we've done, what we've achieved,

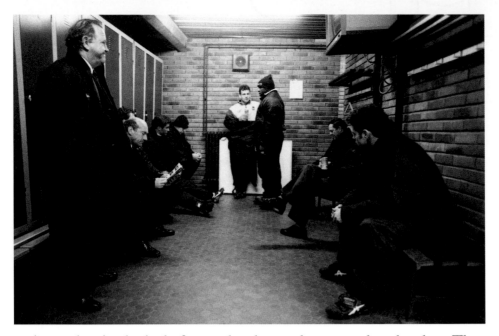

'*Here we were with the Bench and Management, next door from the team, who are going through the final stage of preparation. I walked away from this into the corridor and could hear the French team through the wall. Their emotions were running high. I wondered about what might happen . . .*' – JN

(*Right, top*) Carling had told them: 'Take care of each other. Never leave a colleague down. protect each other.'

(*Right, bottom*) The flankers Dallaglio and Ojomoh regroup as Grayson is collared and turned.

and proud we've looked after each other and protected each other. They think we're soft. Give them another thing coming. Let's show them they're the soft ones; not us; we're not soft. Are we ready for them?' Deep, gritted, clenched-teeth, unintelligible murmuring snorts assenting 'yes', 'you bet', 'let's get at them' sort-of ululating self-approbation. 'Are we ready?' repeated Carling, more loudly. The collective replies this time, too, were louder, more bellowed, more menacingly full of intent. The fifteen-man bear-hug stayed in place. The growling bays became sharper, more fierce. 'Are we ready?' 'We're ready', was the tenor of the final collective caterwaul. 'Right, let's go.' They peeled off, one by one, and followed their captain out to the clamorous field.

Sleightholme recalls that for all his morning turmoils, in the end 'by good luck or otherwise' he had paced his build-up exactly. 'Someone said last night at the hotel, a sort-of joke but I took it in, "The thing with playing in Paris is not to worry about the sixty thousand crowd when you run out, just think of the twenty million back home watching on telly and rooting for you." At once we had to get in line for the anthems, and I was now on a new level of "high". The band struck up and I was singing like I've never sung before, letting rip not only for my country and myself and these fourteen boys alongside – but all of sudden very much for my mum, just my beloved mum. My clenched fist went to my breast to sort-of reinforce my allegiances. I'd never remotely realised how singing God Save Our Gracious Queen would signal the very proudest moment of my life, I've never been like that, you know, emotional, but here I was expressing that feeling to the very depths. It was awesome.

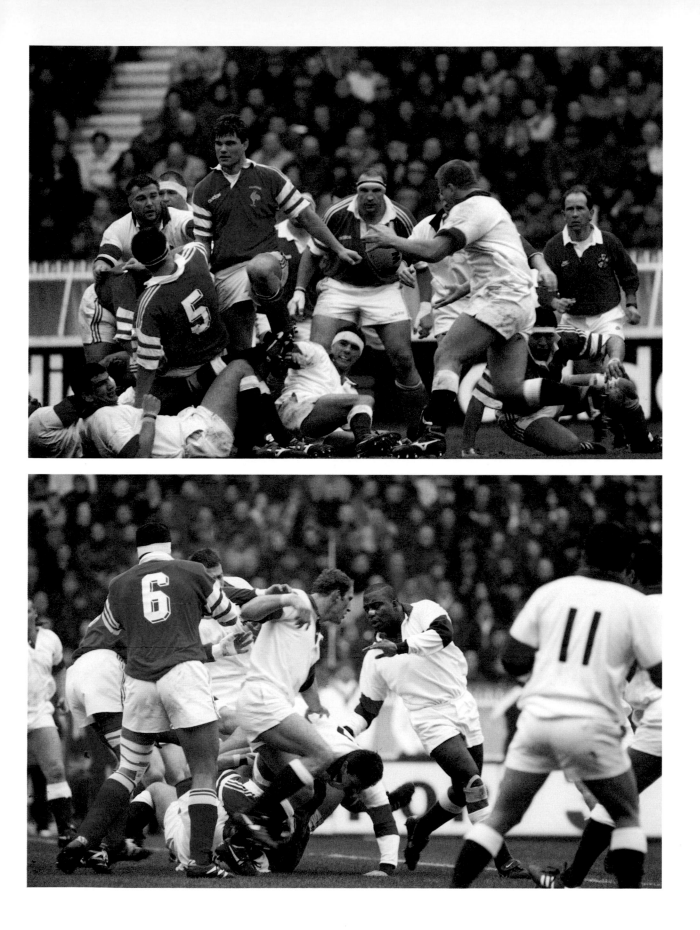

'Then it began. There was a split-second moment of calm, of placid stillness. Scarcely time to take one deep breath. Then all hell broke loose. I just had to make my presence felt. Would the ball come near me first? Or Saint-André? Or Sadourny? It was the latter.

'We had planned to bomb them early in the "box". Within seconds, from the very first engagement by the packs, Matt slung up this towering, stone-dropping beauty high along my touchline. Saint-André and Sadourny both circled below it. I kept my eye on it and took off like there was no tomorrow. Sadourny called for, and caught it well, but he was only half a strike into running back to us when I hit him and pinned him and trussed him and turned him.

'Brilliant. The lads swarmed all over us, rucked back the ball, and I looked up just to see Paul Grayson sling a quick, long midfield ball to Jerry – and then Mike Catt from the back took it at speed with Rory outside him. Mike could have passed, but probably did the best thing and chipped a long low ball perfectly and just inside the cornerflag. Rory pinned his ears back and went for it and with their wing Ntamack all of a dither, Rory failed by a fingernail to "ground" it, or so the referee said. No score, but there could only have been millimetres in it, and certainly first blood to us.

'We had the French totally under the cosh. The release of our pent-up energy, and the excitement of being part of it, was utterly thrilling. From Rory's touchline, from a set-scrum, the French tried a three-quarter movement, orthodox with one miss-pass. Perhaps I was lying slightly flat and Saint-André certainly thought he had space to get round me and he went for it. But I shepherded him, like a sheepdog into the pen, and exultantly sandbagged him into touch. Only minutes had gone. I was involved. I was doing my bit.

'Saint-André tried again. I nailed him again. Apparently the French affectionately call him "*le goret*", the little truffle pig who snouts around and can root out the most unconsidered opportunity, and, sure, he's low-slung and elusive and has certainly scored a bag of tries which never looked to be "on" in the first place. Who says my defence is my weakest thing? I hope they're watching this at Bath. Next time it's Sadourny at me. I not only scrag him in his tracks – but then actually steal the ball and run back at them into a glorious bit of daylight. I veered inside the centre's tackle, dipped my left hip and shrugged off Benazzi's grab, then carried on at pace straight into Ntamack, turned and fed Ben, who galloped on, set up a ruck and, at speed, Matt, Paul, Lawrence, give it to Will at full-pelt. He could have carried on leftwards, but straightened – and then brilliantly cut back inside to wrong-foot the French cover. Rory had spotted it and was at Will's elbow

Grayson keeps England in the hunt: 'Nothing matters but the bar, the ball, your boot – and the prayer that practice has made perfect.'

for the pass. He was nabbed a millimetre away from giving Catty the certain score.'

The fact is that those two chances, both involving Sleightholme's determination to be early in the action, were the only two clear-cut open-field opportunities England manufactured for the next seventy-five minutes. With France not even managing that many, as a spectacle the game had died almost at birth. It became, with the tension and importance suddenly realised by both sides, an 'after you, Claude' contest between the two kickers, Grayson and Thierry Lacroix. Once the close-quartered war of attrition had been declared by the French forwards, desperate for any sort of win against the English, the less experienced visitors at least responded with manliness and guts. It was a heck of a battle all right but, for spectators, not a pretty sight.

Had just one of those two early chances been taken, the script might have been so different. Catt pondered whether he should have put in that almost perfect grubber: 'It's all too easy to be retrospective about a split-second of instinct. But on second thoughts, yes, I think I should have kept the ball in hand, made another yard, and organised a pass to Rory so he could have seen if he had the legs of Ntamack. But these options are instinctive - and the kick nearly worked, it was only half an inch from a try, and any other day you'd have been saying "Great decision to kick because it led to a score".' Underwood said, 'Certainly I got my hand on the ball, but the ref said "no try", so it was no try, simple as that.' I asked if the referee's decision had annoyed him – and before he could answer, five teammates in earshot and in unison chorused, 'Rory, annoyed? Rory's never been annoyed about anything in his life.'

For the second opportunity, after Carling had lanced back inside and fed Underwood, the winger said a Frenchman had made contact in the act of passing, so the ball had been misdirected to Catt too low and towards his knees. Said Catt, 'So Rory had to slam-bang it down to me as he passed; a split-second earlier and it would have been a try; but that's the way it goes. And I reckon at full-back I learned more and more as the game went on and the French started "bombing" me. Normally I reckon I'm pretty good under the high ball, but the referee wasn't penalising

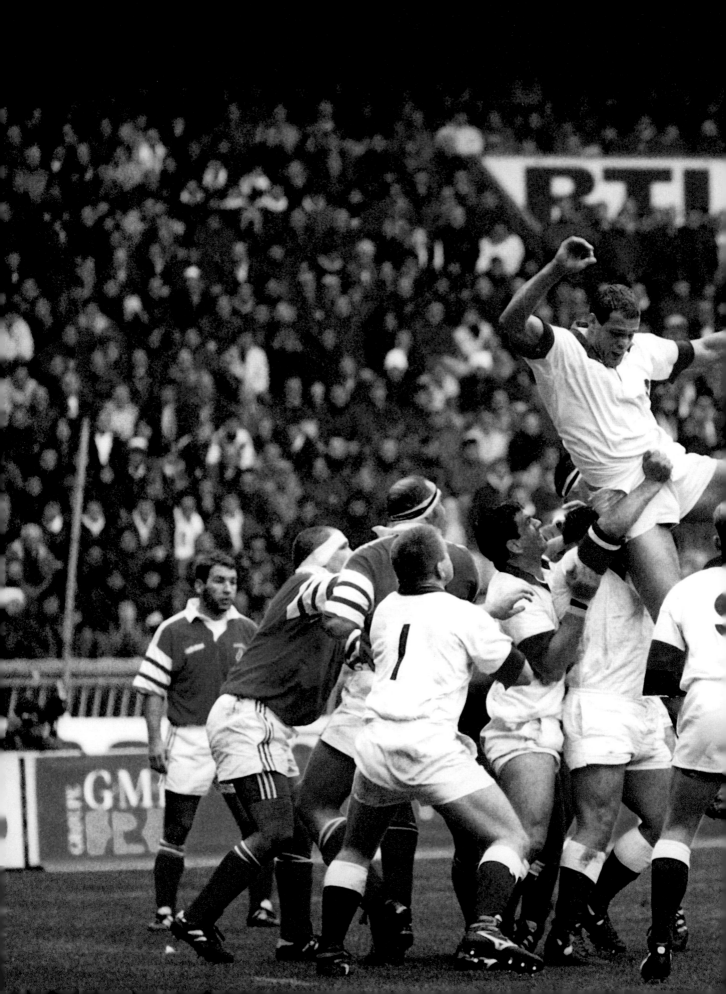

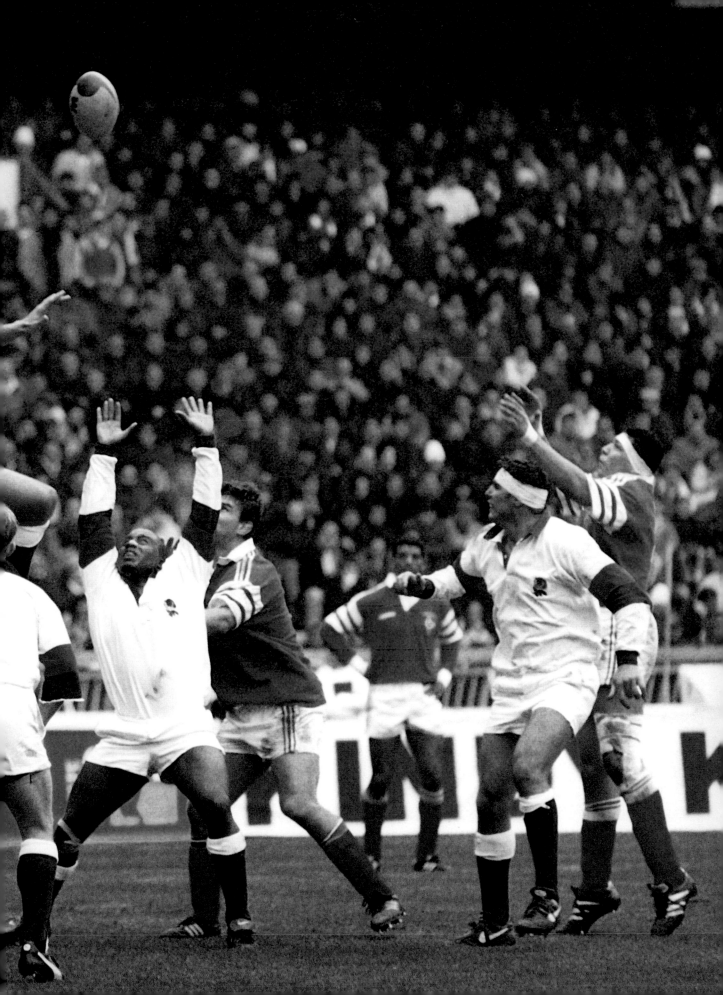

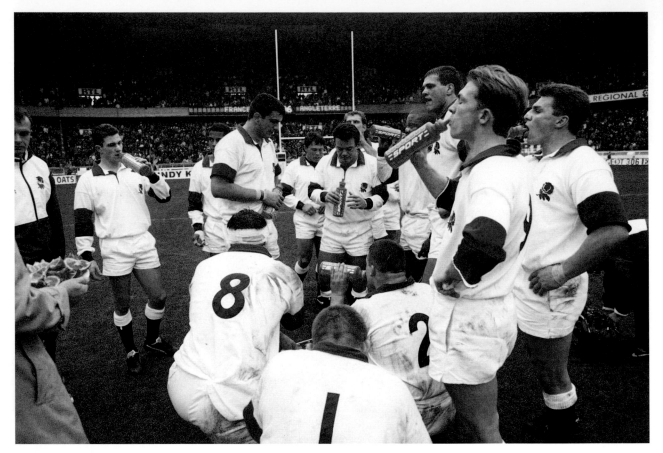

them for blocking so I just had to get up there and accept the punishment like a man, eh?' His bruises were testament to that.

In helping set up the second missed chance after Sleightholme's spurt through the cover, Ben Clarke had been kicked in the head by the young French centre, Richard Dourthe (he was later banned for two internationals), and had to leave the field for Terry Crystal to turban him in a swathe of bandages. Clarke was replaced for five minutes by Dean Richards and suddenly the lilting hymn DEAN-OH! DEAN-OH! rolled round the stadium as proof not only to the continuing affection in which the ageing Leicester warhorse was still held but of the vast numbers of English supporters who had made the trip.

Thereafter, apart from a generally doughty display from England in the deep recesses, they only had Grayson's cleanly struck kicking to cheer. England led 6–3 at half-time. Just after the hour, a drop-goal levelled the scores at sixty-five minutes and then, ten minutes later, Lacroix goaled from the halfway line after an infringement when Clarke had fed Ojomoh, going left, in what looked a duff back-row call.

Steve Ojomoh: 'I've played eleven internationals now, but I cannot remember one you've tried so utterly hard in as this one, but where the

*'I was sitting in a tracksuit on the medical bench, taking my pictures of the match, when the whistle blew for half-time. Someone shouted, "Get those bottles and follow me!" I was on. I ran up to the England players on the pitch, dropped the drinks and started taking pictures. Paul Grayson turned and in his best English asked, "What the **** are you doing here?"*

Looking around, it was amazing – it's very imposing.'
– JN

ball never bounces your way. The end was very upsetting. I'll wake up dreaming about it for a long, long time. On halfway with just a few minutes left, I expected we'd just play conservative. Ben called something, but there was such a din I only caught the last couple of words. I didn't understand, and I doubt if the rest of the pack did either, except Ben and Matt at scrum-half. Back it comes on my side, I had to pick up and drive left. But they pushed me wider, cornered me all on my own, and dumped me. Penalty – and they're back in it. I cannot remember before when the crowd noise means you miss a call. Ten days or so later, Jack walks into my room in the Petersham and says I'm out. I was very very pissed off, to say the least. I reckoned I was the scapegoat and I brooded. Then I suppose you look in the bathroom mirror, take it on the chin, and resolve to come back stronger.'

With only two minutes remaining, another cool, crisp, and towering forty-metres drop from Grayson tied the scores again at 12–12. A draw would have been fair. But with the very last kick of the game, France's twenty-year-old centre Thomas Castaignede nervelessly aimed a pot-shot drop which just had the legs to clear the bar. France had won by 15–12 fifty-four seconds into injury time.

Ben to the 'blood bin'. 'I didn't see who kicked me; you don't in those circumstances, but I hope it was an accident.'

Literally, inches in it. Underwood had been an inch from grounding the ball in the first minute – in the last, as Castaignede's drop left his boot, Grayson hurled himself at it, arms outstretched, for a charge-down. 'I felt the "wind" of the ball rush through my fingers,' said Grayson; 'a milli-second and a fraction of an inch more and I would definitely have charged it down.'

In the dressing-room, nobody spoke for fully eight minutes. The replacements, tiptoeing almost, silently handed round the Lucozade. Crystal stitched Clarke's head wound. Murphy strapped knees and feet. In the first half, England had twenty-four minutes of possession to France's sixteen; in the second, France had twenty-six to England's four-teen. That was about the sum of it – as Carling said, 'In the end we just didn't spend enough time in their half. But I'm proud, proud of everyone, especially the younger guys. We've learned an awful lot to build on.'

The first question at the press de-briefing had Rowell's cockles up. 'Jack, a defeat at last in Paris; you're going to get some media flak, aren't you?'

'I just don't understand you people. You've just seen a new young Eng-land team beaten in the very last seconds after utterly throwing every ounce of their brave hearts and souls into it, and you say they deserve some flak. Well, I won't be reading it or listening to it and, I hope, nor will they.'

The wives and girlfriends join the players for the journey to the Paris Hilton, almost under the Eiffel Tower. Jon Sleightholme sat in the bus with Julie. His bold square face had a radiance: 'I did as much as I could. After that beginning, I'd have loved another run with the ball, but all the chances had dried up. But I never lost concentration. We were beaten so dramatically that I'm left with a huge swirl of mixed emotions – wonderful personal ones, like the drive to the ground, the electric atmosphere, my not cocking it up and getting in my tackles – and then the collective grief of defeat, and knowing how it really hurts and how it so affected the boys with disappointment that I never knew a dressing-room could be so shat-tered, so silent, so utterly shell-shocked.'

As the bus aimed *centre ville* the mood, almost at a stroke, perceptibly changed. Sleightholme, as the day's new international cap, had a long-held England XV tradition to fulfil. A busload of matey catcalls insisted he stand up and move down the corridor to the front, take the tourist-courier's microphone and render a song to his new teammates. Elvis Sleightholme stood up and crooned, eyes closed and, passionately, out of tune:

'Today is gonna be the day
They're gonna throw it back to you
By now you shoulda realised what you gotta do
Back here the word is on the street
That the fire in your heart is out'

As they say in *Hansard*, 'Applause, applause, jeers, jeers . . .' Sleightholme, unembarrassed and content as Larry, resumed his seat alongside Julie. One row behind him, I could hear first Jeremy and then Jayne Guscott talking on their mobile telephone to one of their young daughters, Imogen, back home . . . 'Hello, darling, are you being a good girl for Granny, then?'

A dramatic defeat by a whisker in Paris. But real life goes on.

Behind the Scenes . . .
'*I felt this was a tough time
for England: media
pressure about playing in
France was mounting. Here
at Twickenham before
leaving for France everyone
was very sombre.*'
– JN

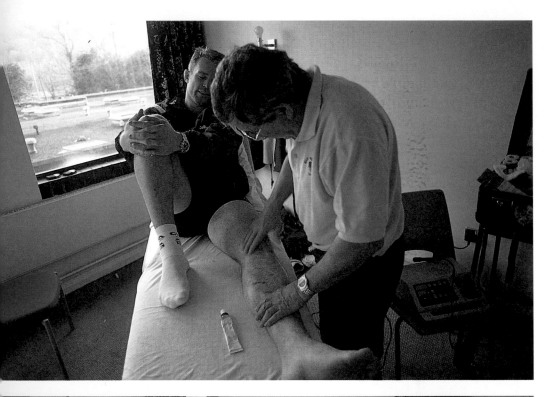

(Top left) '*Tim's injuries had come from a club match before England met for a training weekend. He must have felt awful not coming to France.*' – JN

(Bottom left) '*This was a worrying time for Jack. They needed Ben clarke in France. Ben was doubtful until the last moment.*' – JN

(Top right) '*Arriving at the first training session in France, on show to the French media, I felt it was affecting all concerned. They looked very pensive.*' – JN

(Bottom right) '*While getting over the size of the changing rooms at Parc des Princes, I found Jon Sleightholme at the bottom of the bath, stretching and getting himself together.*' – JN

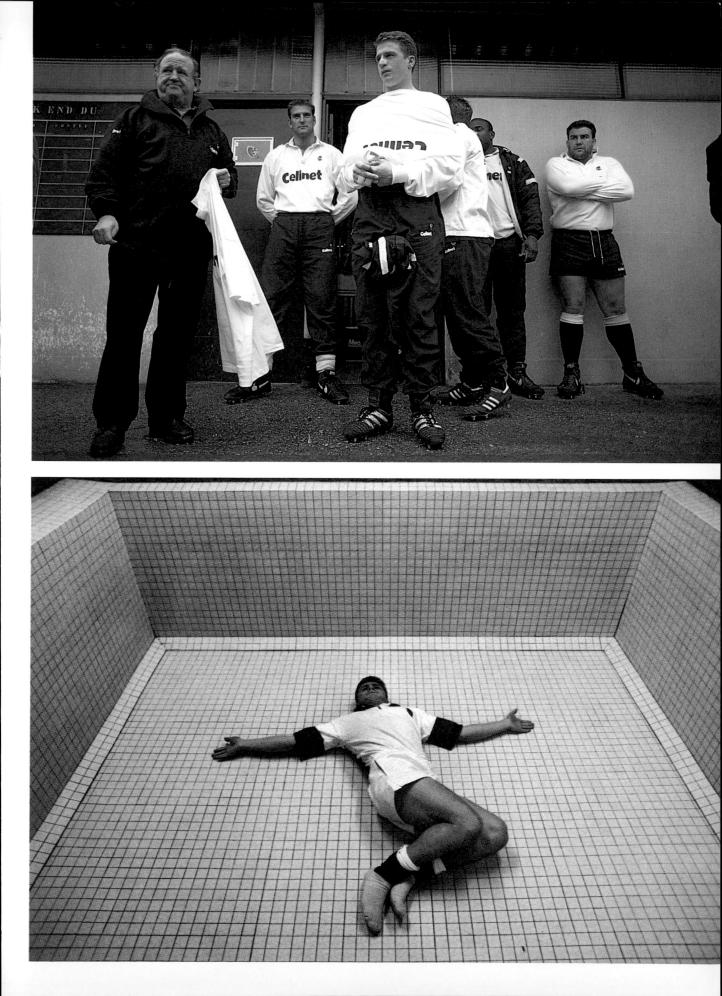

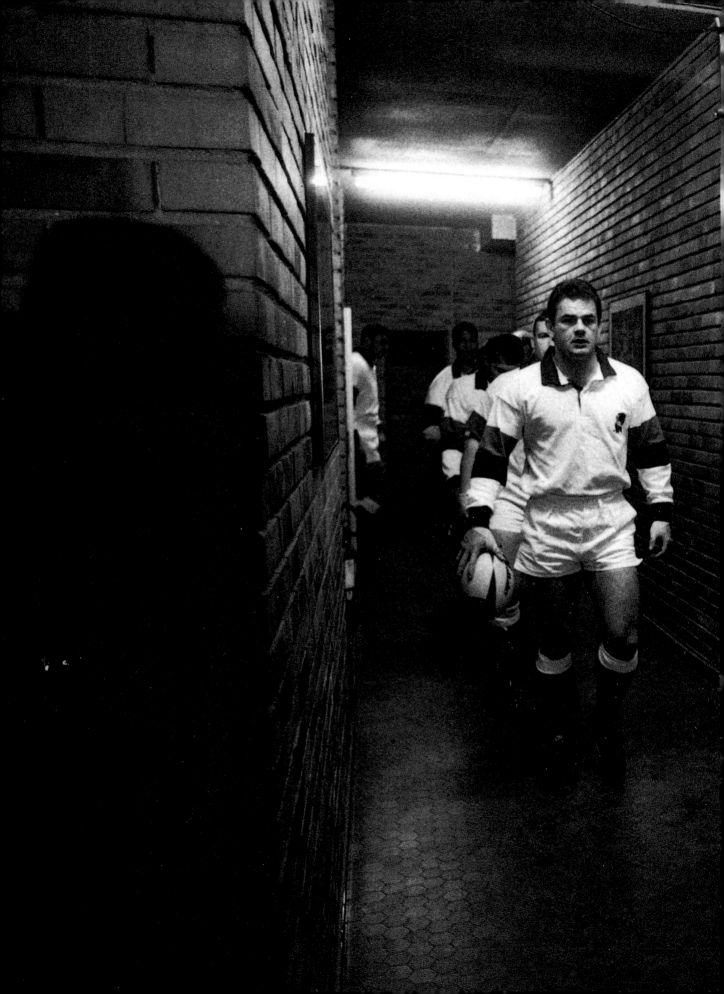

'We're off: Will leads his men out of the dressing room. I can't remember any other sounds (although the shouting of the fans was deafening). I was stupid enough to think that maybe one of them might look at me or say something. Out they went.' – JN

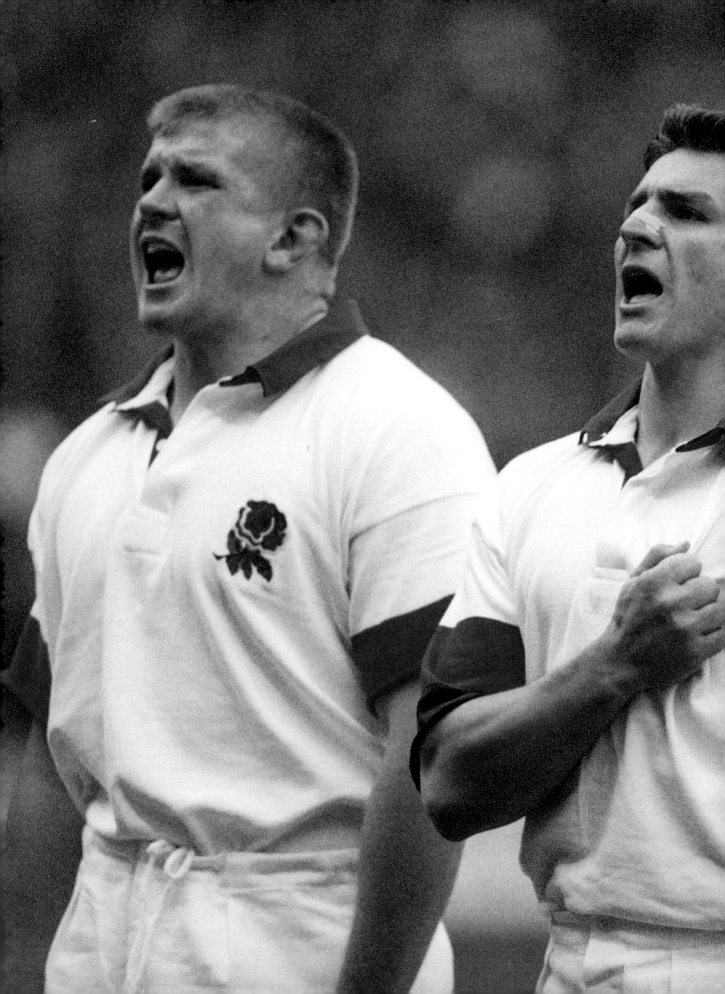

On the Bench

Dean Richards was retained on the replacements' bench a fortnight later when Tim Rodber, fit again, returned to the back-row in place of poor, smashing Steve Ojomoh, slung out of the squad altogether. From across Offa's Dyke, England were threatened at Twickenham with no end of sabre-rattling by yet another remodelled, fire-breathing Welsh XV, boasting of a return to their rugby resplendence of two decades before. We would see. The dragons' so fury signified nothing to Rod whose cruelly scathing English officer narrow-eyed disdain set the tone of the team meeting the night before the match after supper at the Petersham.

Seeing the England soldier, Tim, had missed the gallant French campaign, it was possible that, now back at home, his trenchant soliloquy about Welsh rugby players just wanted to summon up the spirit of the French nobles as they discussed Henry's supposedly ragged lot before Agincourt – you remember, 'Foolish curs, that run winking into the mouth of a Russian bear', or 'There is not work enough for all our hands, Scarce blood enough in all their sickly veins to give each naked curtle-axe a stain . . .' Certainly it was stuff for your kitbag if you were due to go over the top next day.

True to the philosophy set out by Jack and his captain, the meeting was then thrown open to all ranks. As Rowell said to them: 'I cannot emphasise enough that this is not my team, or Will's team, or your team. It's OUR team. We are in it together – as one.' Carling later elaborated: 'The crucial thing is that everyone knows he has an input. The secret with any pre-match discussion is to make it count and to make it fresh. The blokes are tremendously focused on the match by now anyway. If the same person, me for instance, did the motivating thing every time, he'd just be emphasising the same old obvious crap. They'd have heard it all before and would simply switch off. As a team, we all have an input on the field tomorrow – so let's all have an input rallying the team the night before.'

In fact, the evening before the Welsh strutted up to Twickenham, England's coolly impressive rookie fly-half, Paul Grayson, was told to chair the team meeting. It was as suddenly daunting for him as it was a rewarding insight. Paul, at Jack's instructions, had had to stand in front of his concentrating, silent peers and nominate his strategies and aspirations for the morrow. They sat in front of him, rapt, as Grayson marked out with a pen the shape of a rugby pitch – an H top and bottom - on a large white rectangular rollover sheet on the easel. Then, seemingly at random, he marked with a coloured circle some dozen or so positions in all and any parts of the field (mostly attacking, in the opponents' half) to represent scrummages or committed, fairly crowded ruck or maul situations. Then he drew two parallel lines, say half a dozen of them in various places, on the margins to represent lineouts.

As he targeted each 'area', scrum or lineout, and focused on it, Grayson interspersed his 'lecture' with sweeping arrows, squiggles and hieroglyphics on the paper – sometimes identifying and labelling with his marker-pen such tactical proper-nouns as 'Osborne', 'Pizza Hut', 'Lester', 'Copyright', 'Rocket', 'Hong Kong'. These were the England XV's secret freemasons' one-word titles of various intended ploys, which the fly-half at No.10 would pass between his No.8 and pack leader (Ben Clarke) and his inside-centre and captain the next day – all in that side-of-the-mouth

Yet another ladder for Johnson to climb.

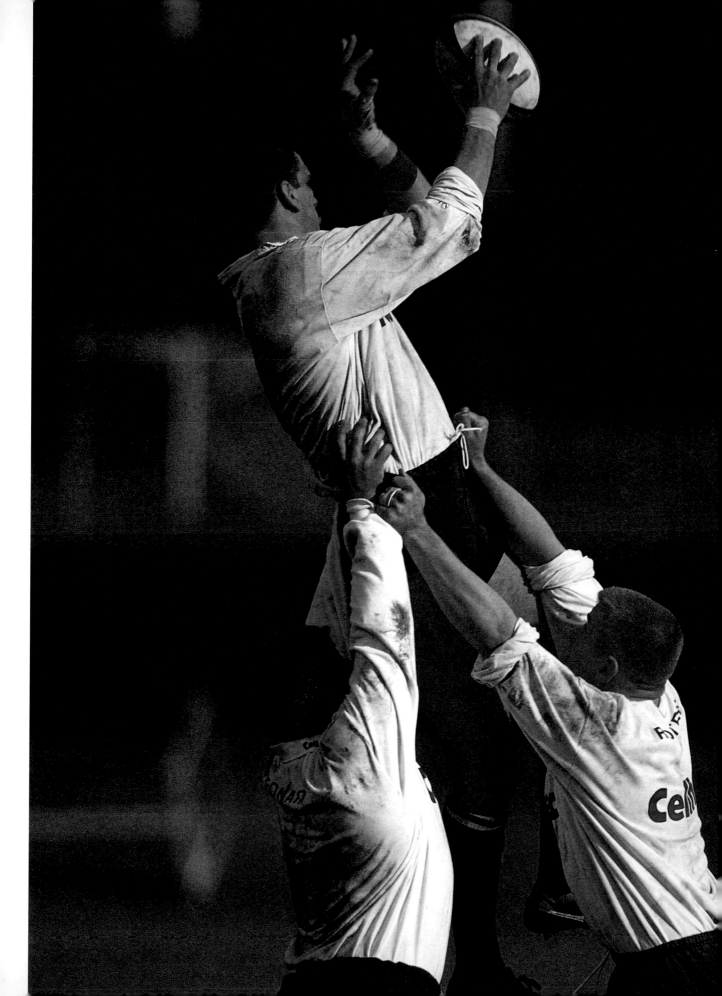

game of Chinese whispers so familiar now on any rugby field. The game's scholars, like these twenty-odd men listening intently, would understand this shorthand, doubtless. One man in the room did not. This is a small sample of what Grayson said: 'Right, it goes without saying that in whatever area we work tomorrow, it's going to be with pace and snap . . . Here (and he swatted a bold marker-pen arrow), I'm convinced this channel through ten can really yield if Lawrence can get us up on a two-on-one here, say, because it at once gets us in front of the forwards and over the gain-line . . .

'Now here, our ball, good attacking area, why not a two-man line, or a five-man, Ben outside me for a circled ball and we've at once struck into their heart and they're in total panic . . . Now in this scrum; if they read it at once, or if our ball gets stuck, held up and static, we could get out of it if Lawrence took this line and angle. He could re-inject all the pace we need and suddenly, there and there, twenty-five to thirty yards downfield, rucking it, our ball, and Dawse and myself might then have these two options . . . It's all a question of playing the channels, the wide angles, keep the variety going, quick ruck ball, sucking them in, squeezing them, giving them hell . . . Thanks, gents.'

Rowell: 'Thank you, Paul. Well done, young man. Anyone else? Ben?' Good, gentle Ben, new pack leader, who knew how to lead by on-the-charge example.

Clarke: 'If in the first twenty minutes we haven't scored – or, rather, haven't scored a lot – or even if we haven't scored in the first hour – it is vital, utterly, that we don't deviate from our pattern, our strength. Let's just stay rock-solid to all our strengths. Last year, all our success came in the last quarter of this game – because we'd done all the hard work getting on top of them and blowing all the running and the challenge out of them. So even if we don't see nine or twelve points on the board after twenty minutes tomorrow, just keep sticking to our discipline and game plan, because, as sure as anything you can bet, they'll be the ones getting downhearted. The Welsh are like that – full of enthusiasm and their own importance for half an hour at most, while their own hype keeps them going, but then it drains away when they realise nothing's happening except we're squeezing all the spirit from them. So it's vital we don't lose patience. Just keep grinding away at them and they'll lose heart and be there for the taking, I promise you.'

Rowell: 'What Ben is saying, I think, is that you fellows in this room are by far the more knowing and better rugby players. And you are, no doubt about it.'

Carling: 'Anyone else? OK, Deano?'

'Team tactics: it was great being in on some of the talks, watching videos of the opposition, seeing how the game plan came about.' – JN

'The bloke on the left is Damon Hill. Nice boots . . .' – JN

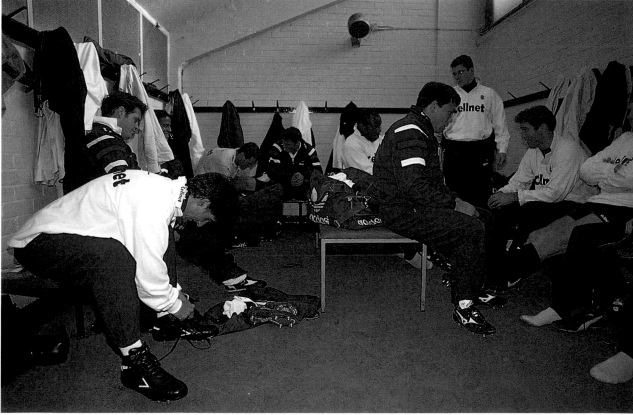

Richards: 'All I know is, boys, I'd definitely love not to be on the bench but on the pitch with you tomorrow. The bench pisses us all off. You know that, all of you. I'd honestly give anything to be out there with you, and that goes for all us six reserves. We are willing and pining to be out there, but we'll also be willing and pining for you fifteen to do the stuff. It's the one match, this Welsh one, which any Englishman wants to be part of, and the one Five-Nations match which just has to be won. To you new guys, nothing really compares to the atmosphere of this Welsh match. It's a confrontation, it's history. They never not fancy themselves. You fifteen are honestly lucky. When I started, all the talk submerged us English for weeks, that England hadn't won down in Cardiff for twenty years or so. But even to Twickenham tomorrow, those Welsh will bring something. Wherever they play rugby they've got a pride and arrogance about them. They genuinely love their rugby, so victory over them tomorrow will give you guys more satisfaction than beating almost anyone else, I promise you. Remember that. Go out tomorrow and stuff it up them. We subs know you will – and I for one would give my right arm to be out there with you as you stuff it up them. Us subs are willing you on all the way.'

Underwood stood up on the sofa: 'Deano's dead right. And we all know our strength is what we can do to them with ball in hand. Mind you, the Welsh like ball in hand, too, so we've got to put the big tackles in, sling them back, build our own space, generally give them a hard time . . .'

The room was still rapt.

Carling: 'Rory, you'd agree with something else – we're not only bigger than them, but better than them. By far. But don't think they're cowards, the Welsh don't lie down easily, you know, bed-time. And they're clever with it. They are planning this very moment somewhere to out-think us. It's in their psyche to do that. They'll be organising funny dropouts, crazy lineout calls, all sorts of ploys. We must be switched on to every scheme. From the moment they hit the pitch, they'll be so pumped up to try and run us off our feet. For God's sakes, we must never be caught once on the back foot tomorrow. We go out there concentrating – and the first funny thing they try and pull, they get hit. Sack of shit . . .

'Each one of us must look our man in the eye, that opposite number, when he comes out and faces us. You must look at him and know he's going to be beaten. Really beaten. It's not macho, it's reality. Every time my man gets the ball I will hit him; every time I get the ball I'll do something to surprise him, worry him, be better than him. It's a personal challenge. I want to take him on, beat him, see him go through pain, both mental and physical. You must all feel the same tomorrow . . .'

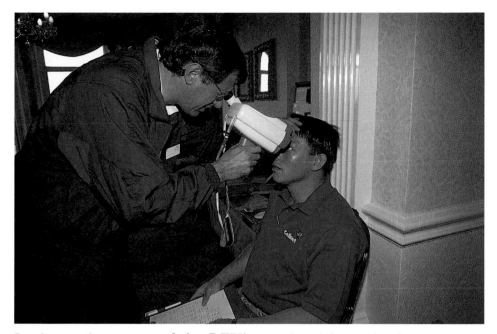

In the week, as part of the RFU's ongoing 'player development pro-gramme', an optician had tested the squad's eye-to-hand co-ordination on an apparatus called Accuvision. The same tests had been done with Olympic athletes. The results had come back and the rugby players, apparently, had outperformed the athletes in the test which measured time taken to put out sixty lights which illuminate for only four seconds – with Kyran Bracken achieving the sensational register of fifty-one in just twenty-seven seconds, beating the original record set by the swimmer Adrian Moorhouse of forty-three in thirty-two. Bracken was closely fol-lowed by Mike Catt and Jon Callard for the silver and bronze.

'Well, it won't get me off the bench tomorrow,' shrugged a ruefully smiling Bracken to the two medics in the bar. Terry Crystal and Kevin Murphy are inseparably warm buddies in their partnership for England, the long and the short, Yorkshire and Lancashire. The two coaches, Les Cusworth and Mike Slemen, and also respectively white rose and red, join them as they wait for Don Rutherford and Rowell to pick them up and go down Richmond Hill for a meal at cheerful Berlini's and a few glasses of good red plonk. With half the squad at the cinema, the other half fretting about either ringing their wives and children, ghosting their columns, or an early night in front of the televisions in their bedrooms – rugger bug-gers of old have totally vanished: these men and their accountants mean business, and dead right too – and there is not much else a coach can do now. The players, to all intents, are on their own to play tomorrow's match. The players know it, only too well, and so do the coaches.

Lanky Dr Crystal and tubby Dr Murphy are a pair all right. And

Cusworth and Slemen are equally a fraternal duo of physical opposites –
Cusworth, a Yorkshire miner's son and an engaging pixie of a man, a
Baldy Hogan of a fly-half who illuminated a decade and more of senior
rugby with Leicester in the late 1970s and all through the 1980s with
umpteen hundreds of games of wit and improvisation. He won only twelve
caps for England in three different time-warps; those were the days when
you could come and go for England at the blink of a selector's eye or even,
sometimes you fancied, the selector's wife's.

Slemen in contrast to Les's gnomish bubble is soberly straight and slim;
less extrovert and worrypot. Slem is handsome-is-as-handsome-does, he
still sports his 1950s jet-black matinee-idol moustache as he ever did when
he was a Lions and England wing of athleticism and polished control.
Rory Underwood has to take the biscuit in the all-time pantheon, but
many in the know would say that, after him, Slemen was the very best of
England wingers. He endured, too, most of the whimsical chop and
change of his time and won thirty-one caps almost in a continuous
sequence between 1977 and 1984.

To earn my beer, I reminded the delightful Slemen of the day he had
scored one of the game's most memorable tries, high up in the South
African veld at Potchefstroom, with the 1980 Lions playing a strong South
Africa XV. It would, he fancies, be difficult to repeat that try in interna-
tional rugby only sixteen years on. 'It's such a very different, far tighter
game now, I'm afraid. No defence could possibly let you get away with
that these days.' Cusworth agrees. 'Anywhere on the field an attacker now
has scarcely time to breathe, let alone sidestep. The level of defensive
"squeeze", pace, tactical input and fitness is far, far more than Slem and I
really experienced just those few years ago. We know, we coach defence as
well as attack – and all defences, we are aware only too well, are so
superbly well coached in the first place that to pick their lock, to get
through the midfield, is becoming devilishly difficult, almost impossible,
on the face of it.'

The answer still, they both agreed, was just one player's sheer natural-
born instinct on-the-hoof which would change the parameters, but in the
framework of a coached and consistent strategy. Then Jack came and col-
lected them for supper.

The next day in the late morning, both the backs and forwards held brief
meetings, in the latter Clarke reiterating the previous night's plans for
shortened lineouts and the necessity to be on guard for any mischievous
Welsh 'funny business at drop-outs and back-row moves.' Rowell listened,
his input precise. Cusworth gave final notes to the backs, leaving them to
ponder in silence his boldly written reminders on the rollover sheet.

Later, Rowell called for hush: 'Just a couple of words, chaps. We've done all the work, and great work if I may say so. Now we channel it all, and our undoubted skills, into a match. It's a big game waiting for us out there, fellows. Now, c'mon, be streetwise. A special expression has come out of our work this season – it's "Collectivity". Take that into the match today. In fact, two words – "Collective will". Right, good luck.'

They filed out, intently like students into an examination-room, down the staircase, and on to the bus. In its way, Twickenham to them was an open-air examination-room. Certainly it would be today. Last time, on their home paddock, boos and jeers had been heard when the Samoans had proved more stoutly resisting than a festive throng had expected. What now if the precociously bright new Welsh team were to surprise even themselves? The English tension was of a different type of twang and taut-ness from Paris. All England expects. And fifteen particular Englishmen were expecting similar from themselves.

In civvies still, the players went down to sniff the flavours, Bayfield especially eschewing that to be first as usual on Murphy's physio couch, and Rodber changing quickly and solitarily at his No.6 station. It was going to be a particularly important game for both Martin and Tim and they knew it. The six replacements – faithful squires to the knights even more so now – busied themselves with their gofers' jobs, unpacking the team's general kit, sorting out tracksuits, helping medics hump and heave their field-hospital into place. I cracked a whispered joke with Phil de Glanville. My giggles distracted Rodber's self-absorbed thoughts. Inside a minute, the message had come for me to keep quiet and sit still silently. Tim was wound up. I nodded craven apology, but he didn't notice.

The other thirteen came back and began to change. Rowell came in after his RFU flesh-pressing calls of diplomatic office. He sat in a corner by the door, his presence as ever a big one. 'It's very quiet in here,' he observed. 'I hope that's a good sign, not a bad one.' Nobody took any notice. Dean Richards unbundled and sorted the replacements' bulbous all-in-one Mr Michelin rainproofs. 'The question is,' said Rowell matily, 'will Dean get on so the crowd can hymn "Dean-oh!"?'

'I keep telling you, Jack,' said Richards with his flickering grin, 'they don't sing "Dean-oh!", it's "Beano!".' Jack guffawed.

Rodber, for one, looked despairing daggers across at his manager and coach. Guscott, changed and booted, clinked across the hard floor and went out for some serious warming-up. 'Mm, Jerry looks sharp, he looks as though he fancies it today, doesn't he?' said Jack to nobody in particu-lar. Jon Callard, ex-schoolmaster and replacement i/c warm-ups and kick-ers, came in with three balls to take out with Kyran Bracken, which they

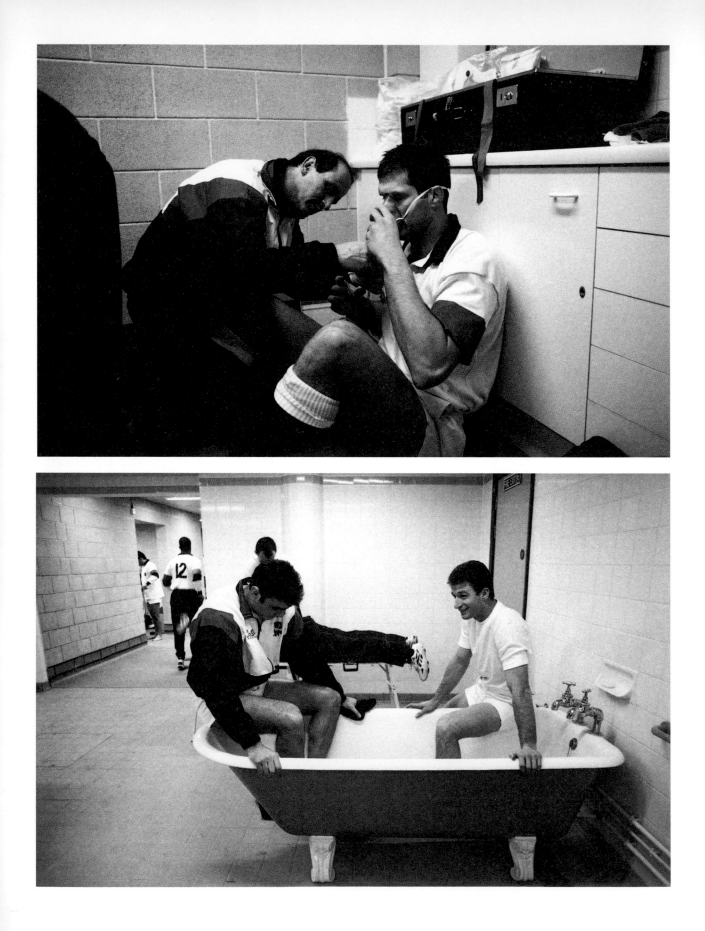

would feed and field for Grayson and Catt. Each of the three balls were too fat, too plumply pumped. 'Useless,' said JC; 'whoever pumped these up has got to go – unless Kevin Keegan wants to order a dozen for New-castle.' He went out to find some more in the groundsman's room.

This was the England dressing-room and captain Carling was palpably in his kingdom and running it. 'Half an hour to go, lads,' he announced, like a stage manager in the theatre, then 'Five minutes to photo' and 'Twenty minutes, lads, and don't forget, no presentations today, just two anthems'.

The referee, Ken McCartney, a tennis-playing fireman from the Scottish borders, put his head round the door and summoned Carling out to the wide tunnel-corridor to toss up with the Welsh captain and hooker, Jonathan Humphreys. The two shook hands, perfunctorily and without eye contact, rather like some boxers at the weigh-in. Humphreys' face was greased-up and the clean bandages and twirls of tape round his ears made him look as if he'd arrived for the match direct from a hospital casualty department. The referee tossed a fifty-pence piece, Humphreys called 'Heads!'. It was, and he chose to kick off. 'Now look, I mean this,' said McCartney with a fierce nervousness, 'I want no funny business and simply the best of discipline out there, do you understand?' The two captains, again perfunctorily, shook hands with the referee, nodded brusquely to each other, and turned on their heels to return to the sanctuary of their own brotherhood for the remaining crucial moments.

Carling glanced at the clock. 'Right, five minutes. Boots on everyone. Ready to go.' Ninety seconds later, 'Right, everybody out' – but by then the management and coaches and six replacements, knowing their places, had all quietly departed. 'Right, boys, gather round, c'mon in tight, squeeze, focus, lads, focus, what are we going to do to them? We're going to hit them so hard . . .' and as the fifteen-man human wigwam bellowed its even more gruff and menacing answers, I could still hear, dully and distant, its great ursine collective breast-beating through the walls when I went outside to join the replacements in the wide tunnel which led to the famous field of green.

The replacements leaned against the wall, distracted, divorced, ejected, excluded, cold-shouldered. After all their unsung, unthanked work for the fraternity. These are different to association football's 'substitutes'; in that game the subs on the bench are sent on the field most times for tactical reasons. At rugby only through injury, and one vetted by a doctor, will a 'replacement' be called off the bench.

It certainly does not do much for the body to be so denied a match when you have been trained (just like the lucky fifteen) to piano-wire

'Bayfield here was so angry before going out. This machine, a giant inhaler, would not work. Frantic moments.'
– JN

'All I can remember about this moment was how cold it was outside. So some of them warmed their feet in the bath.'
– JN

tension and pitch, but it must be undoubtedly more tearingly wearing for the mind.

For Graham Dawe, it is the 32nd time he has warmed his bottom and kicked his heels on the replacements' bench, levelling John Olver's all-time record. Graham has only five full caps in his cupboard – four in that fateful 1987 and one, when the subs were given a run-out against Samoa in the 1995 World Cup. But a record thirty-two 'bench-caps'. After that notorious game at Cardiff in 1987 when fights broke out – in which Dawe did nothing noticeably wrong but seemed to be, as a Bath comrade, guilty by association with Hill and Chilcott – the durable 'Pit Bull' Brian Moore secured for himself the hooker's job, with Dawe his permanent understudy. But the Cornish farmer's marvellously aggressive heart-of-oak commitment to the wickedly sharp stocks'-end of the scrum with the all-England champion club (he drives the three-hundred-mile round journey for training at Bath three times a week from his acres across the Tamar, often with his beloved wife, Liz, just for the company and to share the wheel) kept him in furious and razor-close contest with Moore throughout the decade. Once Moore was not chosen and then retired at the time of the November match against South Africa, Dawe hoped against hope for one last short run – 'I only prayed fervently for just one, just one, match at beloved Twickenham' – in the white shirt, but Mark Regan, with a long career ahead of him, got the youth vote. Poor Graham. He goes on, faithfully carrying the new radiant bull-necked bride's train up the aisle.

The relationship between the man in possession and his replacement, especially in such a specialist position like hooker (Phil de Glanville, say, could 'replace' any of the backs should they be injured) is strewn with ambiguities and must be one of the most difficult in any sport. Because of their age difference – and Dawe being long a

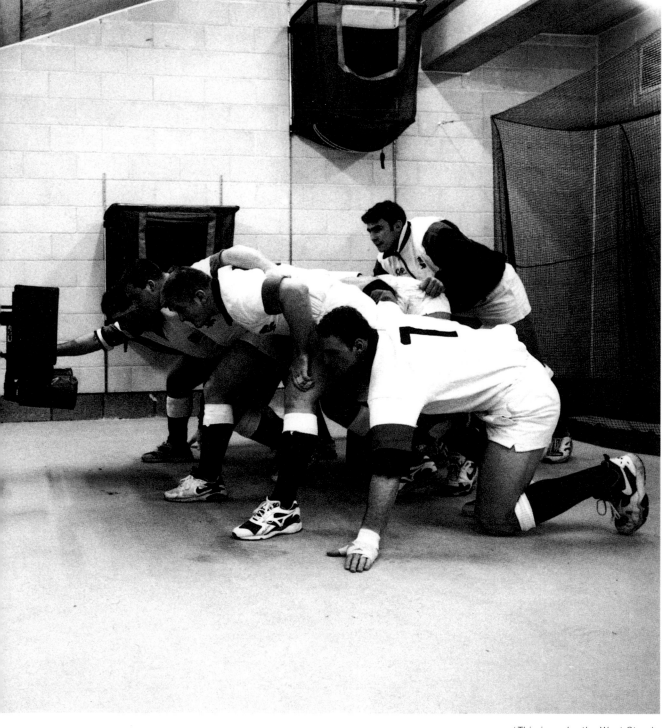

'*This is under the West Stand: the scrum machine. Ben Clarke had shut the door to keep me out. By now they were all very motivated.*' – JN

legendary figure in west country rugby – the venerable Dawe and young Regan at least have a speaking-terms relationship.

Which is more than Dawe and Moore could muster in their long rivalry. In the same England squad all round the world, they never spoke for seven years, could not even bring out so much as a nod of recognition sometimes for a whole season. The fires of rivalry and animosity raged inside both men. When Moore's club Harlequins played Bath there was no question of a truce. 'We just kicked holes out of each other,' says Graham, 'it was utter unbridled give-it-or-take-it to prove both publicly and personally who was the better man, who really deserved that England jersey. It was mine and he had it, the bastard.'

Moore concurs: 'It wasn't only in the privacy of the scrum where we knocked lumps out of each other, but all over the field at every single opportunity. Dawsey wouldn't explain, or have to get particularly roused, he'd just belt you. I suppose we were just as incredibly competitive as each other.'

For seven years, same dining-room, same buses, same practice grounds, same club bars, same after-match functions with dignitaries, the two hookers allowed their silent rivalry to fester. In Australia, vying for the 1987 World Cup place, there was a training session in a large school gym in Sydney. The squad was jogging round its perimeter. Dawe sprinted, Moore responded ... The others, realising the intensity of what had begun, stopped and applauded and mocked jovially. There was no joviality between the two hookers, it had become a fevered, primitive, duellists' run to the death, like the quadrangle scene in *Chariots of Fire*. Round and round they hurtled, neck and neck, toe to toe, stride for stride, each strainingly upping the desperate pace in turn . . . till the coach, Martin Green, realising suddenly the awesome nastiness the challenge had taken on, bravely leaped in front of the two men and stumble-tackled them out of their frightening duel.

That race was in 1987. They did not speak till almost two whole World Cups later, in South Africa in 1994, when, one evening, Dawe and Moore found the rest of the team off for a date of a sudden and the two of them left standing at the bar together, 'We found ourselves getting a drink. Just for ourselves. We paid for them individually, and suddenly began a very stiff, staid and static time-of-day conversation about nothing. It began as if we were complete strangers. We had another drink, then another. We ended up like normal teammates having a friendly chat. Our mutual respect for each other was suddenly in the open. We were still rivals, but after all that time we were now friends as well.'

Remembers Moore: 'At the hotel bar, as we began to speak more freely,

neither of us, not once, mentioned the past, the animosity, the confrontations. We knew that at our ages the end of internationals was in sight for both of us, but in this sudden maturity the past was never mentioned, because neither of us for a moment regretted how our seething rivalry had driven us both on to such intensities.'

Of course, Moore with his sixty-four full England caps was the runaway winner in his battle with Dawe. 'He was just a doughty competitor all right, I'll give him that,' says Graham in admiration. 'But that's all past now, and my dearest wish is just to be called on once again at Twickenham. Perhaps today. I've only played one international here, beaten by France 19–15 in 1987. I was against Daniel Dubroca, an incredibly hard hooker. I learned a lot from him. I wanted more, much more. I'll never forget, I was so zapped and hyped up before we went out I reeled off 100 press-ups on the dressing-room floor and never broke sweat.

'Then came that match in Wales, and we all know what happened there; it gave Moore his chance, and he grabbed it with both hands. I'd have obviously done the same if the roles had been reversed. Funny, my first ever "bench cap", although there weren't "official" caps for anyone that day, was against Japan in 1986. I was so proud. The hooker that day, in his first ever international, was a certain B. C. Moore Esquire. For all my record times on the bench, it must be amazing that I've never once been called on to do my duty. Some guys have been on the bench just three times – and got on three times.

'Still, you must always presume – as well as hope – that you will be called. You don't (honestly) wish any ill or bad injury for the incumbent in your position. But, OK, you pray you will get the chance to show your worth. So you have to be trained and ready to go just like them. You train just as intensely as the lucky team fifteen – more so probably because you're always intent to catch the coach's eye . . . At training, as the week intensifies towards the big day, we have to be just as match-fit, but we increasingly become the Oddjobs, the slave-workers. You are like "seconds" to the champion boxers, helping them and geeing them up for "the big one". Still, I'm luckier than some, I suppose – there are some players in world rugby who have sat on the bench and finish never having one cap to their name in the all-time record books. At least I've got five. I cherish them . . . Holding the tackle shield as training intensifies towards the match puts us in our place. "More dee-fence required from you reserves, harder, harder!" cries the coach as you launch yourself at another England attack. Hopelessly outnumbered 3-to-1 you decide, what the hell, to go for broke and take one of them out just as they are not expecting it. Then, "Calm down, Fifty per cent only," comes the cry as the move breaks down

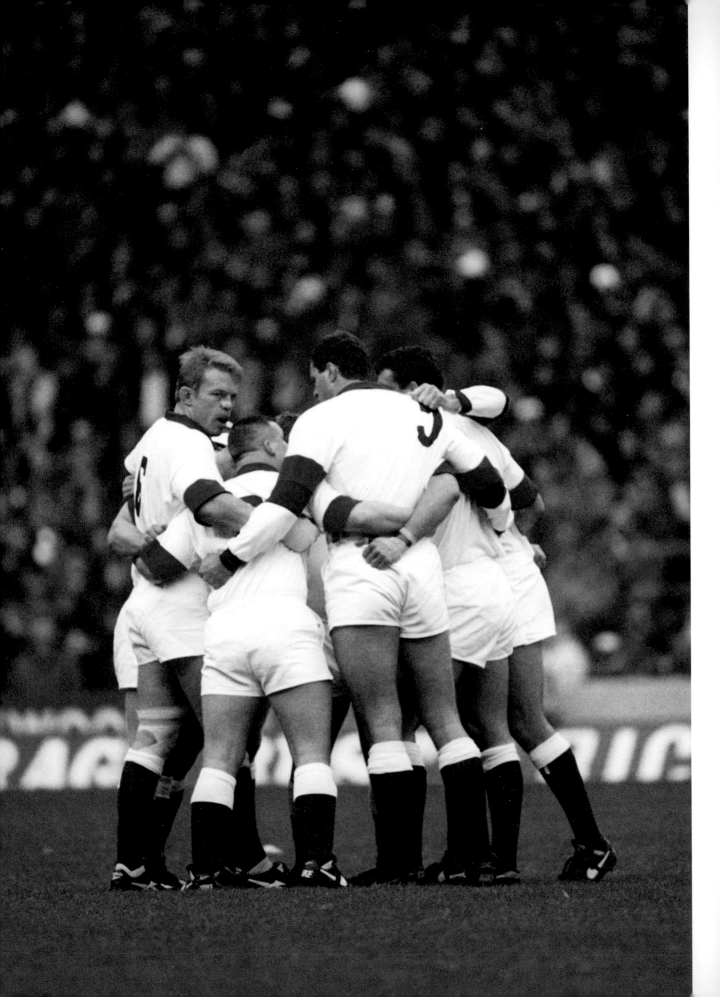

and the physio is summoned to administer help to the collapsed player. We really must stop showing our frustration at being on the bench yet again – one down with five to go, but it never seems to be the first-choice hooker who's down, they never give him a run at me with the ball! . . . As the match approaches, somehow one's frustration settles a bit, and I must say that by Friday before the game there is no animosity between players and bench, for we are all by then concentrating hard on the same goal – to beat Saturday's opponents . . .

'Meanwhile, as captain of the bench, the main duty of my leadership is to provide the packet of sweets or toffees for the bench to suck during the match. Look, today I've filched these high-class mints from Jack's pocket – and by the time he realises it, as he sits in the row behind us, I fancy there will be only a few crumpled pieces of wrapping paper left. So the coach won't be a happy man. What's new!'

Nor was Rowell happy as the match unfurled itself in pretty drab colours. The coach sat in the row behind the replacements, Cusworth next to him, then Slemen, Rutherford, and Herridge. The six replacements each sang the anthem lustily, urged on their men and groaned like any knowing spectator when the referee's judgement went against their side. Every so often, say three or four times in each half, when a particular player was briefly felled or called for treatment from Murphy and Crystal, the appropriate sub (with hope in his heart) would skitter down to the touchline and go into a jogging series of stretches – just in case. But only one of them was to get on today.

England played in a disappointing series of fits and starts against a Welsh team full of insecure promise and more spirit than likely achievement. As a cohesive match it was all ifs and buts, fingers and thumbs and awkwardly bouncing bobblers which nobody could quite get a clean pair of hands to. As England had expected, the Welsh tried their unorthodox 'funny business' and after only ten minutes they fell for the three-card trick when the young Welsh fly-half Thomas tapped a penalty instead of going for goal and a quicksilver little necklace of passes tore open England's midfield for Taylor to barrel through and score. It took England almost half an hour to summon a cohesive retort and the home crowd were clearing their throats and threatening to become palpably and vocally, well, 'restless'. England's supporters through the 1990s had been fed on a rich diet of success. But England led 7–5 at half-time when, after a knuckling-down series of punitive scrummages inside the Welsh 22, Clarke cleverly switched the ball from the blindside angle, Carling made a dart and, although Sleightholme's pass went astray, it bounced kindly for Catt who sent in Underwood for his 49th.

As Rowell told the team the night before, 'It's not my team, or Will's team, or your team. It's *our* team. We are in it together - fifteen as one.'

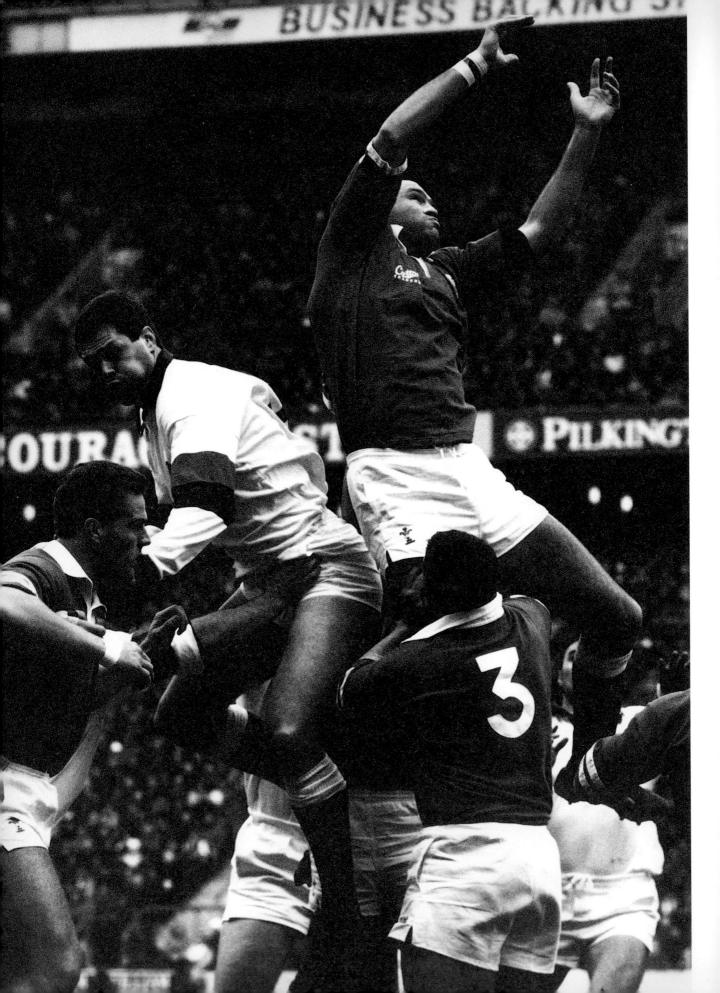

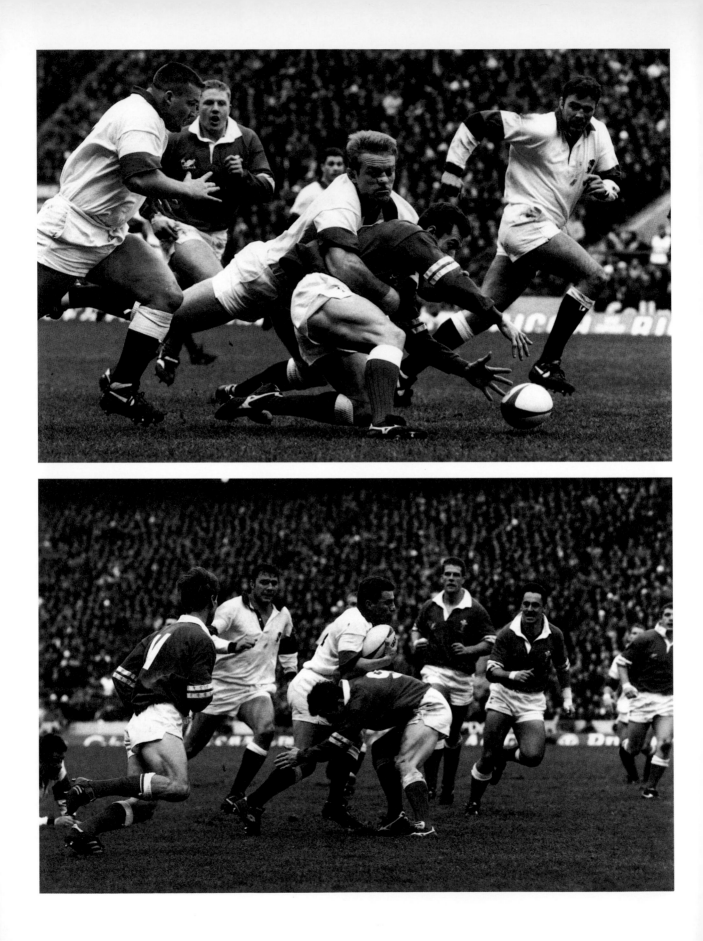

No sooner had the second half begun than Guscott's anticipation and good sense had him charging down a delayed clearance by the full-back and following up joyously to score and stretch the lead. Just as it looked as if England's midfield were now fired up and ready to punch holes in Wales's suddenly rickety defence, Carling came off with a badly bruised leg – replaced by de Glanville and at once, for no particular reason, England seemed to lose the plot again and, with Grayson now landing his goals, at 21–8 England could not apply the squeeze and Wales rallied heartily at the end with a late try by scrum-half debutant Howley. It left the Twickenham throng disgruntled and England's replacements on the bench knowing, in their hearts to a man, that each one of them could have done better.

'Please let it be me' by Jon Callard: 'There is a knock at the door, a little gent pops his head in and declares, "Ten to go fellers, out in seven." That is your cue, you do a whip-round and wish the lads good luck and share with them their final anxieties before taking your place in the stand. Those seven minutes feel the longest seven minutes in your life, even if you have been there before. You go through exactly the same thought process that you did before the last game and the game before that and the game before that. You sit in the tunnel isolated from the world, it seems, no one spares you the time of day, you are surplus to requirements before the game starts. The six of us go through our own rituals, but you can guarantee that they are all of the same fundamental feeling. 'God, I wish I get on today, please let it be me!' Although you don't wish anybody any harm, you just want one more chance to show to yourself and the watching millions that you can do a job when required.

'The team run out to a delirious crowd which is waiting for a spectacle. You know that it is not going to be a straightforward game, the tactics by both sides are going to be risk free. The game is won by strict game plans and the ability to stick to them. Close-quarter combat with every hit being made with your total weight of support behind it. It is about the fifteen guys who are out on the park, but you feel that those chaps are playing for you. They know that you would love to be out there and it eases your position if that last tackle was made in respect of your standing on the bench. The game moves at a furious pace; you keep one eye on the field and the other on the TV monitor. This is just in front of Jack's seat, but in front of him you have the replacements. The clever ones amongst us make a hasty dash up the steps to get to the first two seats, the brutal ones just wait and claim

Rodber gets his man. 'The Welsh don't lie down easily . . . And they're clever with it.'

Sleightholme meets Howley. 'Each one of us must look our man in the eye . . . and know he's going to be beaten. Really beaten.'

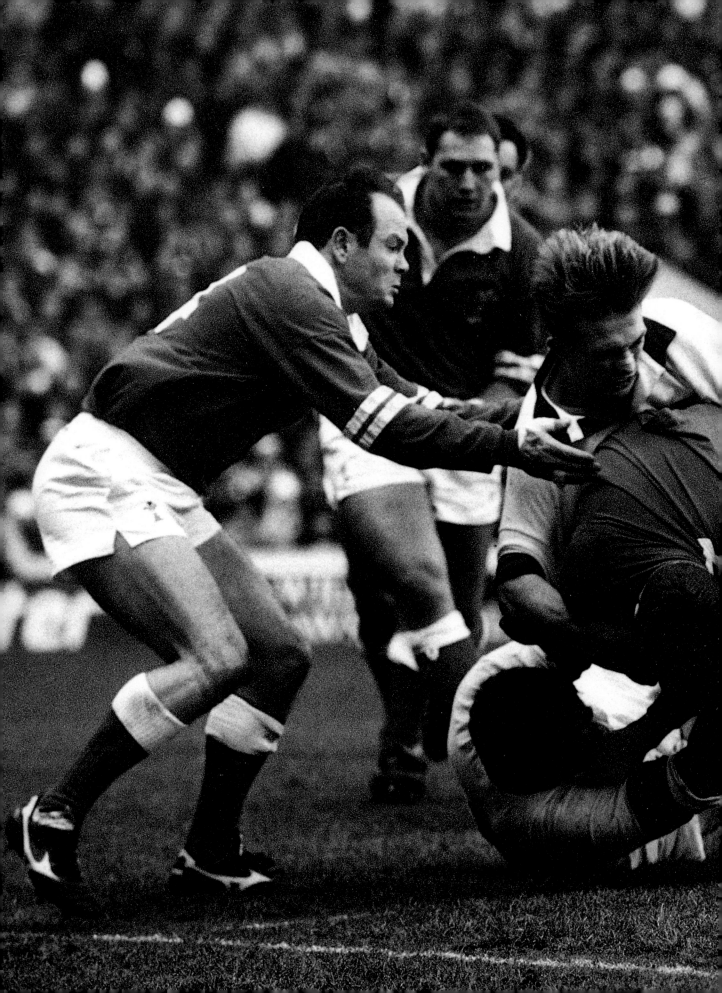

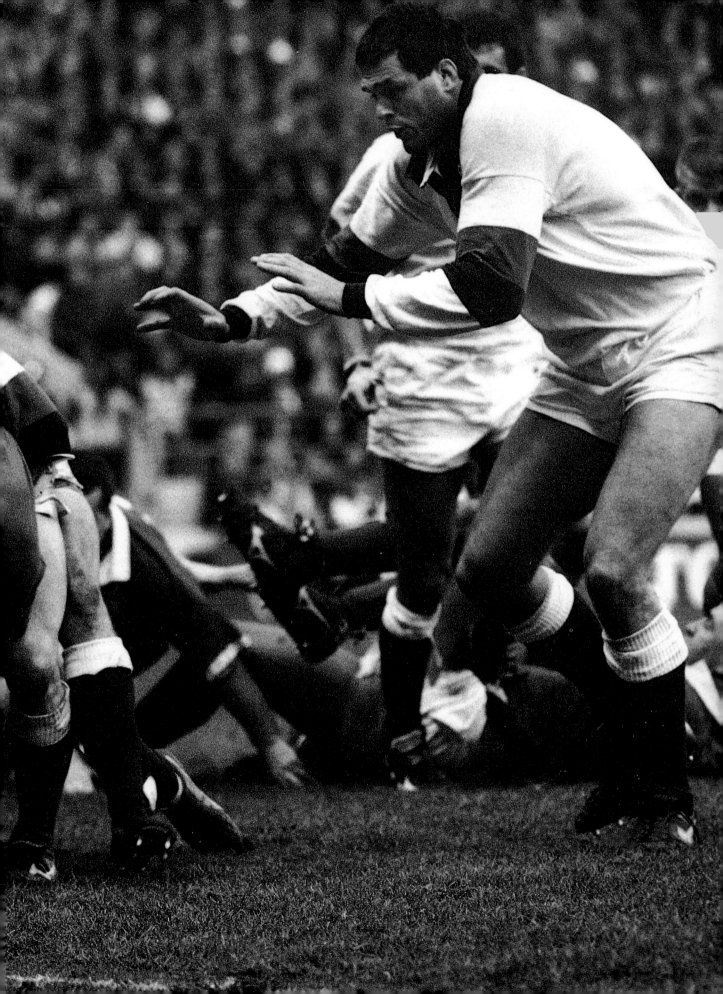

their seat when they are ready, and probably Ubogu will emerge looking not best pleased that you are in a comfortable position, that he would like to have! No diplomatic reasoning here, "shift or else" seems just enough to give up your seat for a good cause, like your longer legs perhaps. The first two seats are directly in front of the monitor and assure the watcher every bit of action from the field. However, it does have its drawback. Jack bellows instructions and lets forth the type of language that you can only describe as Chaucerian. "Give it, drive, watch the blindside," he would yell. Poor old Les, who sits on his left shoulder, gets the full works. You know when Les is becoming stressed, when he leans over and demands a sweet from the benches' stash. Only is one given up with sympathy, and so Cusworth gets one. It is usually presented in such a manner that he daren't ask for another . . . Midway through the second half things are not going the way the squad would like. I mention squad, because it is a squad thing. Everyone is accountable and everyone must stand and take full responsibility. That includes the bench. When the slow handclapping goes up around the stadium, the bench takes it straight on and it affects us more than the players as they are totally focused on the game. It hits you in a funny sort of way. You feel it is reflected on you and all the efforts you have put in over the last three days in preparation for the game. It is not as if we are doing this deliberately, is it?

'The whistle goes to signal the end of the game, players trudge to the changing-rooms disappointed by their collective performance. You know that the next twenty minutes or so is going to be difficult. Don't say the wrong thing when talking to the players as they just might explode in your face. You might want to sympathise, but not sound condescending or demeaning in any sense. The guys are down, even though they have won, but the last thing that they want is someone to reiterate how the game went. The plan of action is to get out on to the field and do a little dirt-tracking. The fitness guru (me) orders a session from hell. The idea is to work up a thirst so you can enjoy the evening and have a few ales or whatever the captain of the bench decides to drink. It is a tradition that the bench just have a private half an hour together on their own to reflect and pay tribute to each other for their efforts over the last few days. In some cases it is to drown out the sorrow of not getting on – again. Think of poor old Dawsey - been on the bench thirty-four times and never got on the field once. He is the honorary captain who will look back on his speeches at bench get-togethers as legendary in their own right. Also he has chosen some fine wines in that time!

'Jon's (Callard's) dedication to the Squad was immense, despite seeing someone else in his cherished position of full-back and deprived of the opportunity to kick at goal.'
– JN

'It is a messy job, celebrating after a game which you did not participate in. But the more times you do it, the easier it gets. However, if someone does get on, it is time for champagne. Fortunately for this England bench, they have the connoisseur of champagne, Victor. Good sport, as he usually ends up paying for it! That's only because the other guys down their last glasses and leg it before the bill arrives. Dada [Victor] likes to savour the taste. Blow that, at those prices in the Hilton you gulp and run.

'Finally, though, it is a tough job! You have to go through your match-day ritual and never be called upon to join the real fray. You have to train and prepare the same as the team, yet not get the chance to play. In training you are the human shield. Bag after bag you have to lift, ball after ball you have to chase, and thump after thump you have to take. With the likes of Johno [Martin Johnson] and Wiggy [Graham Rowntree] who find it difficult to distinguish between fifty per cent and flat out you take some great hits. And what is infuriating is that they love hitting the hell out of you. Ultimately, the hardest part of this role is that you must keep your opinions to yourself. It is not anger or jealousy that fuels your emotions, it is the

*'I walked into the changing
room all happy - we'd won.
"Yeah, but . . . " some of the
players would say. Then Will got
everybody together and told
them a thing or two. They start-
ed smiling after that.' – JN*

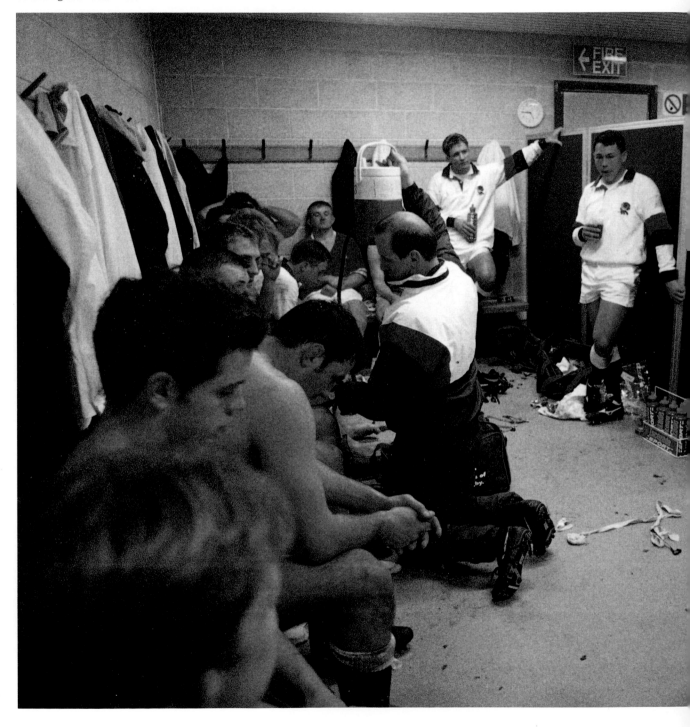

envy that you are not running out on that pitch with the team. Nothing must interrupt with the preparation of the side and you must respect the wishes of the management and stick to those wishes. After all it is what you would expect if you were actually in the team yourself – so, next time, please let it be me.'

If Rowell had remarked on the silence in the dressing-room beforehand, now the unspoken gloom was almost tangible. The Welsh lock Derwyn Jones knocked and came in to swop his red jersey for Martin Johnson's white. 'Blimey, it's like a morgue in here,' he said. 'If we'd have won we'd be drunk and singing already.'

Arwel Thomas looked in to swop his jersey with Grayson. 'Crikey,' he said, 'it's lucky you guys won – what would this silence be like if you'd lost?'

Half a dozen years ago, a 21–15 victory over Wales and, certainly, England would by now have been deliriously swinging from the shower-curtains. Did England in 1996 expect too much of themselves? You bet they did. Rowell had heard Thomas's remark. He walked into the middle of the room – 'Some of you heard Arwel. He's right. Get your heads up. A win is a win is a win. Of course, you might have done better, your standards are that high. But you won. We're a new side, six brand-new players. We've a win under our belts – well done – and let's happily take it on from there. So have a drink tonight and toast yourselves – and what we need to aspire to now is another win at Murrayfield.'

Carling then said, 'We won, the impact will be maximum because we won. Whatever is said about today, don't worry a stuff, we won it. There was a hell of a lot of pressure on us, and we had to win, and we did, we slaughtered them. And, as Jack says, the impact on our future will be seen to be crucial. So let's enjoy it – we know it didn't go as it should have done. But we bloody well won – massive impact – and, everybody, well played.'

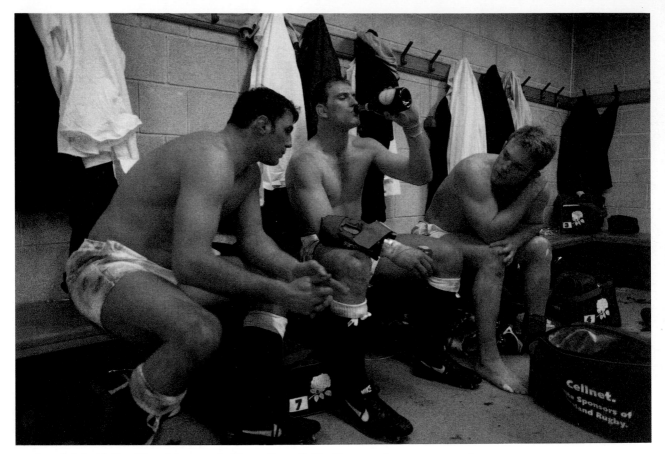

At last a drink of champagne.

 At which Colin Herridge took Rowell and Carling to the press conference. Those knives were no longer simply being sharpened. As the pressmen scribbled, you could sense the glint of cold steel. England expects, its players do, and especially its media messengers. The match in Edinburgh was going to be a crucially important one.

Sufficient Unto the Day . . .

So to Edinburgh – and, cometh the hour, recall The Man.

Dean Richards was restored to the colours for, explained Rowell, 'strategic reasons' to underpin the base of the scrum and tie up and tie in England's raggedy ends, which had been displayed against Wales, especially in the last quarter of that Twickenham match. Richards's return, which made complete sense, predictably caused a fizz among some sections of the English press and they turned up the volume of their bellyache about Rowell and his selectors reuniting the totemistic but lumbering Leicester line veteran with an emerging fleet-footed England team apparently getting tuned into the future. Don't forget, when the first England squad for the Five Nations was announced in January, Richards was not in it and, in the future, had been asked for the return of his sponsored mobile telephone and rowing-machine home-training aid. Dean Richards: 'No, I never thought to myself "that's it, my England career's gone for ever". If you hang about the fringes and they keep in touch, you always know there's a glimmer of hope.'

It goes without saying that the recall of Richards was lauded joyfully by the rugby-loving public round the shires of England. Once again, the haunting lilt of homage to the talisman 'Dean-oh! Dean-oh!, would be heard in an international stadium. And, even more important to the upcoming matter in hand, when they heard the news the Scots gulped and cursed their luck and Rowell's strategy. The glumly deadbat but utterly worthy high skills of the singular Richards made him the one man who might grind to a discordant halt the Scottish XV's hitherto merry jig which had warmed their winter to such a bonny extent that the Grand Slam would be a glistening royal blue if they beat England at home. The bookmakers installed them as red-hot favourites, and already the thistle-badged Grand Slam souvenir sweaters and knick-knacks were being gaily produced by the thousand up there. Ireland and Wales, away, and the queasy-travelling French, at Murrayfield, had already been beaten by the Scots with a collective dash and verve.

To accommodate Richards at No.8, it was Tim Rodber's bad luck to return to the replacements' bench, but it was in the second-row that Rowell and his lieutenants made a move, largely unconsidered and passed-by in the flurry of headlines over Richards's 'strategic' return, which could probably have a far more significant effect on England's long-term future. The stalwart beanpole, Martin Bayfield, perceived to be jaded and off the rim of his (literally) highest of standards in the lineout, was dropped altogether, to be replaced by the 'unknown' Geordie lank of 6ft 6ins and nineteen stones, Garath Archer, a British Army radio telegraphist private who was playing a combative season with Bristol while stationed away from his native north-east with the Royal Signals in Devon.

First up for England at Murrayfield in Scotland's Grand Slam match? It was a truly daunting baptismal font in which to throw the callow squaddie. He was as surprised himself as the rest of England. 'Garath Who?' Half Fleet Street next day rearranged the spelling of his Christian name to 'Gareth' for a start.

He recalls: 'With my Bristol mate, Alex King, I had been called into England's "periphery" makeweight squad for an evening's training at Marlow. I was driving up the M4 and we had a puncture. I rang the Marlow clubhouse to say I'd be late and was it worth coming on? They went and got Colin Herridge, who assured me excitedly that it was worth coming on. "What radio station have you been listening to in the car?" he asked. "Radio One, the music," I said. "Well, switch over to Radio Five and you'll hear you've been selected for England at Murrayfield in the Calcutta Cup match next Saturday and there's about fifty TV and national newspapermen waiting here at Marlow to take your photograph." I

Garath Archer practises in the lineout.

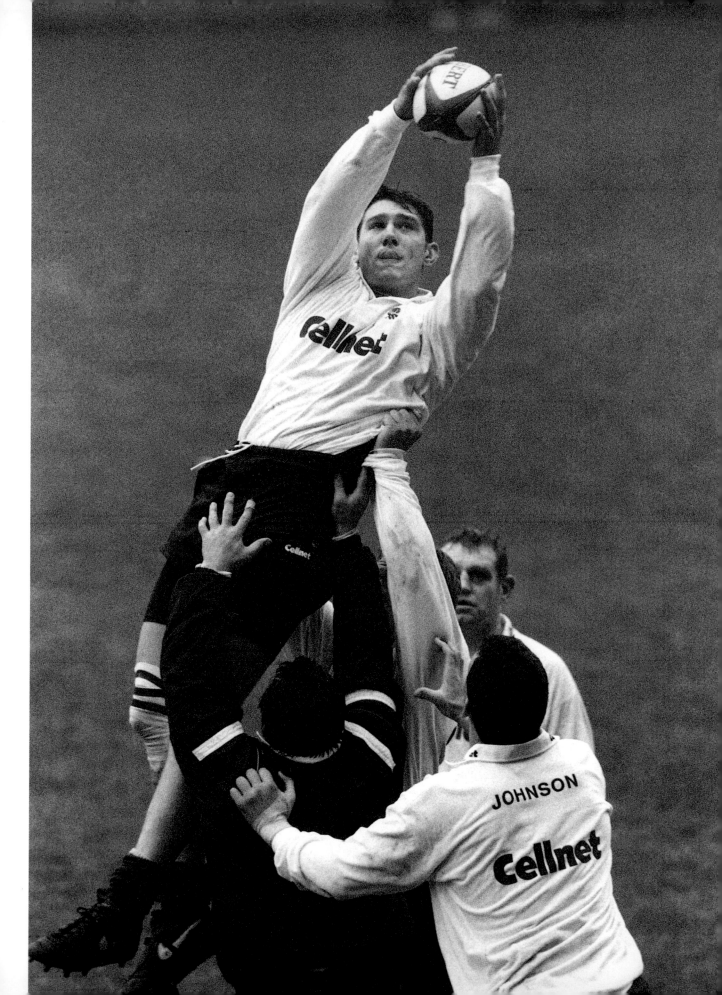

'*Dean Richards, the man who
was to produce great things on
the day.*' – JN

didn't say a word. I thought I was dreaming. We finished changing the wheel, and we started up again. I drove on in absolute silence. We'd gone miles before I said to Alex, "You're not going to believe this, because I certainly can't, but if you don't pinch me hard right now I think I'm going to play in the Calcutta Cup match next Saturday." I then switched to Radio Five, so by the time we reached Marlow, I knew it was true. Almost the first man to come over and congratulate me was Martin Bayfield. I could tell he was bitterly disappointed, but it is the measure of a man who was one of my heroes that he was big enough to say, and mean it, "Well done, I genuinely hope all goes well for you against Scotland and have a wonderful career with England."'

Archer's progress had long been monitored by the RFU coaches, and since he was first seen putting himself about – I think the polite phrase is 'looking after himself' – with a galumphing relish and gusto for Durham School as a fifteen-year-old, he has come through England's schools and youth-grade levels to the A team with a precocious, undaunted and inevitable rumble. His father, Stuart, was a try-scoring winger for Gosforth who played in two Twickenham club cup finals a couple of decades ago.

The return of Richards meant that the affable Clarke forfeited the leadership of the pack. 'Anyway, any man in his right mind steps aside for Deano. Positionally, although I basically prefer being at No.8, whenever I've played with him I am happy to move over to the flank and we've never had a problem knowing which job is what. He is an immense figure, always appearing at the right place at the right time, grabbing the ball, tidying up, driving it forward. Any pack he plays in, he just becomes the focal point of it as if by divine right, it's astonishing. As a pack leader, he doesn't exactly ask much of everyone around him – but we all know what he expects of us.'

Since his first appearance for England – exactly ten years ago to the weekend of this

fulminating Murrayfield occasion – Richards has toured twice with the British Lions and been capped for his country forty-six times. He might have had half as many again but, as happened this winter, his ambling, unathletic, pachyderm gait around the field militates against the zestful high-stepping rugby which succeeding generations of ambitious get-up-and-go coaches understandably strive for. They are the first to admit it – and, as in this case, always the second to shrug, smile and restore him to their sides. Before they do the inevitable latter, it is easy to see their point – for in whatever team of fifteen Richards has found himself the other fourteen have run infinitely faster, jumped higher, tackled lower, passed more crisply and trained much harder. Yet just about every match he has played in, the game always seems to crash and eddy and be settled around this unlikely rocklike beacon.

As the grassroots game hymn its deep fondness for the icon from their own stock – 'it used to be highly embarrassing having my name sung out,' says Dean-oh, 'but I suppose I've got used to it now' – none will admit to not loving their impenetrable and shyly taciturn hero, but very few can claim to know him. One who does is England's coach and the former Leicester captain, Les Cusworth, who remembers the sandy-haired bear-cub diffidently poking his head around the Tigers clubhouse door at Welford Road sixteen years ago, via John Cleveland College and Hinckley RFC: 'Within weeks we knew something special was among us. But nobody quite knew why. He didn't look a gem, not by any means – but he didn't half sparkle in the dark recesses. I remember we blooded him a year later down at Neath. It was one of those filthy wet Wednesday nights we always seemed to be greeted with in South Wales and the Neath boys were correspondingly full of evil intentions as they always are against English clubs. It was going to be an education for young Dean all right, and the Neath pack at once started rolling and rumbling. Dean never batted an eyelid. The game revolved around him, and we won 10–8.

'Around that time at Leicester, alongside the team changing-room there were just three loo cubicles. It was traditionally taken for granted that, say an hour and a half before any home match, the three senior players would have first use of them, to each individually lock ourselves in to, well, take stock and calm the butterflies. The three were the England internationals – me, Dusty Hare, and Pete Wheeler. Till after that Neath match – when Dean would arrive first and park himself in the one toilet, reading his *Hinckley Times*, and us three alleged "stars" would be left fighting over the two spare loos.

'Most people never realise that Dean's quietly soft, self-effacing manner hides just about the most determinedly competitive edge and drive I've ever

Lineout practice before Scotland. 'They will come at us at top speed from every angle . . . '

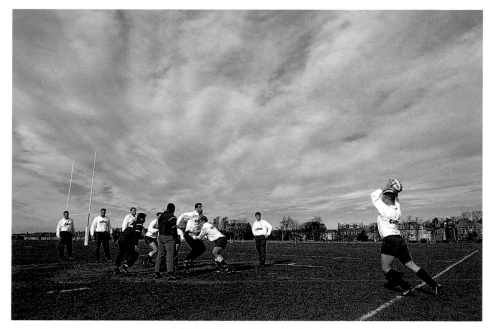

met in any sportsman. Behind that big, daft, gormless grin is a fiercely proud man. And don't think he just plays his rugby by instinct – Dean has an all-round vision for a rugby match's strategies and he has a sixth sense about how to change them on the hoof. Few players have got that. As well as his own unique forward's play, what sets him apart is that he can talk to backs for hours – although you'd never get the bloke to admit it himself.'

Jack Rowell, meanwhile, was getting irritated by the increasingly pointed and personal snipings from the press. Sporadic attacks had begun as far back as the disappointing and generally flat performances by England in the World Cup and one sensed that Rowell was particularly stung, not by any old hack sucking Zubes for his pipe-smoker's cough, but by the discontented hand-wringing of such resplendent former international players, now turned vigorously capable journalists admired by their peers, as Paul Ackford, and even Rowell's mutually-beloved former captain at Bath, Stuart Barnes. Their critiques were winging-in weekly under such headlines as ROWELL LOSES THE PLOT, ROWELL'S ENGLAND ADRIFT, ROWELL FORSAKES THE BROADER VISION.

Rowell seemed more bothered than the players and, on the way to Scotland, the big man blew his top. He told me: 'It is irresponsible. I'm still chairman of five businesses. That's why it is so distasteful having my name muddied with character-assassination. They don't even know how my selection policy works – I don't write my team down and say, "This is it, chaps." I sit down and listen to all the input from people like Les Cusworth, Mike Slemen, Will Carling, Don Rutherford, John Elliot and Peter Rossborough, the manager of the A team. They all chip in and I go with

the flow. Through all my working life I've been given a lot of power and my philosophy has always been to share it around.

'We're trying to rebuild an England team and I find it quite appalling that so-called self-styled "informed critics" can't see what that entails. I don't read the press but my wife does because she's a strong lady. Even my younger son says, "What's going on, Dad?"

'It's too easy just to say it's the British way with national team coaches, like Graham Taylor and Terry Venables at soccer, but the difference is that, if I was earning a quarter-of-a-million a year from the job, the personal criticism might be easier to put up with.'

Well, why not just wash his hands of it, walk away, put his feet up at home or in the board-room? 'No way, I'm not going to be walked over by these people.' Victory at Murrayfield and, who knows, a Triple Crown after the Ides of March would do the business for Rowell all right. In fact, nobody had thought about it, but England were still in with a shout for the Championship itself. If his team could win him that, the manager would consider his critics routed – game, set and match. But that was far ahead yet.

Jack Rowell: 'Through all my working life I've been given a lot of power and my philosophy has always been to share it around.'

Rowell's visionary approach that tactical decision-making must not come down autocratically from on high, and should be inspired by collective discussions inside the squad, was well illustrated once the team had settled on the Thursday evening in the New Balmoral, the stately Victorian 'railway' hotel in the heart of an Edinburgh already building up a frenzied and expectant head of steam – shrill with certainties – for the Saturday denouement. But England seemed unapprehensive. The squad gave off an aura of inner strength. It cocooned itself at once into a monk-like concentration of slippered silence, of course, and at three team meetings, one immediately on arrival and two on Friday, Rowell and Carling on each occasion were happy to give the floor to Richards.

Each time, the Leicestershire policeman reiterated the same simple warning in scarcely audible but softly defiant countryman's tones as his big supple frame sprawled in his too-small upright hotel chair in the middle of the congregation. But every word was audible enough for the cadre

to hang on to, take heart, and inwardly digest: 'They will come at us at top speed, from every angle ... if we let them have the ball they'll speed it up even more ... they'll try everything just to keep the game at a lick – tap penalties, quick drop-outs, short lineouts, daft restarts ... if they begin to get a momentum and start recycling the ball from a string of breakdowns, they can become very dangerous ... we must strangle all their ambition at birth, grab any fifty-fifty ball and make it ours, defuse any break-out before they even know it's on, deny them every scrap with our discipline ... if they find they can't scavenge off scraps, they'll simply have nowhere to go ... prey on the fact that they are favourites, and if we deny them even a smell of a ball to work with, then all the increasing pressures piling in from their crowd will begin to put a terrible onus on them and, you'll see, they'll go to pieces ... but if we let them start linking off-the-cuff, their courage will come flooding back ... best of luck in your first match, Garath, we'll be right there alongside you – and remember, boys, I've never been on the losing side against Scotland.'

Such undecorated profundities by Richards continued to be mulled over when he had finished, and the company remained sepulchrally mute as it stared at its shoelaces or at the ceiling cornices. After a couple of minutes, Rowell signalled Lawrence Dallaglio to the front of the room and the easel, and the muscular square-jawed young Wasp, making only his fourth international start yet already acknowledged by his peers as an integral part of their main strategy, stood for a good quarter-of-an-hour with his felt-tipped pen and, with a scrawl of various arrows and ellipses and dots, he suggested and reminded them of no end of more detailed ploys further to truss up the home side on the morrow ... 'if they call a shortened line-out about here, they like to make a dent here through either Redpath or Doddie Weir, but if we are ready and knock them back on this side, here, Will will open space for a concerted counterattack by us through here ...' and so on and so forth, each stratagem containing the repeated and implicit warning that in any corner of the field they must 'expect the unexpected' from the Scots. Dallaglio ended, 'Although we lost, I still feel content when I think back to the French game, because every one of us concentrated a hundred per cent for almost every second – or at least till we lost it a bit at the end. So if we repeat Paris tomorrow for the full eighty minutes, the Scots won't have an earthly.'

At which Carling cut him off forcefully, 'Streetwise, we've got to be streetwise.'

Then Rowell stood: 'Lawrence has hit it – on your pillows tonight think back to Paris. Every time the French went in to get the ball, and even when they got it briefly, we cut them off, cut them down. So impose your

Paris game even more so on Scotland. And, chaps, I'll leave you with two last thoughts, or three or four ... It's by far the most important game of the year so far. They want it all right – but we want it more. So drink in all Murrayfield's noise and battle hymns and treat every bit of aggro as a direct challenge to your own manhood ... and, chaps, I just can't get that pop song lyric or advertising jingle out of my head, so let me just transfer it to yours, you know the one – "Seek for the hero inside yourself". Now, goodnight, sleep well.'

Garath Archer did not sleep too well. 'OK, not particularly badly, but when I woke up I was at once terribly apprehensive of the day. I wasn't sharing a room with anyone for some reason. I was on my own and I daresay I started letting the nerves get at me. I sat on the bed chewing over all the possibilities. It's really a question of praying you aren't going to make a fool of yourself, isn't it? I crept down to the team room for breakfast. Everyone was silent, wrapped in their own thoughts. I went back to my lonely room by myself. I tried to listen to a bit of music to help compose myself. And then switched on a bit of telly, the kids' cartoons. It was no good ...

'Then, lo and behold, Martin Johnson knocked on my door, and he came in and he sat down and began to reiterate all the various line-out calls and options and things. Then he went through the various Scottish forwards and their strengths and weaknesses, you know, everything. He really settled me down. He said the Scots would throw everything at me to try and disrupt me, to wind me up and make me retaliate. Martin got my mind focused on the job in hand, whereas on my own I'd been allowing myself to get steamed up and in a flap. It was marvellous of Martin, probably the world's best lineout man taking over an hour to tell me what he and the boys expected of me. I would handle it now all right. I was ready for it now.

'And then, do you know what? Out of the blue, Will rang and told me to meet him downstairs in the lobby – and he took me out into the big main street (Princes Street), just him and me together. He said he wanted to give me some of the incredible flavours of Edinburgh on the morning of an England match – he said it should inspire me more than frighten me – and it did that all right as the great Saturday morning shopping crowds all recognised the England captain and jeered him and threatened him with all that was going to happen to him – to us – in a few hours. The stick he got was really something, but we continued walking and talking about this and that, and Will, who took it all with a smile and good naturedly, said he wanted to give me an idea of what sort of anti-atmosphere we would soon be up

against at Murrayfield. And I must say it worked magnificently – me still to get one cap and the record-breaking captain of England with thousands of caps walking me through the heart of their territory. It was wonderfully good of Will to think of it. I was ready for anything the Scots could throw at me after that, wasn't I?'

Certainly, the Scots had displayed a very real antagonism against Carling's England in recent years. There was a lack of grace in the hearts of Scottish rugby folk. 'Cross the border and I'm Public Enemy number one,' grins the captain. In this last decade of the century the ancient and annual Calcutta Cup fixture had become strident with feeling north of the border, and the dirk-sharp edge has glinted at Murrayfield since 1990 when (it was perceived through tartan spectacles) there was a strut of over-confidence about Carling's team when it came up for what turned out to be an apocalyptic Grand Slam decider, which Scotland won against the odds. 'We blew it. It was devastating at the time,' says Carling, 'but it's all water under the bridge now.'

The fierce blue flame of rugby nationalism lit that day in 1990 still burns, even though England have won all six matches since that tumultuous March weekend when, as the Scotland scrum-half at the time Gary Armstrong remarked, 'England rode into town and lorded it like the master race until we stuffed them.' The edge then was possibly sharpened by Scotland's mass disillusion with Thatcherite England's antics at Westminster, the poll tax and all that – but since then the antagonistic hackles of Scottish rugby's middle classes have been pricklingly raised always, and only, for the visit of England every second year, and in spite of the obviously entrenched Unionism of the vast majority of Murrayfield's crowd on every other day of the 365, you will seldom hear sung 'Flower of Scotland' with such nationalistic passion, or hear such volleys of abuse directed at any visiting team, than when England come to Murrayfield.

Such uncordial atmospheres were in place all right as the England team filed off the coach after the short journey from the city centre hotel. A few England supporters, draped in St George's flags, were in place to greet them, but overwhelmingly the pack outside the entrance to the dressing-room was Scottish and jeeringly hostile – aye, and threateningly over-confident too, for this time, don't forget, it was Scotland only, with their three bonny wins out of three, which could win the coveted Grand Slam whitewash. The fact that they might complete it against England made the relish of it grander still.

On the field, the pipes and drums of the Highland Band were already squealing and fluting their evocative tribal repertoire – 'Pentland Hills', 'Highland Laddie', 'Westering Home', and 'Cock of the North' – and

once inside their dressing-room cellar, the England party could still hear them, just faintly and muffled. More audibly, as they went with silent purpose about their familiar, tested pre-match routines, England's warriors could hear (as they had around the hotel for the past three days), just SOTTO and scarcely stealing on the air, the dirge-like strains of 'Flower of Scotland' being softly whistled through the teeth of Lawrence Dallaglio. 'They are not going to get to me when the multitude sing it out there,' says Dallaglio; 'I'll be so fed up with the ruddy song it'll wash right over me.'

Carling comes back in his stockinged feet after tossing up in the corridor with the referee, Derek Bevan of Wales, and the Scots captain, Rob Wainwright. 'Right, boots on, boys!' announces Carling with urgency. 'Quarter of an hour to go.' Ben Clarke stirs himself and begins to change. Paul Grayson, as all good fly-halves should, bounces a ball on the floor, alone and in his reverie. Catt and Rory throw another, and then Carling and Dawson join in for a little rectangular necklace of passes over the still-prostrate forms on the floor of Rowntree and Regan. Johnson whispers intent soft somethings to Archer . . .

Says Clarke: 'The hostile atmosphere just made us dig deeper into our spirit and pride.'

Clarke leads another charge. 'What's wrong with saying, "You Scots need a ball to play with? OK, come and get it off us."?'

A blazered Scottish factotum pokes his head round the door. 'Six minutes, lads.'

Carling says sternly, 'Right, that's four minutes to anthems, boys.' The management have already spirited themselves away without a word; so have the six replacements in their uniform anoraks. Nobody noticed them go.

Now only fifteen are left, those fifteen summoned to go over the top, bayonets gleaming, into no-man's land, into the unknown . . . They are all stood now, and staring at Carling . . . 'for he today that sheds his blood with me shall be my brother' . . . and the captain motions them towards him and says 'In here, boys, close' and he opens his arms wide in an embrace and takes in Richards first, then Regan . . . and now they have all converged into one enwrapped and arms-clasped union – and any noise of passionate foreign expectancy from outside is now drowned in here because each of these fifteen have begun to beat a clattering tattoo on the concrete floor with the studs on the soles of their boots, louder and louder till the fierce stamping of these thirty identical instruments found a flamenco rhythm of its own . . . and all the while first the captain was shouting from the heart of the tight-drawn huddle, 'Identify your job! Identify your job!' Then someone else (was it Richards?) bellowed 'One to one! One to one!'

'C'mon in, tighter, tighter,' urged Carling. 'Right,' he growled with fevered intensity, 'we absolutely blast it for fifteen minutes, blast it! . . . Like you've never done before . . . We're first to everything. We

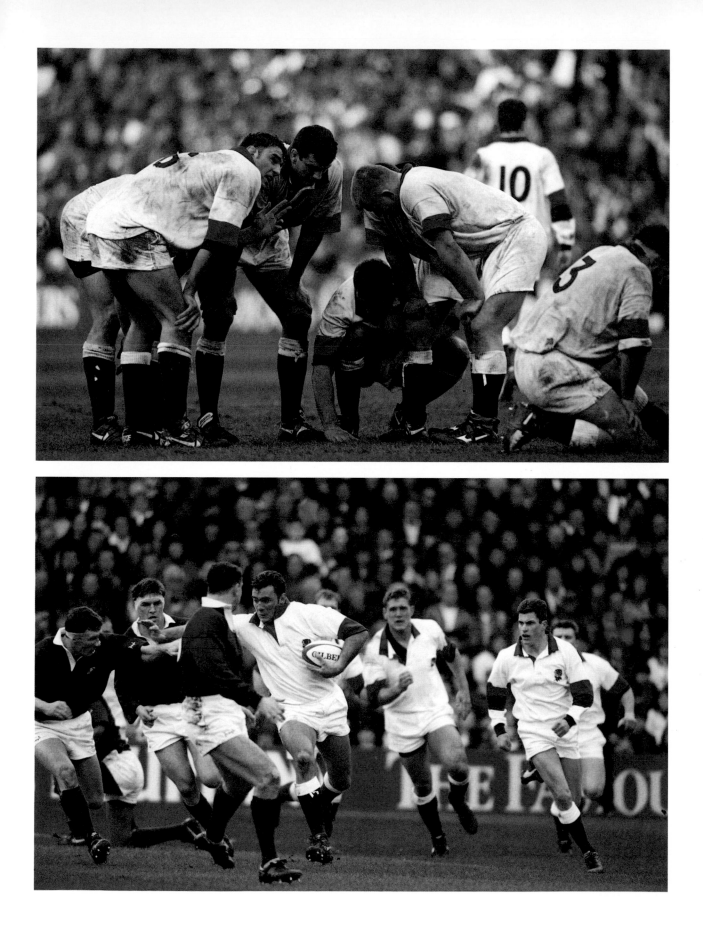

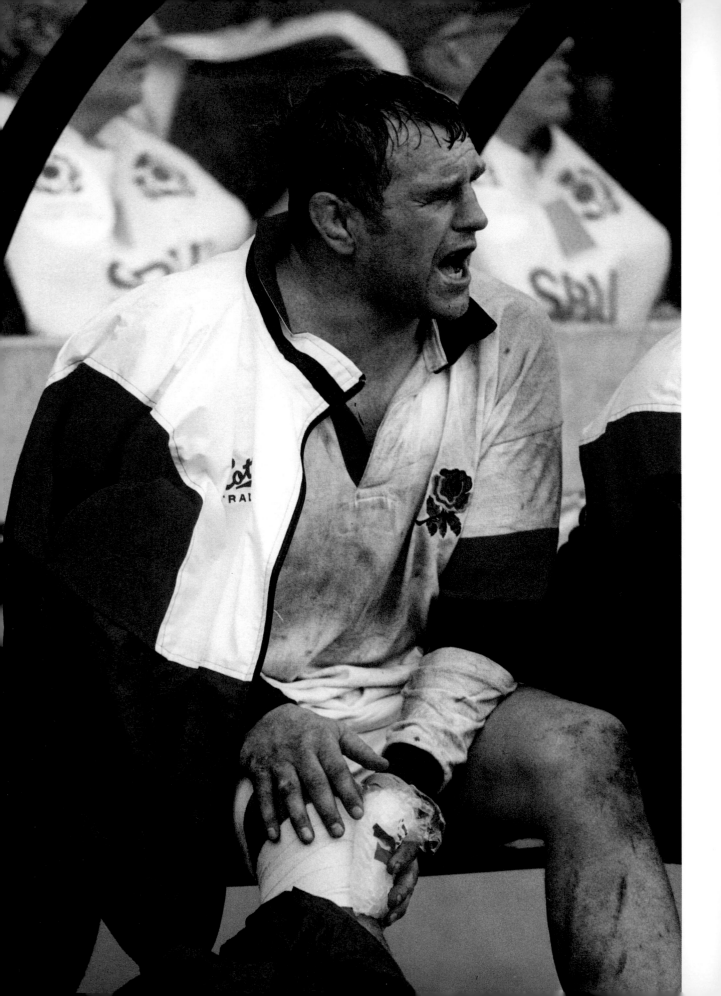

Dean Richards (*facing page*), injured, continues to rally the team in the final minutes from the doctor's bench.

(*Top left*) Jason Leonard advises Garath Archer.

(*Top right*) Richards' cannon's mouth stomach for the fray.

chase. We catch them. We get back ... We beat them for numbers. We beat them for everything ... We use our power. We use our skill ...' and now a crescendo ... 'We do not lose. We do not lose. We blast them. We blast them. Nothing else. Nothing else.'

At each of these exhortations there were collective grunts, and gruff, almost anguished ululations of assent and determination.

Then, it possibly sounded like Ben, 'Ruck, Ruck. Ruck them away. Blow them away.' Then Lawrence, 'C'mon, Arch, c'mon, Arch.' Ejaculating whoops of agreement to that. Someone else from the depths of this heaving, still foot-clacking, fifteen-man mass, 'Keep your cool, Arch. Don't let them wind you up, Arch.' Another voice, 'But screw them, Arch, screw them. Painfully tight, Arch.'

Then Carling again: 'Discipline. Discipline. Discipline from all of us. No penalties, no penalties.'

Then, the captain broke away. 'Right, let's get out there.' Regan followed him, then the others, out of the door and down the corridor ... Fix bayonets! ... And just before the file broke into a canter and emerged into

A triumphant and thirsty Dawson (*facing page*) is followed by Regan. Exulted the hooker: 'The crowd tried to intimidate us. At the end Murrayfield was as silent as the grave; we'd torn the hearts from them.'

'What did you think of that then?' Newly capped Archer (*above*) phones his parents and girlfriend still up in the grandstand.

the vast colisseum and a torrent of boos, I swear Dallaglio was still whistling 'Flower of Scotland' through his teeth ... As is his custom, Richards ambled on last, blinking into the pale northern sunlight with his stockings for once (but not for long) rolled up and gartered. For the umpteenth time in the week, one had the strong certainty that Richards and England meant business ...

The match was cruel and hammeringly hard, but no masterpiece. For the third time in the last three Calcutta Cup matches, there were no tries. England won 18–9, six penalty points by Grayson to three by Dods. It was 12–3 at half-time. Scotland's bonny brio in their previous three matches was ambushed, submerged, and squashed at every turn by the underdogs' almost heroically disciplined strategies. England's front-five was immense, young Archer playing out of his skin, and the back-row trio was as ruthlessly manly as it was effective, corralling blue shirts into their pens like collies with so many sheep – tying in, tying up, noosing and lassoing. Scotland broke out only once, when Townsend scuttled fifty metres before being swallowed up by the cover. Simply, Scotland were not allowed to conjure the wits to lay hands on the ball. In their growing annoyance at that the throng, so expectantly presumptuous of success and no end of

them already decked in Grand Slam souvenir garments, turned its venom even more on the doughty England XV. Oh, sour of Scotland. At the finish, they began to sigh the old lament 'rugby was the loser'. The bald fact, however, was that Scotland was the loser. No Grand Slam, but not even a Triple Crown or a Championship – and, far worse, with Ireland to play in a fortnight, England was on course for possibly both those prizes.

If the eighty minutes was not a masterpiece, it unquestionably included an original and unforgettable masterclass in the arts and sciences of olde-tyme back-row forward's play from the incomparable Richards. With three minutes remaining, and dragging an injured knee, Richards hobbled off, to stand on the touchline in torn shorts and muddy, bloody, sweat-browned shirt – to greet the final whistle with untypical abandon, arms raised in triumph and joy. In the sanctuary of the dressing-room, briefly and touchingly, the policeman began to cry, the tears coursing from his two already blackening eyes.

The only sidestep Richards ever employs is when confronted by a journalist with a pencil and notebook, but now he admitted that of all of them, yes, this planned-for, thought-out victory ranked as high for him as the famous Lions' victory in Australia in 1989 and England's win in Paris in 1991. In those two triumphs you could not imagine, as had happened here against the hype-drowned Scots, that every Scotland kick-off, or dinky box-kick, or every ricochet loose ball or bobbler seemed not so much as to drop into Richards's ursine embrace, but actually to be aimed directly at it, so comprehensive was his domination. The match simply swirled and eddied around him, and so he bent it totally to his will. He muttered, modest as ever and uncomfortable with the acclaim, 'Jack and the back-room boys organised the plan and all our stern homework paid off. Full credit, Scotland tried – but we just left nowhere for them to go.'

Rowell did not need to add words when he shook Richards warmly by the hand. Critics would have to think again after this day. Carling, dunking an ice-pack to his fast-closing right eye, put an arm on Richards's shoulder: 'I've played umpteen times with Deano round the world, but this was something very, very special. It's quite uncanny that where the ball is, there's always Deano scooping it in. He's amazing, quite brilliant, and makes captaincy an easy and utter pleasure.' Beers were snapped open and drunk from the cans. There was no singing. The room was muted over a job well and truly done and a massive sense of satisfaction permeated the whole party. Tony Hallett and Bill Bishop came in to present Archer with his velvet cap and England tie. The young Geordie was still wearing it – and nothing else – when he called on his mobile telephone his parents and girlfriend who were still up in the grandstand revelling in their pride.

Of course, traditionally, Archer had to sing for his titfer. Later, on the warmly convivial coach journey from the ground, Martin Johnson led his young rookie to the microphone and, decked in a tartan wig, Archer hesitatingly, gigglingly, shyly sang what seemed his own homemade concoction:

> 'C'mon old England, you're going up
> C'mon old England, get hands on that cup
> C'mon old England, never give in
> C'mon old England, you'll always win'

He was matily jeered back to his seat, and Colin Herridge took the mike to announce details of the dinner – men only for the players at the Prestonfield House Hotel, their wives and girlfriends at the Carlton Highland. Rugby is the only senior team sport which stages a post-match banquet for both teams after every international match. Apart from the continuing sexual chauvinism, it remains an enduring tradition all round the rugby world. They are these days far less 'boys-will-be-boys' rowdy than they used to be – the players are keen to get the meal and committee-buffs' speeches over quickly and join their ladies in waiting at the other venue and then loosen their black dicky-bows and go their separate ways with their spouses, to bed or on to more booze. But now, just as a warning, Herridge added jovially, 'to respect our hosts and sponsors, fellows, let's try not to be too boisterous at the dinner this time.'

Was he possibly referring to the Calcutta Cup night in Edinburgh more than half a dozen years before, when midnight was long gone and that roistering Scottish flanker John Jeffrey and his young English opposite number played a matey game of rugby, enacting the afternoon under the stars down Princes Street, and using as a 'ball' the venerable and priceless Calcutta Cup itself?

The tyro, freckle-faced English flanker that long-ago night was one Dean Richards. All these years later, on a Murrayfield afternoon, he firmly wrapped his great mitts on the same old priceless Calcutta Cup – and all of Scotland could not prise it away from him.

Behind the Scenes . . .

'*Deano* (below) *managed to communicate something to everybody from the moment he arrived back in the squad - the gentle giant.*' – JN

'*This was taken over the Scottish Highlands a few years ago - when Scotland beat England. This was Rory's first visit back after that match. I was in the other plane, over the wing.*' – JN

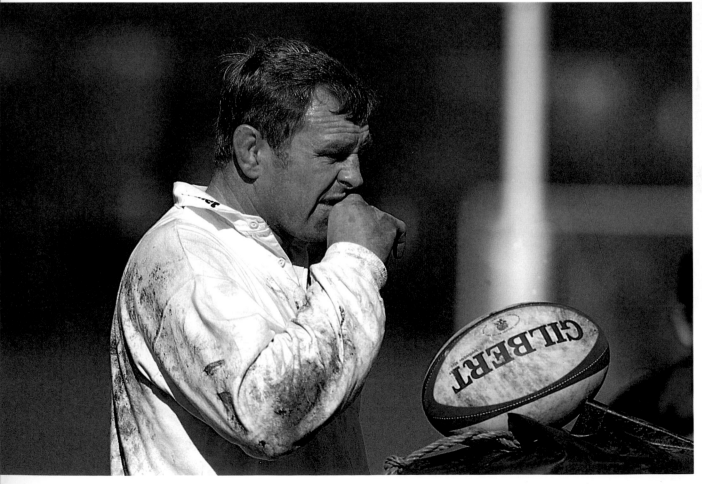

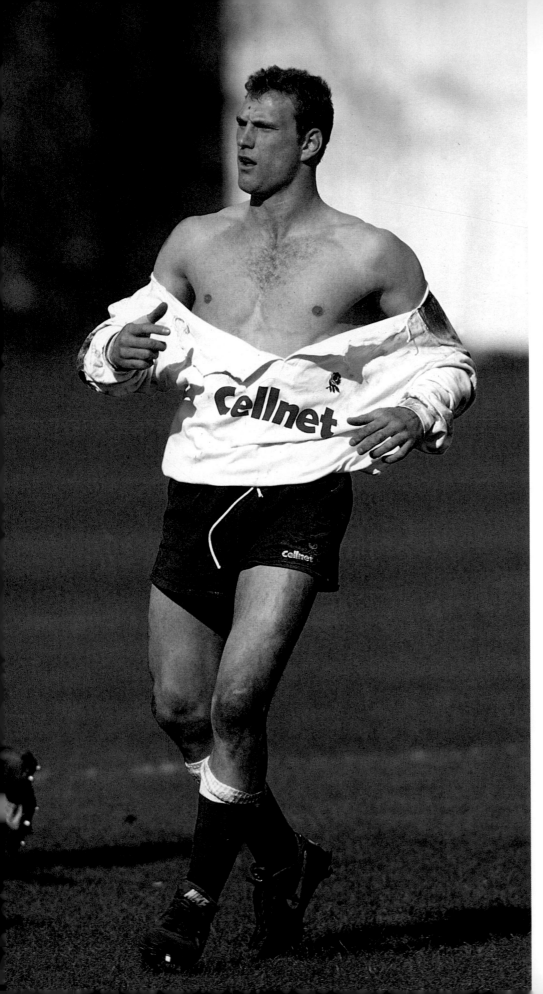

Says Carling of Dallaglio (*left*): 'Like our recent back-row greats, Winterbottom and Teague, Lawrence is a highly talented athlete with a ruthless cold shaft of steel in him.'

Graham Dawe on his farm near Lifton, Devon (*facing page, top*): '*Another man who enjoys his rugby, and a fantastic teacher. Not so good at cards.*' – JN

Jack Rowell watches the team train (*facing page, bottom*): 'I believe in all-court rugby, involving every part of the field and every player, from both props to the wings.'

A Good Time to Go

Routine is the thing as a settled and unchanged sports team approaches its next match. Collectively they do the same as they did the fortnight before and, with some, the year (or even years) before that. Entrances and exits, young players come and older ones go – but no matter, those new callow recruits are settled at once by their seniors into the routine that went before. This is the sixth time the England team has assembled through the winter, and the last – on five occasions they competed with nobility on an alien field and now, to sign off with, they are convinced, a flourish, they are back in the familiar home comforts of their Petersham Hotel which cranes high above the river at Richmond, and from which many rooms afford a dramatic view of England's towering stadium, some two to three miles westward.

Replacement Kyran Bracken: 'In training you are simply the "human shield" – bag after bag to lift, thump after thump to take.'

Mark Regan tightly strapped: 'I suppose you could call this new "open rugby" part of a revolution if you want to . . . but basically all I can think about is happily playing my rugby because, simply, I love the game.'

Routine is all. In a way, only the colour of the jersey worn by their opponents is different from match to match. Last time, from the Petersham, they set forth to slay the Reds. This time, the Greens await them. But the routine remains the same – oh, sure, the odd tactical change depending on particular opponents' strengths or perceived weaknesses, but when it comes to vigorous collective, growling, tub-thumping pleadings to summon up the blood and let all thirty eyes show the aspect of a tiger, then one match is much the same as another.

Thus, routine is all. Says the captain Carling, who wins against Ireland his 66th cap. 'The Petersham has almost become a second home to some of us. You fix your routine and you stick to it. Ever since I remember, on match-day morning I endeavour to watch the beginning of BBC television *Grandstand*, just to let that stirring signature tune wash all over me and get me in the mood. We even did that on the morning of a match at [his school] Sedbergh. Every single match-morning I allow myself to wrestle feverishly with only one difficult and crucial decision – whether to shave before or after the game.'

(*Bottom left*) Forecast Clarke before playing Ireland: 'Wales have the makings of a fine side. Don't underestimate what they can do for us in Cardiff. They can win us the Championship.'

(*Bottom right*) No prisoners, even at practice. Rowntree takes time off to dial up a new sponsor's training shirt.

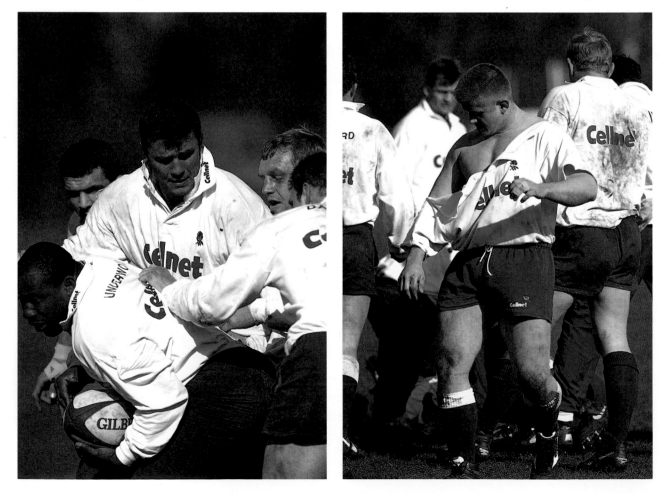

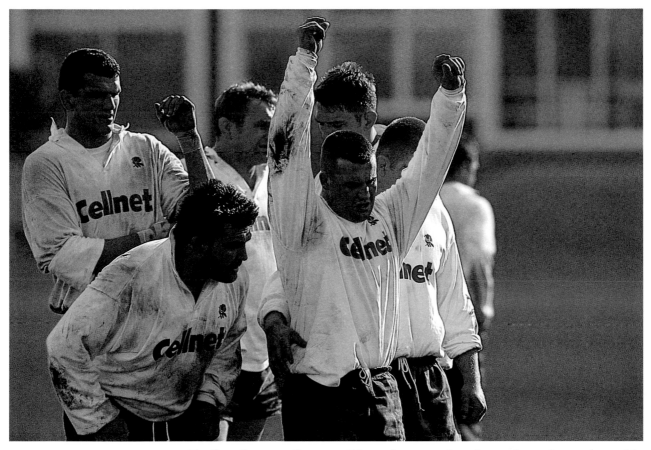

Earlier, Jeremy Guscott (his 45th cap today, forty-three times alongside his captain to forge a world-record centre partnership) had said precisely the same: 'To shave or not to shave, that is the question for me every single time – to stay stubbled for the match or shave for the banquet in the showers or when we arrive at the hotel?' What had he decided this time? 'Don't be silly, I've still got two or three hours left to worry about it before we get on the bus.'

Only if the *Daily Telegraph* stopped printing the crossword puzzle on Saturdays would Rory Underwood have to change his timeless routine.

The scenario for the day was that if England beat Ireland they would win the Triple Crown (an insular but, nevertheless, famous and ancient mythical prize for victories in the same season against the other three British Isles countries). If England beat Ireland and France beat Wales, England could technically still win the Championship on points difference, that is, if they scored umpteen of them to match the myriad of glittering scores the French had dapped-down in running the Irish ragged in Paris by 45–10 in mid-February. Few were forecasting that. No, England had to beat Ireland, and Wales had to beat France. And few, also, were forecasting the latter after France's team-settling pyrotechnics of the month before.

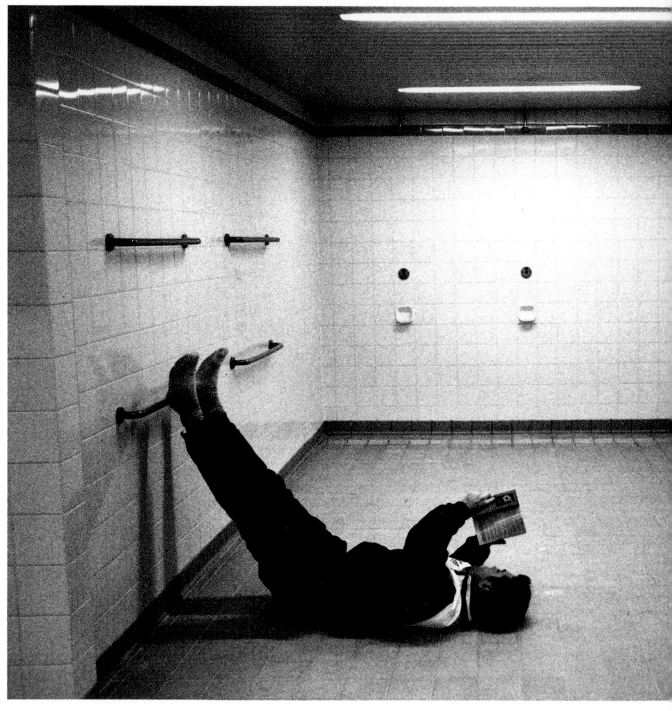

'*Phil de Glanville has a
moment to himself. He made it
on again.*' – JN

This was the general view, although Clarke was the one who kept disputing it. 'Don't underestimate Wales. Certainly not at Cardiff. I'm telling you, Wales have the making of a terrific team. You guys see if they don't put one over the French today.'

Jon Sleightholme came down full of his usual relishing zest for the day. 'Richard gave me my best-ever session with the needles last night. They were coming out of my arms and legs, everywhere. All stress and worry and tension gone. Slept an absolute treat. Feel terrific.' One fancies there cannot have been many more thrilled converts to acupuncture in all its four thousand years of documented history. 'Slights, in this sort of mood, you're bound to score this afternoon,' forecast his Bath confrère, Ubogu.

Martin Johnson sat alone. He glanced at *The Times* sports section, then turned to the front and the Midland Bank executive began to read the business news. He would win his 24th cap today, and had first breakfasted here in this room in 1993 when he was called in, out of the blue, to deputise for the suddenly injured veteran Wade Dooley. All his Saturday Petersham breakfasts since then – and till this one – had been alongside his fellow clothes-prop lock Martin Bayfield. 'I really felt for Bayf when he was dropped, still do,' said the soft-spoken man of few words. 'I knew it could have been me just as readily as him. We didn't play well against Wales, so someone had to be fingered for the general lack of performance. It was Bayf. He showed me the ropes, became a mate, and a good footballer, too, all around the park, but as a genuine lineout specialist one of the very best there's ever been.' Those exits and entrances again. 'But this boy Garath [Johnson was twenty-six last week, Archer twenty-one just before Christmas] is a very different lock-forward. Well, it would be hard for anyone to be such a line-out wizard as Bayf, wouldn't it? But Garath puts himself about and gets stuck in all right. Nothing seemed to daunt him at Murrayfield. He can do a lot of damage anywhere on the field. Highly impressive.'

Two or three places along from his Leicester clubmates, Graham Rowntree – in his spectacles looking for all the world like a studious young vicar, if you were sitting on the other side to his cauliflower ear, that is – admitted to his routine match-day nerves. 'Yes, being at home makes it better. I can't tell you how the insecurities got to me before Paris. Till Jason said, "Make all the tensions work for you, use them to make you more focused on what is expected of you." It worked. Jason's been brilliant with me. Today, the word is this new Irish prop against me, Wallace, is quite a player, a real handful with a "presence" and good body positions too – body position is crucial for props.'

'You'll be fine today,' said Leonard down half the length of the table, 'don't worry, think how scared Mr Wallace is of you this very minute wherever he's having his breakfast.' And Jason re-attacked his Weetabix.

And in the event, 'fine' Graham Rowntree certainly was. He provided another marvellously busy and highly charged performance in the course of a battle-royal with Wallace. It was a refreshing match. Both packs revelled in the confidence of their own abilities and went at it hammer and tongs, till England exerted the dramatic grip in the final chapter. Both sets of backs kept trying to break out and both biased and neutral in the throng were well satisfied at their money's worth. From first to last it was a breezy sunlit show on a breezy sunlit day. The Irish, as their glorious rugby heritage almost demands of them, had come a-buzzin' and a-boppin' out of the traps and from all directions. Said Guscott: 'They hit us at speed and they hit us at angles, and they began to chalk up some points on the board. We looked at each other and began to think, if only for a moment or two, "aye, aye, here we go again, trouble for England against the Irish." But we kept our heads, began to rock them back, kick our goals, and continued to hit them from deep.'

But it wasn't from deep that England hit the Irish at the last, a single stroke which conclusively rounded off the match – and the season – in telling and triumphant fashion. Victor Ubogu's forecast at breakfast was spot on.

Paul Grayson whispered along the line the call of 'Pizza Hut' – the name being derived affectionately from the TV advertisement for that chain of restaurants which featured Rory's brother Tony, their mother, and that World Cup apocalypse in black, Jonah Lomu. The call that would have the centres suddenly fanning off on decoy runs and the winger spearing through at full zip from his orthodox side.

And so it came to pass. Twenty metres out, England attacking the north end, Dallaglio rampages through to set up the ruck. Grayson calls 'Pizza'.

The ball is skilfully won. Guscott and de Glanville fan away and the cover is drawn – and from his right-wing Sleightholme blazes through, diagonally and sensationally to take Grayson's lovely inside pass to score near the left corner-flag. Sleightholme grounded the ball, stood, arms raised in joyous emperor's salute which, before even his team could converge on him, at once served to conduct a vast choir which now gave full throat all around the great stadium. (Some lyric concerning chariots, I think.)

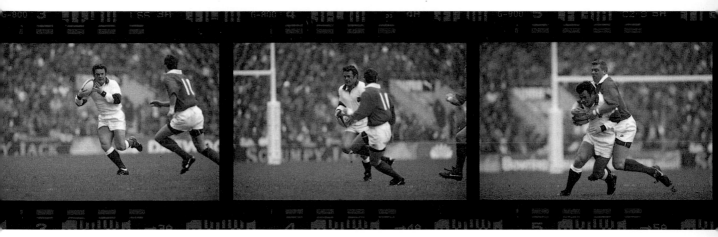

Said Sleightholme: 'Your first try for your country was always going to be special, but I never remotely thought it could feel as special as that. We had tried "pizza" about twenty minutes before, but it hadn't been quite right and I was hauled down ten yards short. I was worried whether we should try it again. Would they be wise to it? Because the knack is to make their defenders highly "interested' in what the centres are doing – you know, why is Jerry cutting inside to link back with the forwards? It worked. It shows practice pays off. There is a long time till England's next international – any amount of things can happen during that time. I wanted to leave an impression of what I'm about, so when the next selection meeting comes up they'll have to say, "Sleightholme? Oh, yes, he scored that try in the last match, didn't he?"'

There were three minutes of the full eighty to go when Sleightholme touched down. There was a good wodge of injury-time but it was all swallowed up in the crowd's continuing noisy and triumphant acclaim. When the final whistle was blown (England 28, Ireland 15) there as a climactic satisfied roar – but not half as raucous and heartfelt as the one which immediately followed, when the PA announced that France had been beaten in Cardiff. Not only the Triple Crown, but England had won the Championship outright as well.

Said Guscott: 'The move came off to perfection. Didn't Jon motor? It

Jon Sleightholme: 'Paul had called "pizza" twenty minutes before and I'd been hauled down. Would they be wise to a second shot? They weren't. The first try for your country has to be special – but I never thought it could be as special as this.'

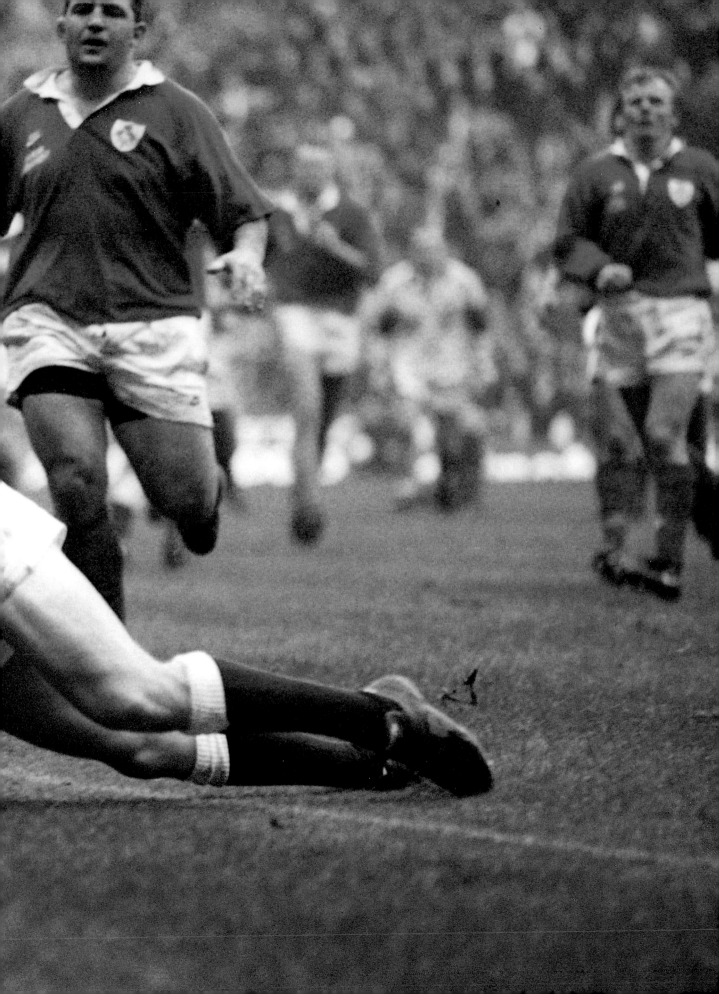

made it all worthwhile and crowned everything – and once we heard the result in Cardiff I looked around and could see a number of very very proud young men who, having played in their first ever Championship year, suddenly found they had won it. There was, truly, an ecstatic look in their eyes at that moment. Jon was one of those . . . full credit to him, you bet, for since he came to Bath he's worked extremely hard, and honestly, become not only quicker but self-critical as well, and able to take all responsibilities on his own shoulders. To hold down a wing place at Bath was a major achievement – and once he did the same for England he hasn't put a foot out of place. Tremendous.'

'What did I tell you?' beamed an elated Ben. 'We were slagged off for not beating Wales by thirty points – and now they go and stuff France and present us with the Championship.' There were fraternal hugs and embraces all round, and the feeling of 'Yippee!' much more demonstratively uninhibited and joyous than that bruised and quiet, slow-burning satisfaction of a fortnight before after Murryfield.

For the new boys, the newest of them, Garath Archer, summed it up: 'This is where I wanted it to happen, at Twickenham. I know it's my second cap, but to me this is my first. I had the dream to play for England for six or seven years, since I was a real kid, and when I did at last it was at Murrayfield and I met pure unadulterated aggression even when I was there singing "God Save the Queen" for the first time. It was like I was an extra in a scene out of *Braveheart* and I thought, "Heck, is this what representing your country's all about?" But today that kiddies' dream of mine really turned out what I thought it would – singing your anthem, full belt, with this great crowd joining in with you, so I felt myself choking and everything welling up inside me, and my ambition fulfilled, and now I knew it for sure. It was a heck of a game, too, a cracker. Their pack is damn good, tough with it. I know I should have stopped their chappie winning so much ball, but the ref was very sharp on stopping any interference with each other's ball, which is as it should be I suppose. So we took our share of damn good ball, too, didn't we? God, I'm delighted.'

'Euphoric' was Paul Grayson's word. He'd 'called' the move for the try, and scored the other 23 points with his boot to give him a debut season's tally, overall, of 22 goals, 80 per cent of England's points through the winter. Not bad for starters.

Meanwhile, a finisher again, but not a starter, so to speak, replacement Phil de Glanville said: 'I've been on and off the bench all year. To help in the try, and then be still on the field when we heard the score from Cardiff was doubly sweet. A tremendous feeling? Well, just look around you.' They were all clustered, arms around each other or their stunned, gener-

ous and chivalrous Irish opponents, on the forecourt at the entrance to the tunnel in front of the Royal Box. A smiling Colin Herridge was delighted to tell them in one of his final team announcements that the Championship trophy was already in the boot of a fast car heading east across the Severn Bridge from Cardiff (where it had been polished, displayed, and ready to be presented to the French captain). But, for now, there was still the Viking-horned Millennium Trophy to be presented by Prince Edward from the Royal Box. As acting-captain, said Herridge, Dean Richards should lead the side up the long staircase.

On the way, Deano passed the replacements' bench. He stopped. To offer the REAL captain a fireman's life on his back. One leg was in plaster. Crutches were alongside. In the thirty-third minute of the match, with nobody near him, Carling had moved to field an undangerous ball in the deep, his boot twisted awkwardly on the turf, and he fell with the awful suddenness of a shot stag. Excruciating. Snapped ankle tendons. His season was over. Might it be worse than that? The crowd, first stunned, then choired as one to acclaim the stricken Carling as he was carried, motionless, from his famous field. His mother and father hurried down from their grandstand seats, fraught with worry, to help console him in Terry

Will Carling is placed on a stretcher after turning his ankle: 'Pull yourself together, Carling, there's a game to win. And after it's won, is that the end for me? I don't know whether to be very, very proud or very, very sad. I'll know for sure when it's done, and we've won . . . '

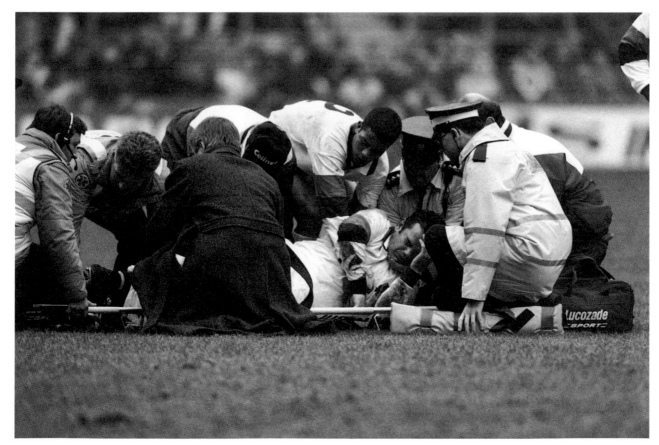

Crystal's medical centre. Happily, he was well enough to watch the last part of the match from the bench.

Richards helped up his captain, fixed the crutches into his armpits, and motioned for him to lead the way. Carling did as he was told, and hobbled up in front, one at a time, Long John Silver on a heaving deck. He did not realise Richards stayed where he was on the staircase, the whole squad behind him. So Carling accepted the trophy alone, and turned to show it to his beloved Twickenham. Just as, about an hour-and-a-half earlier, he had run on to his favourite paddock, sprinting out ahead of the team, 'Ronnie' Regan [in the No.2 position, of course] had stopped the rest in their tracks to let the captain be exclusively and drenchingly washed in the white-hot warmth of applause. Deservedly so. Because it was the very last time, after a span unprecedented in international team sport, that he would be leading out his white-clad team as captain.

One week before, to the very day, Carling had announced he was standing down.

He had taken the whole country completely by surprise, not to say the whole wide world of rugby. An exit coup, out of the blue, and precisely on cue. It made him a rare bird, going at his own bidding; international sporting captains these days are expected to be recriminatingly sacked, or hounded out of office by newspaper-headline power, or both. But not one pundit saw this coming. Carling had told Rowell the news at the Petersham when the squad assembled on the Saturday night. 'Jack just said, "Right, fine".' Had he tried to talk you out of it? 'No, why should he? He knows me better than that.' The timing was pluperfect. No wonder his company is called Insights. With no international tour in the summer, it would allow Rowell and his lieutenants a satisfactorily long interregnum before needing to announce a successor for next season.

At that stroke, Carling had for the first time in a full year shouldered his own way onto the front pages, and to the top of the broadcast news bulletins, for sports-related reasons as opposed to lascivious royal tit-for-tattle or marital tit-for-tat. So at once all his demons of the previous months now beat a path to the Petersham bearing posies and plaudits. Even those from the edges of the sporting press who had hounded him, and those close to him, so mercilessly.

'Look at them,' said Rory Underwood softly as he shook his head: 'It just takes him to stand down as captain and those same people who have spent months, even years, questioning his abilities for the job now flood in to tell him how terrific he's been, and how he'll be missed. How such people can so readily change their colours overnight is quite beyond my comprehension.'

At the Friday evening team meeting, after watching videos of Irish strengths and weaknesses, Carling had stood to break his squad's contemplative silence for the final time after his eight years as captain: 'Boys, tomorrow let's re-visit where we were together at Edinburgh, everyone running, everyone tackling, everybody collaring that loose ball . . . This is the last time I speak to you as your captain. So tomorrow is very very special to me. But I know it's very special to you all as well, particularly as we've formed and grown together this season as a brand-new team with all you fresh new people joining a few of us remaining old dads. Well, let me tell you younger ones, whatever you might have heard outside, if you come back tomorrow with the Triple Crown it will have been a truly fantastic performance. If we can achieve that together it will make me more proud of you than I can imagine, as proud of you as I've ever been proud of any team I've ever played with – and that goes back, I know, to before some of you had even done your O levels. And I am truly proud of myself for staying on to have played with you lot, and I hope you've all been a bit proud to have played alongside me. Let's just determine to do what we did that last night in Paris way back in January – resolve to get back into that dressing-room at the end, sit round, and one by one look each other full in the eye and be mutually proud of what we've done for one another. Let's do it for ourselves – and for the seventy thousand willing us on for a great performance. Let's make sure of it, OK.'

He gulped. He sat down. He was close to tears. A familiar long silence again. Then Dean Richards cleared his throat and – on cue – the management crept from the room. The emotionally tense atmosphere lightened. Underwood put a tape in the video machine. It was hilariously, excruciatingly juvenile. Boys-will-be-boys locker-room stuff, too risqué, too royal-dominated with double-entendres – no, dammit, simply too downright crude – for even the flavour of a single sentence to be repeated. As was the general party-atmosphere bonhomous chit-chat afterwards, when Will continued to look a touch taken aback with embarrassment. Though he happily accepted a framed mock-up front-page of his most unfavourite *Sun*, with a picture exaggerating the Cary Grant dimple in his chin, with the headline GOODBYE BUMFACE – AND THANKS.

Then Colin Herridge was called in for three cheers of farewell and a box of prime cigars and a framed photograph signed by them all. That, too, was truly felt – Herridge's genial and genuine guardianship of the squad through the 1990s has made him one of the unsung pillars of England's continuing triumphs.

Not long afterwards, Will Carling went to sleep in the captain's single-bedroom suite at the Petersham for the last time. If he plays again next

year – which, he says, he certainly intends to – it will be as an ordinary squaddie who has to share the bathroom, the loo, and the view.

Next morning, at 1.05 p.m., Jack stood and looked at his watch in the team room. As ever he speaks softly, intimately: 'Right, chaps, we'll be on the coach at ten-past. Here ends a great deal of hard work. Remember how fantastically well you competed against France; you'll all remember about Wales; and you know for sure what you achieved against Scotland. That is still warm in our hearts. We've increasingly come together this season. But the absolute fact is that in the last eight years the whole of England rugby has come together in an unprecedented, almost unbeatable manner. Absolute history has been made. One important reason, very important reason, is that for those eight years your team has been led, and often inspired by a very special man who has always done justice to himself on and off the field. Today, each one of you must, must, do justice to yourselves – to give Will the send-off he deserves.' Another protracted silence, Jack looking down at them like a paternal heron, then, 'Right, three minutes, on the bus in your own time, but be on it.'

The now familiar single file from the first-floor team room to the bus, the faithful and much liked Petersham staff wishing them well at the bottom of the grand and unique Portland stone staircase – apparently the longest unsupported central staircase in the country – then through the autograph hunters in the forecourt. Each to his place on the bus – and Colin's last count of heads and the regular cry, 'Victor, where's Victor? Oh, OK, OK, here he comes!' (As ever, one hand was signing autographs, the other holding his Cellnet to his ear.) 'OK, driver, let's go.' Jack in the front seat for the best view. Don in the other front row, behind the driver. Inseparable Les and Slem together behind Jack. Colin, beaming, behind them. Then the medics, Smurph and the Doc, Richard across the aisle. In the rear, the same old nursed and nested routine of every match, and just as hierarchical a pecking order as at the front, with that bonny, four-square Falstaff-in-his-prime, Jason, on the very back bench with his front-row, the others dotted in ones or twos up the half-length of each aisle. But if anyone speaks, it's only in murmured whispers.

Down the Petersham Road and left across the ancient bridge, the police motor-cyclists threading the bus through the traffic-light jams . . .

With Will so dramatically handing in his seals of office, might, just might, the management decide on a sweeping new change of the old guard by the next time this England bus comes down from the Petersham to cross the Richmond Bridge in the autumn. Might Rory be contemplating that as he sits alone, serenely inscrutable as ever? After all, he'd spent

this week denying press reports that this game against Ireland would voluntarily be his last. And weren't eighty-five caps and forty-nine tries good enough for any thirty-two-year-old to retire on?

After flying RAF Hawks for the past four years, Rory is now flying a desk and concentrating on a pressured review of crew-resource management. By the summer he hopes to have a 'calmer' little passage with the Red Arrows at Cranwell by way of R & R. So hot-under-the-collar-journos' trivia holds no terrors for him. 'Of forty-nine tries, what do you mean, The Best? They are all different. A winger likes any sort of try. You don't remember a single fact of them so much as the context – like those two last year at Cardiff which wiped out the memories of two bad games I'd had there, giving away tries, on previous Cardiff visits. Or the context of actually scoring to decide a game – like in Dublin in 1991, time running out, we just can't get through, suddenly that scissor with Hodgie [full-back Simon Hodgkinson], a swerve off my right foot, somehow brushing off Keith Crossan's full-pelt tackle, and over the line, hooray . . .'

The bus forked right, then left, the police outriders now nursing it up past the St Margaret's high street, where more and more supporters stand to wave their greetings . . .

'That very first one against France – was it really 1984? – the ball squirted out from a maul, Pete Wheeler harassed their scrum-half, I fly-hacked it, picked up, went through the winger, Begu, and hared for the corner, before changing tack off my left to wrong-foot Blanco and go in at the posts. Or my very first at Twickenham, all of four years after that, a thirty–forty yarder against Ireland, at which, I was so relieved, I did that swan-dive as I went in under the posts. Since when, nothing so dramatic, just narrowly squeaking inside a few cornerflags all over the place.

'It's been a long time. And a long time with Will. I suppose "enigma" is the word that comes to mind with Will. That ridiculousness last night wasn't the 'thank-you-and-goodbye' it might have seemed, it was a genuine mark of respect at his achievements. He began bringing the younger guys into team discussions. In my early days I just sat at the back, kept my head down, and kept quiet. This final season has been a particular revelation. Doubtless it has to him, too. It must have changed him enormously. The *Daily Mail* and all the others have highlighted his private life so incredibly. I suppose an analogy might be the way the footballer Eric Cantona also made his actual sport's performance raise him above all the non-sporting headlines and intrusion.'

Up through St Margaret's the bus is jammed by the increasingly dense match traffic. Colin frets. These outriders are not in the same daredevil-ruthless class as those in Paris (nor the Twickenham boulevards as wide).

The players don't bother. Nor does the retiring capain of this silent band, alone, black-brooding, brown-studied in his reverie . . .

'It had been on my mind since the World Cup. Well, obviously it had. Some have told me it's been my best year as captain. It's kind of them, but that's all very well from the hotel to the pitch. The fact is that with all the other little bits, like keeping in touch each week, ringing people – well, to be honest, I knew I was taking a few short cuts, not enquiring about guys, not listening to the feedback, not gabbing as I used to with Cookie, or planning with Colin and Smurph . . . I was cutting corners. That's never been my way, you know that. So resignation was building up, what with all the other pressures too. Around the beginning of February, I called my great friend from school and university, Andrew Harle, and said, "Come down for the Ireland game, I think it will be my last, certainly as captain." I then rang three or four other close mates to make sure they would come down, too, and it all cemented the feeling: "Yeah, this sounds about right." Immediately after the Scotland match, I spoke to Jon Holmes, my agent, Geoff Cooke, and a couple of other close mates. I said I didn't have remotely the desire to go on to the 1999 World Cup as I had for the previous two – not as captain anyway, for all sorts of reasons. In fact, not being captain would give me a better chance of going as a player. So it was a hard decision to announce – but the right one.

'That's the true story – that and simply because eight years is a long time, and it saps a bit of your energy, and after a bloody good run of which I'm immensely proud, it is so obviously time to move on, and time for the England team to move on. They need a new captain to take them on that journey. I suppose I enjoyed this year particularly because I knew in my heart from quite early on that this was going to be it, my last.

'But how could I have thought less than eleven months ago what was about to happen. After the "old farts", the World Cup dramas and disappointments, and then everything else blowing up in my face – exploding, rather – I was desperate for some calm. Rugby was a tremendous help. When the whole thing started, I went up to play at Orrell. Then I played at Bristol. Not a murmur, no stick from the crowds at all. As if they were

saying, "let's leave him alone, show him he's among 'family', he's taking so much from other quarters." It was touching and very spirit-lifting. Mind you, the tabloids do their bits and pieces, stir it all around, and you think at first the whole world's come to an end – but people glance at it, read it, then toss it away and their life goes on, they're totally unaffected. Why should that sort of stuff bother them, it's not actually important to *them*? I met the guy the other day who's one of the actors on the TV soap *Emmerdale*. He was going, "Oh, my God, oh my God, the *News of the World* did me rotten this way and that way." "Did they?" I said. "When? I never saw it." "What do you mean?" he said. "You must have." I said, "No, I didn't." He couldn't believe it. He thought every single person in the country had read about him and lapped it up – and also, I presume, that every single person in the country believed it. But they don't, do they? It would be ludicrous to think they do.

‘Memories? Millions. But don't ask about the best times on the field, there's photographs to show those – because the best times are in the changing-room, minutes after the big win, a great win, just looking at each other and smiling "that was something special". It happened after our first Grand Slam in Paris, and then so often again, and finally just a fortnight

ago at Murryfield, when Deano motioned "Oi, come here" and I sat next to him, muddied and bloodied and wrecked, and we just gazed long at each other and grinned and grinned . . . or my very first game as captain, against Australia, coming off injured with a couple of minutes to go, and when the final cheer went up, me, the only player in the room, just burst into floods of tears, started crying like a baby . . . or walking out onto the Parc des Princes before the 1991 semi-final with Peter Winterbottom, who'd seen it all, played everywhere, and he just said softly, "This is the place to win, this is the place to win" – and immediately after all the eighty-minute havoc, in the changing-room, he's already lit up his cigarette and he just smiles as he walks past me and he pats my head and mutters, "Not bad, eh, not bad?"'

'Winters was a true great. So was Wade. And Teaguey. There was something special about those hard, hard men. I roomed with Teaguey for the last two weeks of my Lions tour. He was incredible. I feel honoured just to have known him. These big honest warriors are truly special, and if they think you're OK, that's good enough for me. The press can write what they want, but I don't care – if those guys, who I think represent the ultimate benchmark themselves, think that I'm all right, then that's all I've ever wanted out of rugby. Funny, in this new team of ours, Lawrence has got a touch of them in him – a highly talented athlete, but with a real shaft of ruthless steel in him. And young Archer, too: a hard boy, who looks like controlling his discipline. He's got to be like Winters – he was as hard as nails, but also the most disciplined player I've ever come across.

'Last night, in the dark, I looked across the river from the hotel. Twickenham was down there. In eight years, how much we've all changed, how much Twickenham has changed, how much rugby's changed, how much I've changed. Earlier, after the meeting, a few of the guys had come up, in ones or twos, just quietly, and I'd begun to get all emotional. I never like showing that. I said to Deano, "Now look here, none of this letting me run out on my own tomorrow. I'll get emotional, and I don't want that till we've won. Right?" "Nothing to do with me", he said, "I always amble out last, you should know me by now." OK, but I bet they're still hatching something. And I know I'm going to get very, very emotional at the anthem, that's for sure . . . C'mon, we're here, pull yourself together, Carling, there's a game to win. And after it's won, is that the end for me? I don't know whether to be very, very proud or very, very sad. I'll know for sure when it's done and we've won . . .'

His team ducked after him out of the bus. He led them through a great cheering congregation massed on Twickenham's west concourse. Back-

slaps and 'all-the-best' . . . and he led them into the blessed dressing-room sanctuary for the very last time.

And so it was won. And so it was done.

Some four hours later, they were back in the same bus, heady with their triumph and with their wives and sweethearts, and heading for the Hyde Park Hilton. No new-capped sprog to serenade his new team this time – but what about a former captain for the job? Herridge handed Carling the microphone. Leaning his crutches on the seat, he stood and crooned – and talk about 'ol' blue eyes', Carling had spent the season sporting a pearler of a black eye on one side or the other, this time it was his right eye – the appropriate one from his military-family background, 'Two Little Boys Had Two Little Toys, Each Had a Wooden Horse . . .'

It brought the house down, just as it did, later at the banquet, when he accepted the Championship Trophy which had been hurried up from Cardiff. It would be the last time he would be on the top table with the committeemen. He had been up there since he was twenty-two. Only seven of the sixty-six times had he been on a table down with 'the boys' – and those seven times were so long ago 'that I seem to remember I was usually under the table anyway'.

And when it was socially and diplomatically right, Guscott took one crutch and held his arm, and he hobbled across the marbled foyer out of the hotel and along Park Lane to the matey Rose & Crown – and there, waiting for him, the drinks in, were Teaguey and Wade and Winters, Mooro and 'Judge' Rendall (who hadn't at first taken to 'the whipper-snapper' all those years ago), and Probyn and Andrew and Morris and more . . . and the new 'old-timer has-been' fell into the veterans' embrace.

Back at the hotel, young Garath Archer was worried. With his Scouser sweetheart Kate on his arm, he had searched in vain for his erstwhile captain. He wouldn't find him there. 'I just want to thank him from both of us from the bottom of our hearts. He didn't need to have done it, did he? But it simply made our day – announcing our engagement to all the world in his final banquet speech.' Kate displayed her diamond-bright finger. 'Got it with my Newcastle signing-on fee,' said Garath.

Real life goes on.

'I had a great sense of "the end of term", having had such fun throughout the season. Everybody was collecting shirts, balls and memorabilia signed by comrades. People were pondering their futures. Wondering who would be filling those shirts next year.

'While looking back over the season in pictures: it makes me remember how lucky I have been to be involved in a great sport at the highest level with fantastic people.

'When I talk to the players now I am talking to friends, but also to people with whom I have something in common: a sense of coming through, and being successful.

'I would like to thank everybody at the RFU. All the squad members, including Jack Rowell, Les Cusworth, Mike Slemen, Don Rutherford and, of course, Colin Herridge.'
– Jon Nicholson

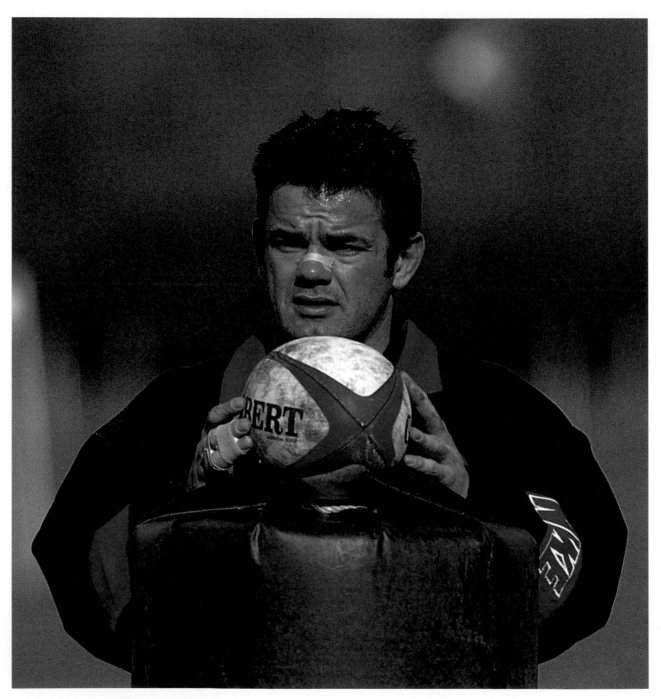

Goodbye to all this. 'Eight years is a long time. It was a hard decision, but the right one.'

Afterword by Will Carling

The year between April 1995 and '96 was a momentous one for rugby – and it was a fairly interesting one for me, too!! (I think, Frank, I'm allowed those double exclamation marks). But rugby, marvellous rugby, helped me get through it, as you've already read in this book. My eight years as captain changed my life completely. It was an honour and a privilege, at no time more so than in this final season with a new team in which we blooded bold young men in all the pivotal positions. For that reason, I like to think my last year was the one in which my captaincy had most effect.

I can't believe it wase all those years ago that I won my first cap in Paris, and thinking to myself that I might as well enjoy this because it could well be not only my first but my last? We lost narrowly by 10–9, and I was still in for the next match against Wales. We were beaten again. Carling P2, L2. Somehow I kept my place for Scotland, and we scraped a win at Murrayfield and I came in elated and flopped down next to Rory in the dressing-room and he looked miserable and said, 'What a ruddy awful game that was,' and I said 'Hey, hang on a minute, Rory, that was my first international win and I think it's great, don't mock my hour of glory.'

I thought of that moment exactly eight years later, in what I knew would be my last match at Murrayfield, as captain, when I heard our brand new cap Garath Archer was feeling restless and insecure on the morning of the game. So I whistled him up and said, 'Do you fancy a stroll? Let's have a wander around Princes Street and taste the atmosphere.' Off we went together into the heart of 'enemy' territory. We talked about this and that, and we had Durham in common and he told me how he'd crossed the border to Edinburgh before and been on a long and thirsty pub crawl, and then I quietly told him that I believed he was going to be a very good international player indeed and that he'd be making this morning stroll as an England player many times again in the future.

Such fleeting little moments have been pinned down in this book. International sportsmen have often been legitimately charged with not seeing the wood for the trees and being immersed in their own self-centred anxieties and challenges so the broader spectrum of the wide stage they play on is lost. This book will dispel that feeling for all of us. It places our team and its rugby in the context of the game's most traumatic year since William Webb-Ellis 'picked up the ball and ran'. Karen Levesconte and the squad's indispensable Colin Herridge helped get the project off the ground and then nursed it through to the end. The title we chose was apt, I think, and the whole squad agreed to open the hitherto sacrosanct dressing-room to a writer and photographer to record a team's most intimate collective rituals. What international team has ever done that? Frank was the wise old scribbling fly-on-the-wall trying to be invisible even after the management and the replacements had left the room for that special five minutes before the chosen fifteen file out into the cauldron, and Jon, differently, became so integrated in his England tracksuit and all the gear that he became an integral part of the pre-match card evenings, becoming very popular by always losing heavily!

But I think you will agree that his pictures have captured the essence and much more of his season with 'the lads'. For my part, I know I now

have vivid and tangible proof in my bookcase that in 1996 I really did sign off as England captain after eight truly wonderful and lucky years. So at least I won't need to keep pinching myself for the rest of my life at the wonder of it all.

The Squad on Will Carling

Jeremy Guscott: 'He should be mighty proud of what he's done. I know he is. Never more than this year. He took a very strong lead over "professionalism", then his coping of the period of the "old farts" and "everyone knows what" was truly eye-opening as he pulled a new team together, focused the new boys – and performed supremely well on the field.'

Jason Leonard: 'a genuine diamond, honestly. Everyone looks up to him, wants to do their utter best for him, because he's seen it all, done it all. And that's talking as his Harlequin's captain!'

Mark Regan: 'Proof of the man is that he treats everyone exactly the same, whether he's got fifty caps or one cap. If anyone engendered the team spirit I found myself part of, Will did.'

Jack Rowell: 'England rugby will now be like Trafalgar Square without Nelson.'

Twickenham Saturday 18 November 1995

England 14 – 24 South Africa

Tries: de Glanville (1) *Tries*: Williams(2)
 Van der Westhuizen (1)

Conversions: – *Conversions*: –
Penalties: Callard (3) *Penalties*: Stransky (3)

J. E. B. Callard	15	A. J. Joubert
D. P. Hopley	14	J. Olivier
W. D. C. Carling (Captain)	13	J. C. Mulder
J. C. Guscott	12	H. P. Le Roux
R. Underwood	11	C. M. Williams
M. J. Catt	10	J. T. Stransky
K. P. P. Bracken	9	J. H. van der Westhuizen
J. Leonard	1	A. van der Linde
M. P. Regan	2	J. Dalton
V. E. Ubogu	3	T. G. Laubscher
M. O. Johnson	4	J. J. Wiese
M. C. Bayfield	5	M. G. Andrews
T. A. K. Rodber	6	R. J. Kruger
R. A. Robinson	7	F. J. van Heerden
B. B. Clarke	8	J. F. Pienaar (Captain)

Replacements

D. Pears	16	J. T. Small
M. J. S. Dawson	17	H. W. Honiball
P. R. de Glanville	18	J. P. Roux
G. C. Rowntree	19	R. A. W. Straeuli
R. G. R. Dawe	20	W. Meyer
L. B. N. Dallaglio	21	C. L. C. Rossouw

Twickenham Saturday 16 December 1995

England 27 – 9 Western Samoa

Tries: Dallaglio(1) *Tries*: –
Underwood (1)
Conversions: Grayson (1) *Conversions*: –
Penalties: Grayson (5) *Penalties*: Kellett (3)

M. J. Catt	15	V. Patu
D. P. Hopley	14	B. Lima
W. D. C. Carling (Captain)	13	T. Vaega
J. C. Guscott	12	G. Leaupepe
R. Underwood	11	A. Telea
P. J. Grayson	10	D. Kellett
M. J. S. Dawson	9	J. Filemu
G. C. Rowntree	1	M. A. Mika
M. P. Regan	2	T. Leiasamaiva'o
J. Leonard	3	P. Fatialofa
M. O. Johnson	4	P. Leavasa
M. C. Bayfield	5	F. L. Falaniko
T. A. K. Rodber	6	S. Kaleta
L. B. N. Dallaglio	7	S. Vaifale
B. B. Clarke	8	P. Lam (Captain)

Replacements

J. E. B. Callard	16	K. Tuigamala
P. R. de Glanville	17	A. Autagavaia
K. P. P. Bracken	18	S. Smith
V. E. Ubogu	19	M. Birtwhistle
R. G. R. Dawe	20	G. Latu
R. A. Robinson	21	O. Matauiau

Parc des Princes Saturday 20 January 1996

England 12 – 15 France

Tries: – *Tries*: –
Conversions: – *Conversions*: –
Drop Goals: Grayson (2) *Drop Goals*: Lacroix(1)
 Castaignede (1)

Penalties: Grayson (2) *Penalties*: Lacroix (3)

M. J. Catt	15	J-L. Sadourny
J. M. Sleightholme	14	E. Ntamack
W. D. C. Carling (Captain)	13	R. Dourthe
J. C. Guscott	12	T. Castaignede
R. Underwood	11	P. Saint-André (Captain)
P. J. Grayson	10	T. Lacroix
M. J. S. Dawson	9	P. Carbonneau
G. C. Rowntree	1	M. Perie
M. P. Regan	2	J-M. Gonzalez
J. Leonard	3	C. Califano
M. O. Johnson	4	O. Merle
M. C. Brayfield	5	O. Roumat
S. Ojomoh	6	A. Benazzi
L. B. N. Dallaglio	7	L. Cabannes
B. B. Clarke	8	F. Pelous

Replacements

J. E. B. Callard	16	P. Bernat-Salles
P. R. de Glanville	17	A. Penaud
K. P. P. Bracken	18	G. Accoceberry
V. E. Ubogu	19	R. Castel
R. G. R. Dawe	20	M. de Rougemont
D. Richards	21	L. Benezech

Twickenham Saturday 3 February 1996

England 21 – 15 Wales

Tries: Underwood (1) *Tries*: Taylor (1)
Guscott (1) Howley (1)
Conversions: Grayson (1) *Conversions*: Thomas (1)
Penalties: Grayson (3) *Penalties*: Thomas (1)

M. J. Catt	15	W. J. L Thomas
J. M. Sleightholme	14	I. C. Evans
W. D. C. Carling (Captain)	13	L. B. Davies
J. C. Guscott	12	N. G. Davies
R. Underwood	11	W. T. Proctor
P. J. Grayson	10	A. C. Thomas
M. J. S. Dawson	9	R. Howley
G. C. Rowntree	1	A. L. P. Lewis
M. P. Regan	2	J. M. Humphreys (Captain)
J. Leonard	3	J. D. Davies
M. O. Johnson	4	G. O. Llewellyn
M. C. Bayfield	5	D. Jones
T. A. K. Rodber	6	E. W. Lewis
L. B. N. Dallaglio	7	R. G. Jones
B. B. Clarke	8	H. T. Taylor

Replacements

J. E. B. Callard	16	G. Thomas
P. R. de Glanville	17	N. R. Jenkins
K. P. P. Bracken	18	A. P. Moore
V. E. Ubogu	19	S. Williams
R. G. R. Dawe	20	L. Mustoe
D. Richards	21	G. R. Jenkins

Murrayfield Saturday 2 March 1996

England 18 – 9 Scotland

Penalties: Grayson (6) *Penalties*: Dods (3)

M. J. Catt	15	R. J. S. Shepherd
J. M. Sleightholme	14	C. A. Joiner
W. D. C. Carling (Captain)	13	S. Hastings
J. C. Guscott	12	I. C. Jardine
R. Underwood	11	M. Dods
P. J. Grayson	10	G. P. J. Townsend
M. J. S. Dawson	9	B. W. Redpath
G. C. Rowntree	1	D. I. W. Hilton
M. P. Regan	2	K. D. McKenzie
J. Leonard	3	P. H. Wright
M. O. Johnson	4	S. J. Campbell
G. S. Archer	5	G. W. Weir
B. B. Clarke	6	R. I. Wainwright (Captain)
D. Richards	7	E. W. Peters
L. B. N. Dallaglio	8	I. R. Smith

Replacements

J. E. B. Callard	16	K. M. Logan
P. R. de Glanville	17	C. M. Chalmers
K. P. P. Bracken	18	G. Armstrong
V. E. Ubogu	19	S. Murray
R. G. R. Dawe	20	A. P. Burnell
T. A. K. Rodber	21	J. A. Hay

Twickenham Saturday 16 March 1996

England 28 – 15 Ireland

Tries: Sleightholme (1) *Tries*: –
Conversions: Grayson (1) *Conversions*: –
Drop Goals: Grayson (1) *Drop Goals*: Humphreys (1)
Penalties: Grayson (6) *Penalties*: Mason (4)

M. J. Catt	15	S. J. P. Mason
J. M. Sleightholme	14	S. P. Geoghegan
W. D. C. Carling (Captain)	13	J. C. Bell
J. C. Guscott	12	M. J. Field
R. Underwood	11	N. K. P. J. Woods
P. J. Grayson	10	D. G. Humphreys
M. J. S. Dawson	9	N. A. Hogan (Captain)
G. C. Rowntree	1	N. J. Popplewell
M. P. Regan	2	A. T. H. Clarke
J. Leonard	3	P. S. Wallace
M. O. Johnson	4	G. M. Fulcher
G. S. Archer	5	J. W. Davidson
B. B. Clarke	6	D. S. Corkery
L. B. N. Dallaglio	7	W. D. McBride
D. Richards	8	V. C. P. Costello

Replacements

J. E. B. Callard	16	C. M. McCall
P. R. de Glanville	17	P. A. Burke
K. P. P. Bracken	18	C. Saverimutto
V. E. Ubogu	19	P. S. Johns
R. G. R. Dawe	20	H. D. Hurley
T. A. K. Rodber	21	T. J. Kingston

Index